Beauty in Science and Spirit

17 December 2006

To Pen

May you find beauty in
the book

Paul Carr

Beauty
in
Science and Spirit

Paul H. Carr

Beech River Books
Center Ossipee, New Hampshire

BℝB

Beech River Books
P.O. Box 62, Center Ossipee, N.H. 03814
1-603-539-3537
www.beechriverbooks.com

LIBRARY OF CONGRESS CATALOGING-IN-PUBLICATION DATA

Carr, Paul H.
Beauty in science and spirit / Paul H. Carr. -- 1st ed.
p. cm.
Includes bibliographical references and index.
ISBN-13: 978-0-9776514-7-4 (pbk. : alk. paper)
ISBN-10: 0-9776514-7-9 (pbk. : alk. paper)
1. Religion and science. 2. Aesthetics. 3. Art--Philosophy. I. Title.

BL240.3.C37 2006
215--dc22
2006031995

Chapter titles set in an Italian Cursive, 16th Century font and main text set in Goudy. Book design by Brad Marion.

Printed in the United States of America

Dedication

To my late wife, Karin Hansen Carr, (1940-1986), who died before her book, "Dragons [Bombs] from the Sky: My WWII Childhood," could be completed, but who lives on in our five daughters.

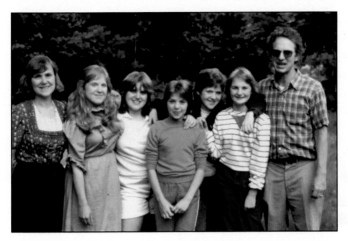

Karin Kirsten Tina Sylvia Emily Lilo Paul

PLATE 1: Carr Family in 1985

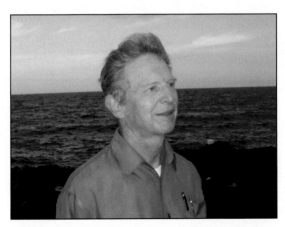

PLATE 2: The author, Paul Carr, Ph. D. Physics

Paul led an AF Research Laboratory group investigating the properties of microwave ultrasonic surface acoustic waves (SAW) and superconductors. His eighty scientific papers and ten patents have resulted in new components for radar, TV and cell phones. He received a John Templeton Foundation grant for his philosophy course "Religion and Science: Cosmos to Consciousness" at the University of Massachusetts Lowell. His web page is *www.MirrorOfNature.org*.

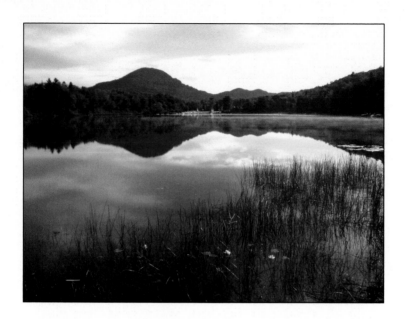

PLATE 3: Mount Norris reflected in Lake Eden, Vermont

THE SUMMIT
Paul H. Carr

To the top of the mountain one day I did go,
To see all the scenes that a summit can show.
For the work and the toil up the long yet small trail,
The perspective was grand where fine views do prevail.

To the right to the left, all around from the heights,
Are the things, which make wonderful, beautiful sights:
The small farmhouse and barn, the big mill in the town,
They do all have a place as the climber looks down.

The small ponds, like some emeralds clear,
Are all scattered about, like dewdrops so sheer.
The big lake, like a sheet of the clearest of glass,
Which is blue as the sky that does over us pass.

If immense and important or tiny and small,
The great God has a place in the world for us all.

PLATE 4: Steeple on the Kresge Chapel at MIT

"Science and art spring from similar creative impulses..." from Massachusetts Institute of Technology President Killian's dedication of the cylindrical Kresge Chapel, designed by architect Eero Saarinen.

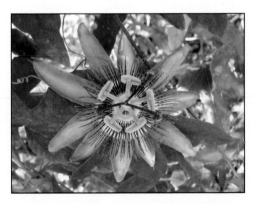

PLATE 5: Passion Flower.

Flowers have vibrant colors and harmonious symmetries. This subjective, aesthetic beauty contrasts with the objective, functional beauty that attracts insects for pollination and reproduction. Could the aesthetic beauty we see in flowers be evidence of our evolution from simpler life forms?

PLATES 6, 7, AND 8: Logarithmic spiral with Divine Proportion, 1.618:1, seen in snail and nautilus shell

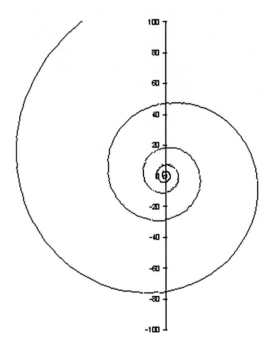

R = expo (0.315 x Angle)
75.58/46.74 = 1.618
46.74/28.90 = 1.618

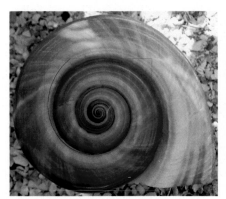

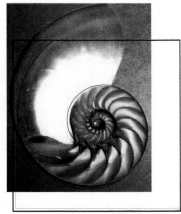

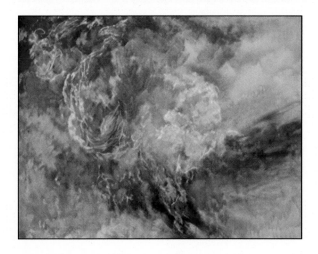

PLATE 9: *Light through the Trees,* Elvira Culotta's acrylic painting. The author associates it with the nebula pictured below (Courtesy of Elvira Culotta).

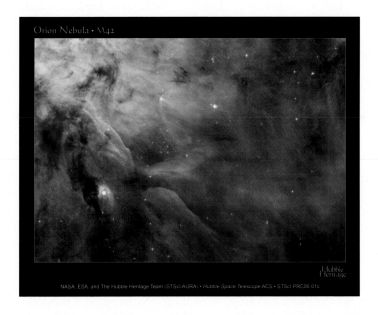

PLATE 10: Orion Nebula M42 formed by an explosion of a star at the end of its life. New stars are being formed from the gravitational attraction of the dust (NASA, ESA, Hubble Heritage Team).

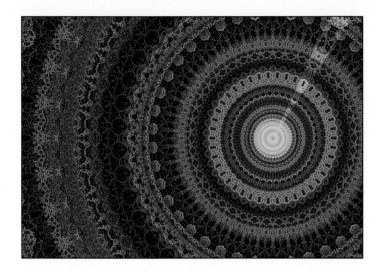

PLATE 11: Professor Heller superposed on his computer twenty-one plane waves, travelling in twenty-one evenly spaced directions around the compass or circle. The crests and troughs of these waves combine constructively and destructively to form this pattern. (Bessel 21. Courtesy *<<http://EricJHellerGallery.com>>*).

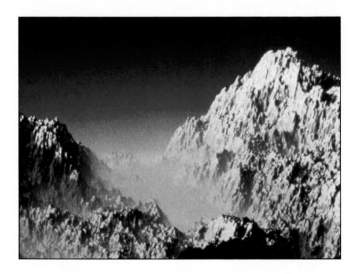

PLATE 12: Fractal mountain landscape with mystical and mathematical beauty. Richard Voss generated this landscape with a computer program having both random and deterministic elements. Used with permission.

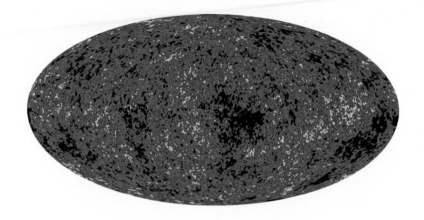

PLATE 13: Oldest radiation in the universe shortly (0.4 million years) after the "beginning." Temperature variations in the cosmic microwave background radiation are plotted with different colors. The cooler regions in blue could have "seeded" the stars and galaxies shown below (NASA/WMAP Science Team).

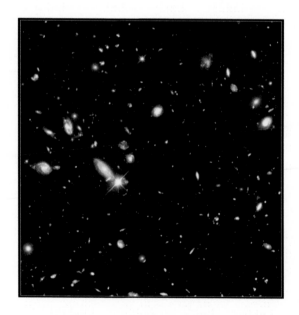

PLATE 14: Galaxies 12 billion light years away, about 2 billion years after the big bang. Only one star is visible. NASA Hubble Telescope Deep Field Image (January 15, 1995. STSCI, NASA).

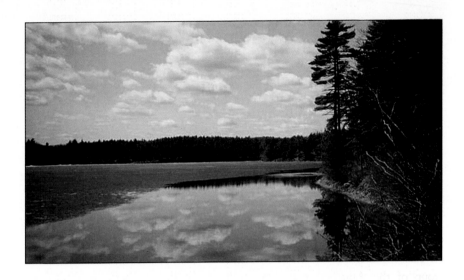

PLATE 15: Walden Pond from the site of Thoreau's hut.
"Water indeed reflects heaven." —Thoreau.

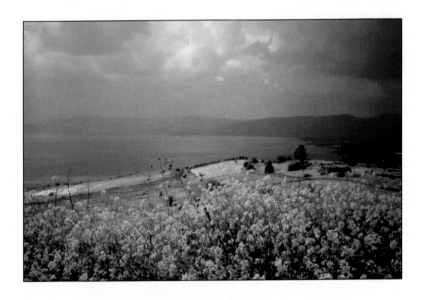

PLATE 16: Lake of Galilee from the Mount of the Beatitudes.
"Consider the lilies of the field, how they grow; they neither
toil nor spin, yet I tell you, even Solomon in all his glory was
not arrayed like one of these" (Matt. 6:28).

Acknowledgments

"The development of science is basically a social phenomenon, dependent on the hard work of and mutual support of many scientists and on the society in which they live."

—Charles H. Towne, 1964 Nobel Prize, Stockholm.

This book arose from dialogues with many people. These include members of the Institute of Religion in an Age of Science (IRAS) at the July conferences on Star Island off Portsmouth, New Hampshire and the luncheon discussion group of the American Scientific Affiliation (ASA), which Tim Wallace organizes at the MIT Lincoln Laboratory.

I particularly wish to thank Karl Peters for selecting this book for discussion at the July 2005 IRAS Seminar, led by Jeanie Graustein, who also gave helpful feedback on my draft manuscript. The following give insightful reviews at the Seminar: Roger Brown, Katherine Baucke and Paul Ulbrich. Roger Gillette and Robert Bercaw's written comments were most helpful. I had helpful discussions with Muriel Adcock, Pam Banks, Jerry Josties, Mel Gray, Kent Koeniger, Ed Lowry, James C. van Pelt, Joan Goodwin, Stan Klein, Holmes Rolston III, Niel Wollman and James Baratta.

In Chapter 3 on Cosmology, I would like to thank Owen Gingerich for a stimulating dialogue and for providing me with the Copernicus quote from *DeRevolutionibus* and also with the poem about Kepler. I would also like to thank Alan Guth for helpful discussions and for providing me with FIGURE 3.1 and FIGURE 3.5 from his book *THE INFLATIONARY UNIVERSE*. Many thanks to V. V. Raman for helpful discussions and his permission to use his "Rig Vedic Hymn of Creation."

I would like to thank John Updike for stimulating discussions on science and religion and for permission to use the photograph shown in FIGURE I.7. I would also like to thank Eric J. Heller for helpful conversations and permission to use FIGURE 1.11. Many thanks to Stephan Wolfram for permission to use FIGURE 1.8 and Richard Voss to use FIGURE 1.12. I am indebted to Derek L. Pursey for permission to publish his "A Creation Story for the 3rd Millennium" in Appendix C.

I would like to thank Phillip Bosserman and Kevin Van Anglen of the Thoreau Society, and Steve and Carol Berry, John Brown, Charles Dubs, Ralph Dieter, Carl Hein, Larry Gould, Billy Grassie, Albert Levis, Pat Largess, Steve Mittleman, Bob Shore, Drew Meulenberg, Dick Morenus, Henry Wadzinski, Ralph and Nancy Penland, Kirk Wegter-McNelly, Max Stackhouse, Wesley Wildman, John Quiring, Jim Miller, Jill Zimmermann and Arthur Yaghjian for helpful dialogues and comments.

I am deeply indebted to my wife and soul mate, Ginny, for inspiring my own sense of beauty and for her help, comments, and editing. I am also indebted to my daughters and my nieces for their many helpful comments over the years.

I am indebted to my editor and publisher, Brad Marion, of Beech River Books for his helpful suggestions for improving my draft manuscript.

Chapter 5, "Beautiful Fractals: 'Does God Play Dice?'" is based on the article "Does God Play Dice? Insights from the Fractal Geometry of Nature" published in *ZYGON: Journal of Religion and Science, 39:*4, (December 2004), pp. 933-940.

Chapter 6, "A Theology for the Evolution of 'Forms Most Beautiful': Haught, Teilhard de Chardin, & Tillich" is based on a paper "A Theology for Evolution: Haught, Teilhard, & Tillich" presented November 21, 2003 at a meeting of the North American Paul Tillich Society, held during the American Academy of Religion Meeting, Atlanta, GA. It was published in *ZYGON: Journal of Religion and Science, 40:* 3, (September 2005), pp. 733-738.

Chapter 7, "The Beauty and Power of Technology Touching Theology" is based on the paper "Technology Touches Theology and Visa Versa: Relational Contextual Reasoning" presented at the 10th European Conference of Science and Theology, ESSSAT, European Society for the Study of Science and Theology, April 1-6, 2004, Barcelona, Spain.

Contents

Illustrations

Illustrations are © Paul H. Carr unless otherwise cited in the text.

COVER: Swallowtail butterfly on purple loostrife. The length of the long base of the triangle, inscribed on the butterfly, divided by the short sides is 1.6; the divine proportion or golden ratio is 1.618:1 as described in Chapter 1.

Foreword

by Philip Hefner

I am grateful to Paul Carr for opening up the vistas of beauty—in life generally and in the mix of science, spirit, and religion. There are a few precursors to be reckoned with, but very few substantial discussions with the breadth of resources and interpretations that are offered in this book, BEAUTY IN SCIENCE AND SPIRIT.

This book moves beauty to the center of our reflection on science and spirit, rather than leaving it at the periphery. The desire for beauty, after all, is not only universal in human history, but it manifests itself everywhere, in all facets of experience. Whether there is universal consensus on the criteria of beauty may well be argued, without reaching resolution, but the fact that every individual and every culture hold to that which they consider beautiful—is not contested.

In what is often called "high culture," we find beauty in humankind's great art. It is on display in our leading museums, in our concert halls, and in our literature. We nurture this artistic beauty in our schools, academies, and conservatories. Billions of dollars are given to the support of high culture's devotion to beauty. This manifestation of beauty often belongs to an elite, those who possess the education and sophistication required to appreciate it. Outside this elite, in what we might call "popular culture," the devotion to beauty is just as earnestly pursued and just as prominent. Every city has its murals that cover any suitable wall; some are planned and approved by the community's leaders, others appear spontaneously, authorized only the spirit of the artist. Graffiti, even those that may be objectionable, are frequently pleasing in form. Street musicians are everywhere on the urban scene.

≈ ϰιϰ ≈

Utilitarian objects reveal the beauty of design, whether it is in the shape of a toaster, a lamp, a washing machine or an eighteen-wheel tractor trailer hauling freight across country. These objects are the product of the bonding between beauty and technology. Carr's discussion reminds us that scientists also pursue beauty: it appears in Mandelbrot fractals in a dramatic fashion, as well as in the spectacular photographs that NASA exhibits. It also appears in mathematical equations and in theories that help us understand the natural world. Ockham's razor—that the explanation of any phenomenon should make as few assumptions as possible—applies to science, philosophy, and theology. What is this "razor" but a criterion of beauty, since parsimonious explanation is more beautiful than a cumbersome one that is burdened with redundant arguments?

So far as we know, beauty has been our ambience forever. The earliest known artifacts of hominid culture—the Paleolithic bone and stone implements, for example—are beautiful in their design. Ornaments of all types, as well as carvings and the figurines that represent mythical powers, such as totems, exhibit their beauty. The cliff and cave drawings, going back 30,000 years, have been recognized as beauty since their first discovery by modern humans. That is why the first anthropologists called them rock and cave "art." They were first compared to the art works that hang in the Louvre and other great museums. Now we tend to understand them as part of the ubiquitous presence of beauty in all human ventures—hunting, rites of passage, veneration of the sacred.

We cannot escape the conclusion that beauty is everywhere and that every one of us carries the thirst for beauty and also ideas of beauty with us in all we do and think. Scientists in their search for knowledge, prediction, and useful application, engineers working on the resolution of practical problems, spiritual seekers questing for the ultimate, theological thinkers elaborating doctrines—all of these transpire in an ambience of the thirst for beauty, even when that thirst is not perceived or acknowledged. Since this is so, how can beauty be left out of our reflections on science, religion, and spirituality? When beauty is left out, something central to human nature is missing, and that deficit makes itself felt in our efforts to understand the world and, even more, in our interpretations of the human quest for knowledge of the world. Both our self-knowledge and our knowledge of the natural world are less adequate than they might be if we do not bring beauty into our reflections.

Since beauty is inseparable from the human quest, we must recognize that it is a necessity for human life—as essential as the air we breathe, the water we drink, and the food we eat. We may not recognize the essential place of beauty if we confine it to the grand museum or to the work of the recognized "classic" artist, whether that be Michelangelo or Shakespeare. The fashioners of prehistoric implements were not prehistoric Rodin's, just as the cave painters were not prehistoric Picasso's. The beauty they produced is the beauty that is inherent in human nature, the beauty that animates the ideas and work of each of us.

The thirst for beauty that permeates our lives is an opening to transcendence, because it is not only a necessary dimension of ordinary living, it also leads us beyond the necessities of mundane life. Beauty activates our imagination. What is imagination but the sensibility that ordinary life brims over with possibilities that are not yet actual, but which we can bring into actuality as the future unfolds? In its role as a testimony to what is not yet, but which can be, beauty opens our eyes to the possible and thus also to the dimensions of the future. If we are looking at a Mandelbrot fractal, we see more than the physical sensations that prompt Mandelbrot's striking images. When we see a mural on a city street that depicts the life and dreams of the people who live in the neighborhood, we share their sense that there is more to this city scene than we thought. In the same way, Picasso's *Guernica* gives us a perspective that transcends the factual destruction of a Spanish village and Arthur Miller's *DEATH OF A SALESMAN* evokes a sensibility of the too often overlooked hopes and pathos of an ordinary man. *Guernica* becomes every town and Miller's salesman becomes every one of us. Little wonder that the thirst for beauty has permeated every religious quest—the stained glass of Chartres cathedral, the mandalas of Buddhism and Hinduism, the calligraphy of Islam, the poetry of Israel. Not as decoration or recreation, but as an opening to the transcendent. So, too, in science, the beauty of theories, models, and graphs opens up knowledge that is not yet actual, but which comes into being as the scientist pursues the vision that is opened up. The photos of the Orion nebula and the early universe, for example, which appear in this book, elicit a powerful drive to know more about the history of our universe and also of its future.

Paul Carr's book is filled with wonderful provocative source material for our reflection upon beauty. He recognizes its "delicate dance between

mystical, subjective revelations and the mathematical, objective processes that maintain the universe and life." We might add that, in this delicate balance, beauty sharpens our sense of what both our subjective life and the objective world can become—harbinger of the future, if we remain sensitive to the delicate nature of beauty's dance. This is dance that leads to what Gerard Manley Hopkins spoke as "beauty's self and beauty's giver."* Some will speak of nature itself as that self and giver, while for others the dance will lead to God. All who share in the dance will find riches in this book.

Philip Hefner
Professor of Systematic Theology Emeritus
Lutheran School of Theology at Chicago

*Gerard Manley Hopkins, "The Leaden Echo and the Golden Echo," THE POEMS OF GERARD MANLEY HOPKINS, 4th edition, eds. W. H. Gardner and N. H. Mackenzie (New York: Oxford University Press, 1967), p. 92.

Introduction

Origin of this book

The most beautiful thing we can experience is the mysterious. It is the source of all true art and science.

—Albert Einstein (1930)

What is beauty? Beauty is harmonious and balanced. For Aristotle, beauty resided in order, symmetry, and definiteness. Plotinus, in believing that beauty must be present in the details as well as the whole, anticipated fractals, where each part is a fraction of the whole. Beauty, for St. Augustine, was synonymous with geometric form and balance. The parts of the human body have a harmonious beauty. Leonardo da Vinci believed that beauty resided in symmetry and proportion. His Vitruvian Man has the divine proportion 1.618:1 (Chapter 1).

When was your first moment of beauty? My first memory of beauty was at age five, when my father helped me climb to the top of Jay Peak in Northern Vermont by taking off his belt and pulling me up the steepest parts of the rocky tail. The memory of that spectacularly beautiful mountaintop experience made a lasting impression. When I was fifteen, my Boston Latin School English teacher gave us an assignment to write a poem. I wrote the following sonnet (see COLOR PLATE 3 and FIGURE I.1):

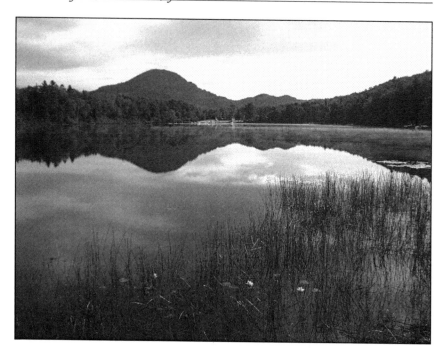

FIGURE I.1: Mount Norris reflected in Lake Eden, Vermont

THE SUMMIT

To the top of the mountain one day I did go,
To see all the scenes that a summit can show.
For the work and the toil up the long yet small trail,
The perspective was grand where fine views do prevail.

To the right to the left, all around from the heights,
Are the things, which make wonderful, beautiful sights:
The small farmhouse and barn, the big mill in the town,
They do all have a place as the climber looks down.

The small ponds, like some emeralds clear,
Are all scattered about, like dewdrops so sheer.
The big lake, like a sheet of the clearest of glass,
Which is blue as the sky that does over us pass.

If immense and important or tiny and small,
The great God has a place in the world for us all.

Besides taking me mountain climbing, my Methodist-minister father and my music-teacher mother nurtured my interest in science, math, and music. They gave me the education I needed to win a scholarship to Massachusetts Institute of Technology. However, my life there was a culture shock. I met for the first time people for whom the scientific worldview was their "ultimate concern," a term that theologian Paul Tillich had defined as religion. His picture appeared on the cover of *TIME* Magazine on March 16, 1959. I later took his "Theology of Culture" course at Harvard University.

Paul Tillich (*Parade,* 1955) described his mystical "One Moment of Beauty" as follows:

> Divine revelation comes to few men, but understanding of it came to me one moment years ago. I looked, for the first time, at beauty revealed by a man who had been dead more than four hundred years. As the son of a Protestant minister in eastern Germany in the days before World War I, I had grown up in the belief that visual beauty is unimportant...
>
> Strangely, I first found the existence of beauty in the trenches of World War I. At 28, I became a chaplain in the German army and served for five ugly years until the war ended. To take my mind off the mud, blood and death of the Western Front, I thumbed through the picture magazines at the field bookstores. In some of them I found reproductions of the great and moving paintings of the ages. At rest camps and in the lulls in the bitter battles, especially at Verdun, I huddled in dugouts studying this "new world" by candle and lantern light. But at the end of the war, I still had never seen the original paintings in all their glory.
>
> Going to Berlin, I hurried to the Kaiser Friederich Museum. There on the wall was a picture that had comforted me in battle: *Madonna with Singing Angels,* painted by Sandro Botticelli in the fifteenth century. Gazing up at it, I felt a state approaching ecstasy. In the beauty of the painting there was Beauty itself. It shone through the colors of the paint, as the light of day shines through the stained-glass windows of a medieval church. As I stood there, bathed in the beauty its painter had envisioned so long ago, something of

the divine source of all things came through to me. I turned away shaken.

That moment has affected my whole life, giving me the keys for the interpretation of human existence, brought vital joy and spiritual truth. I compare it with what is usually called revelation in the language of religion. I know that no artistic experience can match the moments in which prophets were grasped in the power of the Divine Presence, but I believe there is an analogy between revelation and what I felt. In both cases, the experience goes beyond the way we encounter reality in our daily lives. It opens up depths experienced in no other way. I know now that the picture is not the greatest. I have seen greater since then. But that moment of ecstasy has never been repeated.

This experience of beauty in art reminded me of MIT President Killian's saying during the dedication of the modernistic Kresge auditorium and chapel in 1955: "Science and art spring from similar creative impulses." Architect Eero Saarinen had designed the auditorium to be dome-shaped, an eighth of a sphere that rested on three points of an equilateral triangle. The chapel was cylindrical with a modernistic steeple (see COLOR PLATE 4 and FIGURE 1.2).

MIT Prof. Giorgio de Santillana's (1961) course "The Origins of Scientific Thought" showed how the mystical beauty of music led Pythagoras, about 590 B.C., to discover that the harmonious intervals of the musical scale could be expressed as simple ratios. The string length ratio of the octave is $1:2$, that is, the string length of a note at the bottom of an octave is twice that of the high note at the top. Pythagoras was the founder of a spiritual order based on the mystical meaning and value of numbers. He exemplifies the emergence of mathematical beauty and ultimately science from the mystical and the spiritual. Today, science and mathematics often influence art and music; these ideas are expanded in Chapter 1 "From Art to Science to Art."

In 1967, after completing my B.S. and M.S. at MIT and my Ph.D. in Physics at Brandeis University, I became the leader of a scientific research and development team at what is now called the AF Research Laboratory. There we did fundamental research on the properties of microwave ultrasonic surface acoustic waves (SAW) and supercon-

FIGURE I.2: Steeple on the Kresge Chapel at MIT

ductors, which resulted in smaller, lower-cost components now used as filters in radar units, TVs, and cell phones. We also found that genetic algorithms, computer models of the Darwinian evolutionary process of mutations and natural selection, are very effective in optimizing the design of high-performance microwave antennas (Chapter 5).

In 1995, I took an early retirement to have more time to relate my scientific career to my spiritual roots. I presented workshops at the Institute of Religion in an Age of Science Conferences at Star Island off Portsmouth, New Hampshire (see *http://www.iras.org*). I received a grant from the John Templeton Foundation for my philosophy course, "Science and Religion: Cosmos to Consciousness," at the University of Massachusetts Lowell. This book builds on and extends the ideas in this course.

Mountain landscapes, sunsets, flowers, and snowflakes are beautiful to me. I was amazed to learn, through Gleick's (1987) *CHAOS: MAKING A NEW SCIENCE,* that the beauty of nature has an underlying mathematical structure called fractal geometry. When Stephen Wolfram published his *A NEW KIND OF SCIENCE* in 2002, many of its intricate patters struck me as being beautiful and similar to Madelbrot's *FRACTAL*

GEOMETRY OF NATURE (1983). Similarly, beauty in religious art and in sacred spaces can be seen from the pyramids to cathedrals. This led to the idea that science and spirit both have beauty in common. Both are beautiful to me. Beauty has many facets. How might they be defined?

What is beauty?

If everyone were cast in the same mold, there would be no such thing as beauty.

—Darwin, 1871

Beauty is "the harmony of contrasts" (Whitehead, 1933). Beauty resides in the symmetric balance between order and randomness. Complete order can be boring and total randomness unattractive. Beauty walks the razor's edge between monotony on one side and chaos on the other (Haught, 2000). A musical theme repeated without modest variations can be boring. Extreme variations can be dissonant and chaotic. Beauty is the delicate harmony between order and chaos. The novelty of contrasts overcomes the monotony of shear order.

Beauty is also a delicate dance between mystical, subjective revelations and the mathematical, objective processes that maintain the universe and life. The balance is similar to that between the right- and left-brain, between the holistic-subjective and the logical-objective. The subjective and individual pole can depend on preferences, tastes, cultural conditioning, and life history, leading to the saying, "beauty is in the eye of the beholder." The objective pole, on the other hand, is an essential and ineradicable part of human nature, which has contributed to our survival as a species, according to psychologist Nancy Etcoff, in her book SURVIVAL OF THE PRETTIEST: THE SCIENCE OF BEAUTY (1999). The objective aspect of beauty is trans-cultural. Babies are regarded as beautiful in all cultures. If they were not, they would not be cared for, and humans would become extinct. In addition to natural selection, sexual selection is involved in the conception of babies. Sexual selection is influenced by what we find beautiful in the opposite sex. "Philosophers ponder beauty and pornographers proffer it" (Etcoff, 1999).

Objective beauty can be measured. For example, when men see a beautiful woman, their testosterone hormone level increases. The more

beautiful the woman, the higher the testosterone level, which is measurable. Another measure of objective beauty is the fact that more money is spent on beauty than on education or social services in the United States (Etcoff, 1999). Tons of makeup, 1,484 tubes of lipstick, and 2,055 jars of skin care products are sold every minute. During 1996 a reported 696,904 Americans underwent voluntary aesthetic surgery that involved tearing or burning their skin, shucking their fat, or implanting foreign materials. People yearn for the essential beauty of the human body symbolized by such sculptures as *Venus de Milo* and Michaelangelo's *David*.

Mystical beauty is hard to define, but you know it when you experience it. Mystical beauty is ineffable, experiential, holistic, energizing, and a priori. It resonates with our innermost being and is based on an immediate experience having ultimate and eternal value of which we are intuitively aware. The merger of individual consciousness with the cosmic whole has mystical beauty. It requires participation with the whole being in contrast to detached observation.

The colorful cave paintings of animals drawn on the limestone walls in Chauvet, France have mystical beauty. These paintings have clean, sweeping lines, some of which are shaded to one side as though to convey three-dimensionality. It is amazing that human beings living 30,000 years ago could create such dynamic, vibrant paintings of animals, which can still touch us today. As Albert Einstein (1930) said, "The most beautiful thing we can experience is the mysterious. It is the source of all true art and science."

Flowers have vibrant colors and harmonious symmetries. (See COLOR PLATE 5 and FIGURE I.3). This subjective aesthetic beauty contrasts with the objective, functional beauty that attracts insects for pollination and reproduction. Could the aesthetic beauty we see in flowers be evidence of our evolution from simpler life forms?

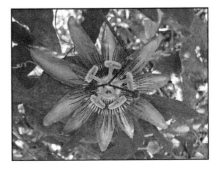

Figure I.3: Passion flower

John Keats (1819) is describing subjective, mystical beauty in the conclusion of his "Ode on a Grecian Urn":

> Beauty is truth, truth beauty,
> That is all ye know on earth and
> All ye need to know.

He clarified this in his letter to Bailey, dated 22 November 1817.

> I am certain of nothing but the holiness of the heart's affection
> and the truth of the imagination. What the imagination seizes
> as Beauty must be Truth—whether it existed before or not. I
> have the same idea of our passions as Love, they are in their
> sublimity creations of essential beauty.

FIGURE I.4: April blossoms in front of John Keats' House, Hampstead, London.

Great art, music, literature, and science express beauty and truth. In the absence of truth, beauty is commonplace and can even be ostentatious. In the absence of beauty, truth sinks into triviality and loses its motivating power. "Truth matters because of beauty" (Whitehead, 1933). The mathematician Hermann Weyl was quoted as having said not long before he died, "My work always tried to unite the true with the beautiful, but when I had to choose one or the other, I usually chose the beautiful." The truth of beauty for science, however, must ultimately be capable of being empirically verified (McAllister, 1998). As Whitehead said, "Truth is confirmation of appearance to reality." Hence, objective beauty is closer to scientific truth than subjective, mystical beauty.

Physicist Steven Weinberg (1992) sees scientific beauty as more than a personal expression of aesthetic pleasure. Objective beauty is much closer to a horse trainer's enthusiasm for a beautiful racehorse. This sort of beauty can be objectively verified: can the horse win a race? Similarly, can a beautiful scientific theory explain and make predictions for the natural world?

Physicist Albert Einstein (1949) described scientific, mathematical beauty as follows: "A theory is more impressive the greater the simplicity of its premises, the more different kinds of things it relates, and the more extended is its area of applicability" (p. 33). Scientific beauty has (1) simplicity, (2) comprehensiveness, and (3) the brilliance to illuminate new phenomena. Shortly after Einstein published his theory of special relativity, which predicted the equivalence of mass and energy, he was told that an experiment with electrons in a vacuum contradicted his predictions. He replied that the *comprehensiveness* of his theory, which applied to the whole universe, could not be refuted by a single experiment. Later, the experiment was found to be in error due to a leak in the vacuum system. This exemplifies the comprehensive beauty of a scientific theory, which is supported by quantum physicist, Paul Dirac's, statement, "It is more important to have beauty in one's equations than to have them fit experiment." He meant that a leap of creative imagination can be so compelling in its elegance that physicists will be convinced of the truth of a theory before it is subjected to experimental test.

Einstein's search for a consistent theory for all of the forces in the universe (or Theory of Everything) is being continued by Steven Weinberg. In Weinberg's DREAMS OF A FINAL THEORY (1992), he

describes the emerging Theory of Everything (TOE) as beautiful. TOE will be expressed as a system of interlocking equations that will describe all the forces (i.e. gravity, electromagnetism, strong and weak nuclear forces.) It will be beautiful because it will be elegant, expressing the possibility of unending complexity with minimum laws, and be symmetric, because it will be invariant in time and space. Steven Hawking in his BRIEF HISTORY OF TIME (1988) said that the Theory of Everything will enable us to know the "Mind of God" in all its simplicity, comprehensiveness, and brilliance in illuminating new phenomena.

The delicate balance between the mathematical-objective and mystical-subjective leads to the complementary beauty of science and spirit. The scientific account of the origin of the universe complements that of spiritual stories. Each can be beautiful in its own way, because spiritual and scientific stories have different purposes. Spiritual stories answer "why" and give guidance and motivation for living now and in eternity. Scientific theories explain "how," give a coherent rational account of measurements, and make predications. Integration of the "how" with the "why" can lead to a beautiful new story that transcends national and cultural differences.

The complementary beauty of science and spirit is analogous to physicist Niels Bohr's complementarity principle for the particle-wave duality of small elementary particles. Most of us think of electrons as being particles, but the geometric diffraction pattern observed when electrons are scattered off a crystal can only be explained by their wavelike nature. Similarly, the colorful interference patterns of light when it passes through two slits are explained by its wave-like property. However, the shot noise observed when low intensity light is measured with an electronic detector is explained by light's particle property. Light particles or quanta are called photons. Physicist Max Planck (1977), who pioneered this concept, said: "There can never be any real opposition between religion and science: for the one is the complement of the other."

The complementary beauty of science and spirit builds on Stephen Jay Gould's (1999) ROCKS OF AGES: SCIENCE AND RELIGION IN THE FULLNESS OF LIFE. Gould wished to eliminate conflicts between science and religion by saying the each has its own domain, area of validity, or "non-overlapping magisteria." The natural world belongs exclusively to science and the moral to religion. He believed that science will never

explain away religion, nor can religion ever incorporate the findings of science. My vision of science and religion's complementary beauty is more optimistic, however, in believing that modern cosmology can be incorporated into a beautiful new story (Chapter 11), just as the creation story in the first chapter of Genesis was based on the cosmology of its day. The complementary beauty of science and spirit is useful in resolving the intelligent design and evolution controversy (Chapter 2).

Overview of chapters

If nature were not beautiful, it would not be worth knowing.

—Scientist-Mathematician Henri Poincaré

Charles Darwin explained the evolution of "forms most beautiful" by variations and the natural selection law in 1859. Yet the intelligent design community still doubts Darwin (Dembski and Ruse, 2004). How could a process having randomness lead to life and even beauty? Furthermore, the efforts of the Discovery Institute in Seattle, Washington to have the intelligent design and evolution controversy (Chapter 2) taught in public school biology classes has raised a number of other questions. What is spirituality? What is science?

Spirituality and mystical beauty are similar in the sense that both are expressed in terms of symbols. Spiritual transformations are the source of the world's religions: the enlightenment of the Buddha under the fig tree, the baptism of Jesus, St. Paul's visionary conversion on the road to Damascus, and the revelation of Mohammed in the cave. Spirituality is the a priori and inspirational source of religion. Spirituality is unencumbered by organizational failings and historical atrocities performed in the name of religion. Spirituality involves that which is of greatest importance to us, concerns us ultimately, and gives meaning, purpose, and guidance for living.

To answer, "What is science?" Chapters 3 will trace the emergence of modern cosmology from ancient stories and astrology. To the question, "Why study the natural world?" mathematician-scientist Henry Poincaré answered, "If nature were not beautiful, it would not be worth knowing." The awesome beauty of nature lured ancient people to explain the world with myths, illumined by art. The mathematical beauty of modern

science emerged from the mystical beauty of these ancient stories. The deciphering of nature's code over thousands of years is an exciting detective story (Davies, 1984). Today Einstein's language of mathematics (Arianrhod, 2005) frames the evolution of the beautiful cosmos.

Was there not a certain mystical beauty in the ancient myths that used to explain the natural world? The Greek god of the Sun, Helios, rode a sun-drawing chariot pulled by horses through the sky. The journey of the Sun, naturally, began in the East and ended in the West, at which point Helios completed his daily rounds and floated back to his Eastern palace in a golden bowl. In the first chapter of the Bible, the Divine Spirit moved on the face of the waters creating light from darkness and order from chaos. This inspired Haydn's beautiful CREATION ORATORIO and Michaelangelo's magnificent murals in the Sistine Chapel.

Science began emerging as a separate discipline from myth and spirituality when the Greeks explained the rising and setting of the sun by the rotation of the sun about the earth (Chapter 3). The planets revolved around the earth on crystalline spheres and made the beautiful "music of the spheres," because their distances from the earth had the same proportions as the musical scale. Ptolemy in the second century A.D. developed the mathematics for this geocentric cosmology, which astronomers used to predict the motion of the planets until the sixteenth century. In 1543, Copernicus proposed his new theory of the "sun at the center of the most *beautiful* temple." In the seventeenth century, Newton discovered the laws of gravity and dynamics that predicted the motion of "this most *beautiful* system of the sun, planets, and comets." In 1859, Charles Darwin's ORIGIN OF THE SPECIES explained the evolution of "forms most *beautiful*" by variations and natural selection. Even though our concepts of the universe have changed, we perceive it as awesome and beautiful. In this sense, beauty is eternal. Astronomer Mario Livio (2000) has called this the *cosmological aesthetic principle*.

The transition from mystical to mathematical beauty is evident in American thought, as described in Chapter 4, "Beauty: From Theology to Fractals." In the eighteenth century, Jonathan Edward's theology saw nature as evidence of God's beautifying activity. In the nineteenth, transcendentalists Emerson and Thoreau perceived God as being in nature. In the twentieth, Benoit Manelbrot discovered the mathematical beauty of nature.

In his *FRACTAL GEOMETRY OF NATURE,* Mandelbrot (1983) showed that mountains do not have the straight edges of cones in Euclidean geometry and clouds are not perfect circles, but have beautiful fractal edges. He noticed that tree branching from trunks to twigs have the same fractal scaling as our lungs, from trachea to bronchi. Each branching generation is a *fraction* smaller than the one before, therefore the term *fractal.* Fractal statistics, which is like pulling a card from a stacked deck, can account for variations in the stock market, our weather, tree rings, and variations in the height of the Nile River. As we will see, fractals can be generated by computer algorithms which have random and deterministic elements, as does evolution. This interplay between chance and necessity leads us from the beautiful creation story of Genesis, where the Divine Spirit created order out of chaos, to the evolutionary creativity of variations and natural selection.

Nevertheless, many still doubt Darwin, like Huston Smith, author of the best-selling *THE WORLD'S RELIGIONS,* who at the American Academy of Religion Meeting in November 2000 said, "I do not believe that God could have created us in his image by the mutations of the genes." This was Smith's way of denying that evolution can explain the origins of human spirituality. Many people agree with Smith. Einstein in criticizing the statistical nature of the theory of quantum mechanics said: "God does not play dice." In Chapter 5, "Beautiful Fractals: 'Does God Play Dice?'" we will learn how the beautiful fractals patterns seen in snowflakes and the branching of plants can be analyzed to shed light on this question.

In answering it, we need to understand that local *randomness* and *global* determinism can coexist to create orderly, even beautiful patterns such as a self-similar structure called a fractal. The interplay between randomness and determinism is analogous to the mutations and natural selection of Darwinian evolution.

How could a random process lead to order and even beauty? Randomness by itself leads to disorder. However, randomness coupled with a deterministic law, is creative. We will see how the simple computer algorithm below can generate the Sierpinski triangle or fractal triangle (see FIGURE I.5). The sides of the large white triangle in the center are one half of the whole triangle. Similarly, the sides of the three smaller triangles are one quarter of the whole triangle. Each generation

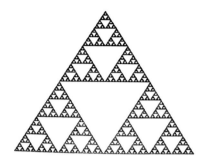

FIGURE I.5: Sierpinski or Fractal Triangle

FIGURE I.6: Generation of Fractal Triangle

of smaller triangles is scaled down by the same *fraction*, one-half of the one before, hence the term *fractal*.

The Chaos Game is a simple algorithm for generating the Sierpinski triangle or fractal triangle (top). *Randomly* draw a point as shown in the Left Figure above. Next, roll a dice to find the direction of the next point. In the Right Figure above, the roll of a dice gave a 5 or a 6, which corresponds to vortex C. Then apply the *global* rule: draw a point half way to C(5,6). This algorithm is repeated again at each new point to form the black granular parts of the Sierpinski triangle. The

position of each black point or dot in the Sierpinski triangle is
determined by both a random and a deterministic element.

This computer algorithm thus simulates the randomness and
lawfulness of Darwin's theory of evolution. "Does God play dice?" An
answer is "yes" and "no." Yes, if one considers the random nature of
evolution and fractal statistics. No, if one considers nature's globally
deterministic laws and rules. Chaos theorist Joseph Ford's (1987) answer
is, "God plays dice (randomness), but they are loaded dice (by global
laws)!" (p. 314).

Chapter 6, "A Theology for the 'Forms Most Beautiful'" deals with
the evolution of life, describes the tragic beauty that emerges from
suffering and death, and discusses the goal and direction of evolution. It
compares Tillich's "End of History" with Teilhard's "Omega Point"
towards which evolution is converging.

Chapter 7, "The Beauty and Power of Theology Touching
Technology" describes the fruitfulness of theology working together with
technology. The beauty of medieval cathedrals symbolizes the power of
technology and theology. The theology of a transcendent God inspired
the construction of these magnificent structures. The technology of
flying buttresses on the outside walls enabled them to reach "celestial
heights" without collapsing.

Another example is "The
Beautiful Holy Land,"
(Chapter 8) where modern
irrigation technology is
working with theological
religious motivation to
make the desert bloom.

John Updike (1986)
wrote, "Whenever theology
touches science, it gets
burned." Technology does
indeed challenge traditional
religious beliefs. I once had
the privilege of discussing
my more positive ideas with
him.

FIGURE I.7: Writer John Updike and
Paul H. Carr, July 14, 2001, discuss
"Whenever theology touches science,
it gets burned." (Updike, 1986).

An example of technology working *without* theological moral constraint is the exploitation of nature's beauty by our secular society, as in Chapter 9, "The Beauty of Nature vs. its Utility: the Environmental Challenge." The environmental challenge is to balance ecology with economics. A. Z. Amin (2000), director of the United Nations Environmental Program has said: "Combining a knowledge of the earth sciences with the forces of spiritual values aims at transforming our fundamental relation with the earth from one of destruction to redemption." The power of spiritual values and the intrinsic beauty of nature can hopefully lead to a global ethic and a moral imperative to implement more efficient, renewable technologies. An environmental success story is the consecration and conservation of Thoreau's Walden Pond as a sacred site.

Religion regards nature's beauty as evidence of divine creativity. Beautiful art and music are not only expressions of human creativity; they inspire creativity (Chapter 10). Meditating on beautiful art and listening to uplifting music can stimulate new insights. The highly symmetric Dharmaraja mandala, a symbol for Buddhist meditation, was the source of inspiration for IBM scientists, Alex Muller and Georg Bednorz, who won the 1987 Nobel Prize for their discovery of the highly symmetric, copper-containing, high-temperature superconductors (Holton, Chang, & Jurkowitz, 1996).

Creativity can be a link between science and spirituality. The four-step process of scientific insight is similar to that of spiritual transformation. Both are creative. Without insight there would be no scientific discoveries. Without transformation and wisdom, spirituality would not be able to give meaning to such issues as the sickness and death that challenge our lives. Scientific creativity results in new ideas such as Darwin's theory of evolution, which contradict established ideas and therefore require the courage to create. Spirituality can be a source of this courage.

The scientific story of the origin and evolution of the cosmos has intrinsic beauty and transcends national and cultural differences. The images of modern science and cosmology have aesthetic beauty and the potential to birth a beautiful new story (Chapter 11). Beautiful fractal figures can be drawn using computer algorithms, which have both randomness and global laws. Darwin's theory of evolution is similar to fractal analysis: the randomness of mutations and global natural

selection. The evolutionary interplay between chance and necessity has emerged from the creation story of Genesis, where a Divine Spirit created order out of chaos and light from darkness. Hopefully, this Old Story will nurture the emergence of a New Story. The New Covenant (New Testament) of Christianity had its roots in the Old Covenant (Old Testament) of Judaism. Islam emerged from the Hebrew-Judaic tradition and Christianity. Buddhism grew out of Hinduism. The passage from mystical to mathematical beauty portrays the emergence of science from spirituality and nature. The following chapter will describe the emergence of science from art.

Chapter 1
From Art to Science to Art

One who has art and science also has religion.
One who does not, better have religion.

—Goethe

Math came from myth, the quantitative from the qualitative. We will trace the emergence of mathematical beauty of modern science from the mystical beauty of ancient myths, illuminated by spiritual art, which explained the natural world. Is artistic beauty a premonition of scientific discovery? We will investigate artistic images, which could be preverbal expressions of novel concepts later analyzed by mathematicians and physicists. Today, science and mathematics often influence art and music. Hence, the title "From Art to Science to Art."

The mystic Greek mathematician Pythagoras about 590 B.C. examined relationships between mathematics and music. By plucking stringed instruments, he found that the harmonious intervals of the musical scale could be expressed by simple ratios (de Santillana, 1961). For example, by placing his finger in the middle of a stringed instrument so that the length of each segment was one half that of the total length, he noted that the tone of each half-string was an octave higher in frequency than the whole string. Thus, the string-length ratio or proportion of the octave is 1 to 2. Similarly the ratio or proportion of the fourth is 4 to 3, of the fifth 3 to 2. These intervals are common in the musical scale. The numbers that occur in these ratios are 1, 2, 3, and 4,

the sum of which is 10, the "perfect" number. The Phythagorian Sect's discovery that the musical scale is related to numbers, which had mystical power, was a beginning of mathematics.

The Divine Proportion

Proportion is an aspect of art. The quantification of this proportionality was a step in the emergence of mathematical beauty from the holistic, mystical beauty of art. The key number in the divine proportion or golden ratio, 1.618, Phi, was named after Phidias, the great Greek sculptor who lived around 490-430 B.C. Phidias' greatest achievements were the *Athena Parthenos* in Athens and the *Zeus* in the temple of Olympia.

FIGURE 1.1: Pentagram
with the Divine Proportion

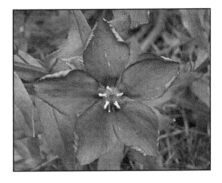

FIGURE 1.2:
Star-Shaped Pimpernel

The five point star or pentagram was a symbol of recognition for the Pythagorians. The five point star and the pentagon are both inscribed inside a circle. The ratio of a star line AC to its longer segment AD is the Divine Proportion, 1.618:1. In the Divine Triangle ABC, AC / BC = AC / AB = 1.618. This five-point star appears in religious art because it has the Divine Proportion, 1.618:1. The Divine Proportion also occurs in nature: in flowers, in the spiral shells of snails and the chambered nautilus, the wings of butterflies, galaxies, and the human body.

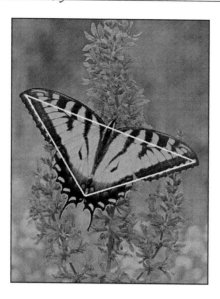

FIGURE 1.3: The Eastern Swallowtail Butterfly on the purple loosestrife has the proportions of the Divine Triangle, whose sides have the ratio 1.618:1.

The father of Greek geometry, Euclid, about 300 B.C. spoke of the Golden Ratio or Divine Proportion as: "A straight line is said to have been cut in extreme and mean ratio when, as the whole line is to the greater segment, so the greater to the lesser" (Livio, 2002).

[----------A---------][----------------------B---------------------]

In other words, the ratio of the total line length A + B to the segment B is equal to the ratio of segment B to the remaining segment A. This is expressed as the following equation:

Total Line [A + B] / Segment B = Segment B / Segment A

Or equivalently

[A + B] / B = B/A

If one divides the numerator and denominator of the left hand side of the equation by A and then multiplies both sides of the equation by B/A, one obtains the following quadratic equation:

$$(B/A)^2 - (B/A) - 1 = 0 \qquad \text{Quadratic Equation}$$

Using high school algebra for the solution of a quadratic equation, we obtain the following:

Golden Ratio $(B/A) = \frac{1}{2} + \sqrt{5}/2 =$
$0.5 + 5^{0.5} \times 0.5 = 0.5 + (2.236 \times 0.5) = 1.618$

An interesting property of the large rectangle below with divine proportion 16.8 x 10 is that a square, 10 x 10, inscribed within the large rectangle results in a smaller rectangle 10 x 6.18, with the same Divine Proportion. Similarly, a 6.18 x 6.18 rectangle inscribed within the 10 x 6.18 rectangle, the resulting smallest rectangle 6.18 x 3.82 has the Divine Proportion. This can be continued for smaller and smaller rectangles. The John Templeton Foundation uses these as its logo, which includes the chambered nautilus. The new rectangular format of high definition television has dimensions close to the divine proportion.

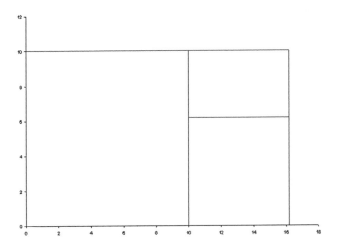

FIGURE 1.4: Rectangles with the Divine Proportion, 1.618:1.

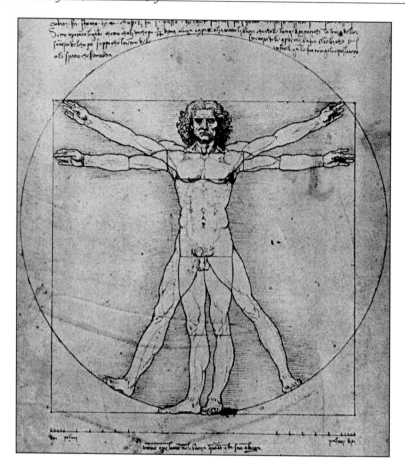

FIGURE 1.5: Da Vinci's *Vitruvian Man*

Leonardo da Vinci's knowledge of the emerging science of anatomy is evident in his paintings. His *Vitruvian Man* has the Divine Proportion, 1.618:1, or Golden Ratio seen in nature. The distance from the shoulders to the fingertips, when divided by the distance from the elbow to the fingertips, is 1.618. Similarly, the ratio of the man's height to the height of his navel is 1.618:1. The ratio of the diameters of the spirals in the shells of the chambered nautilus and the snail is also 1.618:1 (See COLOR PLATES 7 and 8 and FIGURES 1.8 and 1.9). The Divine Proportion connects us to the creatures of this earth!

Leonardo's *Vitruvian Man* shows that the human body is so proportioned that it can be inscribed inside both a sphere and a square.

FIGURES 1.7, 1.8, AND 1.9: Logarithmic spiral
with Divine Proportion, 1.618 : 1, seen in
snail and nautilus shell.

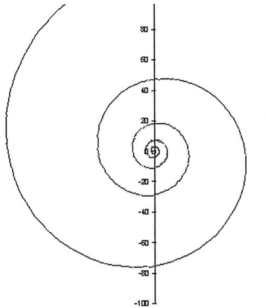

R = expo (0.315 x Angle)
75.58/46.74 = 1.618
46.74/28.90 = 1.618

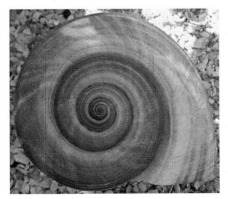
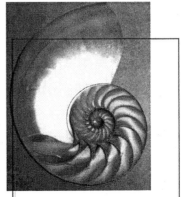

The sphere is a symbol of the divine and the square, the earth. The word "human" derives from "humus," the fertile soil that supports life. Leonardo seems to be saying that humans are both "of the earth" and divine. Knowledge of the earth leads to science and knowledge of the divine leads to religion. Thus, Vitruvian Man can also symbolize the complementarity of science and spirit.

Leonardo's inquiries (1452-1519) were followed by those of Galileo (1564-1642), who wrote: "Natural philosophy (science) is written in this grand book—I mean the universe—but it cannot be understood unless one first learns to comprehend the language and interprets the characters in which it is written. It is written in the language of mathematics, and its characters are triangles, circles, and other geometrical figures" (Hummel, 1986). Galileo's experiments on mechanical motion led to the mathematics of moving bodies ultimately formulated by Newton, who was born in 1642, the year that Galileo died. Newton once remarked that he stood on the shoulders of giants, one of whom was Galileo.

Before the late nineteenth century, when photography became available, astronomers including Galileo, drew what they saw through their telescopes. William Parsons, The Third Earl of Rosse, made a drawing of the Whirlpool Galaxy in 1851, which is comparable to a modern photograph. These spiral galaxies have the Divine Proportion. Hand-drawn but scientific accurate drawings have a certain aesthetic beauty. Galileo's classic drawings of moon craters and bird paintings of naturalists like Audubon are scientifically accurate with an artistic beauty.

The Divine Proportion is related to the Fibonacci sequence, which was discovered by Leonardo Fibonacci in the thirteenth century. Any number in the sequence is the sum of the two numbers before (Livio, 2002):

0, 1, 1, 2, 3, 5, 8, 13, 21, 34, 55, 89, 144, 233, 377, ...

The ratio for numbers larger than 34 approaches the value of *phi*:

8 / 5 = 1.6000	55 / 34 = 1.6180
13 / 8 = 1.6250	89 / 55 = 1.6182
21 / 13 = 1.6154	144 / 89 = 1.6180
34 / 21 = 1.6191	233 / 144 = 1.618
	377 / 233 = 1.6180

This relationship between the Divine Proportion and the Fibonacci numbers was discovered by the astronomer Johannes Kepler (Chapter 2). The Fibonacci numbers occur in nature as, for example, the number of tines in a pine cone and the petals of flowers.

Artistic premonition of science?

Can artistic beauty be a premonition of scientific discovery? This question arose as I was showing Paul Klee's Insects (*Plan of Creation*) (Klee, 1997) to my daughter at the Museum of Modern Art in San Francisco. I said, "Look at all those spirals, particularly in the big insect. They remind me of the helical DNA molecule by which heredity is passed from generation to generation." This painting was completed in 1919, well before the discovery of the structure of the DNA molecule in 1953.

Another example is the fractal triangle seen in thirteenth-century cathedral art (below), which was later analyzed by the mathematician Sierpinski (1882-1969) (Lesmoir-Gordon et al, 2001). In Chapter 5 we will describe computer algorithms that can generate Sierpinski's fractal triangle. Was thirteenth-century art a premonition of Sierpinski's triangle or could it just be a serendipitous coincidence?

Benoit Mandelbrot (1983), who discovered the fractal geometry of nature answers this question as follows: "Long ago, the Eiffel Tower

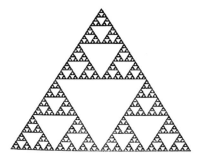

FIGURE 1.10: Sierpinski's (1882-1969) Fractal Triangle

Figure 1.11: Thirteenth-century Italian art, from Stephan Wolfram's A NEW KIND OF SCIENCE, pg 43, used with permission.

served me among key examples that man was familiar with fractality long before it came to mathematics and the sciences. Fractality was soon traced back to time immemorial, in particular by many examples of religious iconographs identified by William Jackson (2004) in his book *HEAVEN'S FRACTAL NET."*

Leonard Shlain (2002), in his book *ART AND PHYSICS,* asserts that art is precognitive. Artists create images and metaphors, which are preverbal expressions of novel concepts later analyzed by mathematicians and physicists. Shlain roots his theory in brain research and in a Jungian archetypal unconscious. Beauty originates in the ground, source, mystical a priori, collective unconscious which is the source of human creativity in art, science, and spirituality.

Artist Paul Klee believes that the artist shares a partnership in the universe, recognizing a basic oneness with the world in which he finds himself. The artist extends the creative forces in nature, abstracting meaning with his personality's own style. He said: "The artist creates works of art, or participates in the creation of works, which are an image of the creative work of God... Just as children imitate us while playing, so we, in the game of art, initiate the forces which created, and continue

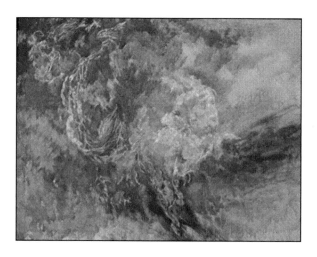

FIGURE 1.12: *Light through the Trees,* Elvira Culotta's acrylic painting. The author associates it with the nebula shown in FIGURE 1.13.

to create the world" (Jackson, 2004). We will learn more about the creative process in Chapter 10, "The Courage to Create Beauty."

I once asked my artist cousin, Elvira Culotta, to describe the abstract acrylic on canvas painting shown in COLOR PLATE 9 and FIGURE 1.12. She said: "I think of it as light coming through tree leaves." For me it looks like the inside of a super nova explosion (COLOR PLATE 10 and FIGURE 1.13) that ends the life of a star, which will be discussed in Chapter 3. People sometimes see things in an abstract painting that the artist never intended.

Influence of science on art

In our day, we see art being influenced by science. Cognitive and computer scientist Douglas Hofstadter's (1979) book *GODEL, ESCHER, BACH: AN ETERNAL GOLDEN BRAID* examines relationships among mathematics, art, and music. Recursiveness, which in mathematics is a number or function that repeats itself, is illustrated in Escher's symmetry

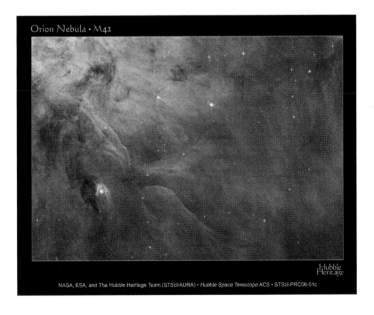

Orion Nebula • M42

Hubble Heritage

NASA, ESA, and The Hubble Heritage Team (STScI/AURA) • *Hubble Space Telescope* ACS • STScI-PRC06-01c

FIGURE 1.13: Orion Nebula M42 formed by an explosion of a star at the end of its life. New stars are being formed from the gravitational attraction of the dust.

drawings (see Photo Gallery <<http://www.mcescher.com/>>). These drawings depict, for example, gray birds, which would traditionally be one or a few figures on a white background, as being complemented by a symmetrical repeating set of white birds. The background has thus become an equivalent part of the picture. This is contrary to the tradition of art to have a portrait (figure) in the foreground with a necessary background (ground.) The figure-ground distinction exists in music. Traditionally, the melody or theme (figure) has a subsidiary accompaniment (ground). Escher's symmetry drawings represent the uniqueness of Bach's music, where two (or more) melodies or voices are in harmonious conversation, known as counterpoint. This is in contrast with conventional music, in which a single melody has a background accompaniment.

Harvard University physicist, Eric J. Heller (2005), believes: "Science inspires art and art informs science." Professor Heller does mathematical modeling of wave behavior, chaos and quantum mechanics, and collision theory. He plots the results of this modeling and selects those that have an artistic quality. For him science creates art, which is used to communicate scientific results.

"Art has a unique capacity to convey insights, intuitively and emotionally, about complex subject matter. If there is a short circuit to wisdom, it is through art. I try to exploit the powers of art to relate secrets of Nature only recently uncovered. A key element in my work is exploitation of Nature's almost narcissistic self-similarity, her repetition of pattern on vastly different scales and in radically different contexts" (Heller, 2005).

The circular symmetric figure in COLOR PLATE 11 and FIGURE 1.14 is similar to that of the rose windows seen in cathedrals as well in Buddhist mandalas. Professor Heller generated these on his computer by superposing of twenty-one plane waves, travelling in twenty-one evenly spaced directions around the compass or circle. The crests and troughs of these waves combine constructively and destructively to form the rose-window pattern.

For the mathematically inclined, this figure approximates a Bessel function near the center of the "comet," and an increasingly disordered structure away from there. The resulting image, is displayed over a much wider area, and reveals its quasicrystalline structure (See <<http://EricJHellerGallery.com>>). All additions of more than three plane

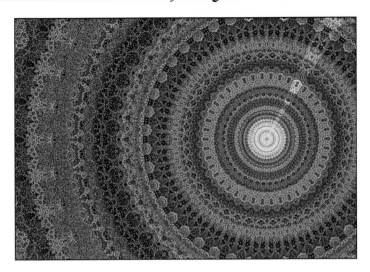

FIGURE 1.14: Professor Heller superposed on his computer twenty-one plane waves, travelling in twenty-one evenly spaced directions around the compass or circle. The crests and troughs of these waves combine constructively and destructively to form this pattern. (Bessel 21. Courtesy <<*http://EricJHellerGallery.com*>>).

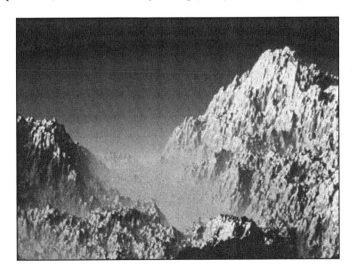

FIGURE 1.15: Fractal mountain landscape with mystical and mathematical beauty. Richard Voss generated this landscape with a computer program having both random and deterministic elements. Used with permission.

waves are quasicrystals. The slice shown in lighter colors is one repeating unit, which if copied twenty times, would regenerate the whole image. This image is a quasicrystal as well, except that the approximate repetitions of the sun region are very far away, outside the image.

This rose window was generated by superposing or adding twenty-one plane waves, which is a deterministic process. Professor Richard Voss generated the fractal mountain landscape shown in COLOR PLATE 12 and FIGURE 1.15, having both mystical and mathematical beauty, with a computer program having both random Brownian motion and deterministic elements. We will discuss Nature's fractal properties or self-similarity in greater depth in Chapter 5, "Beautiful Fractals: Does God Play Dice?"

Conclusion

We have seen the emergence or birth of mathematical and scientific beauty from the mystical beauty of art and music. The Pythagorians in 590 B.C. discovered the mathematical structure of music and the Divine Proportion, 1.618:1, in the pentagram. Images of the fractal triangle analyzed by Sierpinski in the twentieth century were visible in thirteenth century art. Helices in artist Paul Klee's *Plan of Creation*, painted in 1919 were discovered in 1953 in the X-ray structure of the DNA molecule. Artist Escher's recursive symmetry drawing reflects the influence of mathematics on art as does Eric Heller's and Richard Voss's computer art.

In a sense we have gone full circle, from art to science to art. Artists conceive images such as fractal triangles, which are later analyzed by mathematicians and scientists. Now scientists understand the fractal geometry of nature so well that they can program computers to generate drawings, which have the aesthetic beauty of nature (COLOR PLATE 12 and FIGURE 1.15).

How can this knowledge of the origin and nature of science help us understand the intelligent design controversy in Chapter 2?

Chapter 2
Complementary Beauty and Intelligent Design

The exquisite beauty and elegance of the portion of the universe that
we can explain overwhelmingly display the glory of God...

—Randy Isaac, 2005

Teaching Intelligent Design

President Bush stated that intelligent design *(ID)* and evolution "should both be properly taught so the people can understand what the debate as all about" (Bumiller, *New York Times*, Aug. 3, 2005). Later that same day, his science adviser, John H. Marburger, III, on the contrary, said "evolution is the cornerstone of modern biology" and "intelligent design is not a scientific concept."

Intelligent design thus continues to fuel debates that arose after Darwin published his ORIGIN OF THE SPECIES in 1859. In 1860, in a debate at the British Association for the Advancement of Science, Bishop Wilberforce concluded that he was proud not to trace his ancestry from a monkey. Thomas Huxley, known as Darwin's bulldog, replied that he would far prefer to be descended from a monkey than from a bishop who misrepresented the truth!

The increasing acceptance of Darwinism since 1860 is part of the trend from the mystical to mathematical beauty. The present intelligent design movement accepts Darwin's variations and natural selection as a

mechanism for small changes, but does not believe that it can account for the origin of life. Biochemistry Professor Michael Behe, Lehigh University, PA, in his best selling book, *DARWIN'S BLACK BOX: THE BIOCHEMICAL CHALLENGE TO EVOLUTION* (1998), claimed that the first cell was so irreducibly complex that it required an "intelligent designer." A cell is packed with hundreds of microscopic machines, every one of which must function for the cell to stay alive. The micro-machines could not have evolved by Darwinian processes, since they can not function independently. Behe speculated that an "intelligent designer" assembled all the necessary parts for the first cell in a "black box." The cell then evolved by conventional variations and natural selection.

The *ID* conflict is between scientists like Behe, who have faith in the classical theological design argument, and those who have complete faith in evolution. The latter have therefore offered arguments against Behe's irreducible complexity claim. Among these is Brown University's Professor Kenneth Miller. His paper entitled "The Flagellum Unspun: The Collapse of Irreducible Complexity" (2004) showed that the cellular micro-machines are basic building blocks that can function independently. They are ubiquitous, occur in many different cells, and therefore evolved by a Darwinian process.

Figure 2.1: Biochemist Michael Behe speaking at the ASA Conference, Messiah College, August 7, 2005.

Cell micro-machines evolved in a manner similar to that of the automotive Global Positioning System (G.P.S.). It is sold as an optional accessory for navigating in unfamiliar places. It adds an important capability, but it is not essential for driving. This use develops the technology, so that it is available for an essential function, like navigating a boat surrounded by fog. The same holds for micro-machines. They can evolve in cells where they add an import capability and then be adapted for a different cell to perform an essential function.

Unintelligent design

Intelligent design *(ID)* has problems explaining unintelligent designs. Why would an "intelligent designer" make such imperfections as the blind spot in the human eye? Why do humans have an appendix, which has no apparent digestive function and often gets infected? Why would an intelligent designer plan for baby tigers so cute that you want to take them home? When they grow up, either they eat you up or eat you out of house and home. About 99.9% of the organisms that have ever lived on this earth are now extinct. A designer who planned for things with a 99.9% failure rate wouldn't keep his job very long!

Why would an "intelligent designer" plan for the deadly AIDS virus? This was question was raised by biology Professor Darrel Falk, Point Loma Nazarene University, California, at the August meeting of the American Scientific Affiliation (see *www.asa3.org*), Messiah College, Grantham, Pennsylvania. Falk noted that the deadly AIDS virus is ingenuously designed to destroy human cells. Professor Michael Behe agreed. Falk then said: "Could the 'intelligent designer' have been the devil?" Behe eventually replied: "This is a theological question and I am not a theologian." (The theodicy problem of how a good and all powerful God could have created evil is discussed in Chapter 6.)

Professor Falk had previously explained evil in the light of Biblical and Process Theology. God created the world with spontaneity in nature and freedom for humans. Spontaneity and freedom can result in evil as well as good. Each evolutionary event is the result of an entity or a human's (1) freedom and creativity, (2) deterministic historical and genetic inheritance, and (3) Divine presence, lure, and guidance.

God of the gaps

Mathematician and theologian, William Dembski, research professor of philosophy at Southwestern Baptist Seminary in Fort Worth, Texas, grants that the genetic algorithm (discussed in Chapter 5) is appropriate for optimizing a design. However, he claims that it takes intelligence to use the algorithm, for example, to set up the initial conditions. He uses the mathematics of probability to try to show that chance mutations and natural selections cannot account for nature's complexity. This is basically a "God of the gaps" position. If science can not explain it, God fills the gap by intervening.

In one sense, Dembski is in good company. Isaac Newton did the same thing. He had the good fortune of having the sun much more massive than any of the planets. Thus, he was able to approximate the motion of the earth around the sun on the basis of their gravitational attraction. He realized that in actuality, the motion of the earth is also determined by the gravitational attraction between it and Venus, Mars, and all the other heavenly bodies. Newton was concerned that these multiple-body interactions would ultimately lead to chaotic instabilities in their planetary orbits. He then postulated that God was intervening to remove the chaos. Two centuries later, the French mathematician La Place calculated these multiple planet interactions more precisely and found the instabilities averaged out. When La Place's emperor, Napoleon, asked him about the role of God in his cosmology, La Place replied: "I have no need of that hypothesis!"

I asked William Dembski at the same ASA meeting the following "God of the Gaps" question. "If God is the designer of the irreducible complexity, which science cannot explain at present, shouldn't one become an atheist when science explains it in the future?"

Dembski indicated that this question is a *non sequitur*, it does not necessary follow that one should become an atheist if *ID* should fail. Some people have left the faith as a result of biologist Richard Dawkins' assertion that evolution is a result of blind chance. In making this atheistic, materialistic claim, he is invading theological turf, which a scientist should not do. Dembski has received emails from scientists who were brought back to the faith by *ID*. He is not betting that *ID* will fail, but if it should, those are the breaks. There are other reasons for believing.

Does not his answer reflect a double standard? If biologist Dawkins (1986) should not draw atheistic conclusions from science, should not mathematician Dembski refrain from his theistic claim? The scientific process—not necessarily the scientist—should be agnostic in trying to explain the "how" of the natural world. Agnosticism, as the synthesis of the theism-atheism dialectic, has been a fruitful milieu for the development of science. When theism had political power in the seventeenth century, the Roman Catholic Church condemned Galileo for believing that the earth was not the center of the solar system. Three centuries later, the Church confessed that it had erred. Should not the same be said for President Bush's taking sides in a scientific/spirituality dispute?

Intelligent design is bad science, not because it is false, but because it has not proposed falsifiable or verifiable hypotheses that can be empirically tested. *ID* has not predicted new phenomena whose fruit is technology. *ID* has not been published in peer-reviewed scientific journals. The 120,000 member American Association for the Advancement of Science (Raven, 2002) passed the following resolution, "Intelligent design is an interesting philosophical or theological concept... but not one that should be taught in science classes." The teaching of intelligent design in a biology class would give students the mistaken impression that it is a legitimate scientific concept.

Even today, there is still a Flat Earth Society. Bobby Henderson (2006) is advocating that equal time should be given to teaching that the universe and life were created by a Flying Spaghetti Monster. Should controversies over the flat versus the round earth and the creating Flying Spaghetti Monster be taught in science classes?

Physicists Matt Young and Taner Edis (2004), editors of the book, *WHY INTELLIGENT DESIGN FAILS: A SCIENTIFIC CRITIQUE OF THE NEW CREATIONISM,* assembled a team of physicists, biologists, computer scientists, mathematicians, and archaeologists to evaluate intelligent design from a scientific perspective. The team took intelligent design's two most famous claims—irreducible complexity and information-based arguments—and showed that neither challenges Darwinian evolution. The "intelligent designer" (...and You know who You are.) proposal gives sort shrift to nature's inherent self-organizing ability. Machine intelligence itself is a product of chance and necessity. Intelligent design

is not a scientific principle, but useful in highlighting the beauty of a self-creating, complex world without a detailed human design.

Although the scientific community has rejected intelligent design, the Discovery Institute in Seattle, Washington, of which Behe and Dembski are Fellows, has been successful in influencing state and local school boards to teach *ID*. Proposals hostile to evolution are being considered in more than twenty states, including Pennsylvania and New York. Senator Rick Santorum, a Pennsylvania Republican, has argued that intelligent design is legitimate scientific theory that should be taught in science classes. In the past few years, college students across the country have formed Intelligent Design and Evolution Awareness chapters.

ID has had success with the Kansas school board and a defeat from a Federal Judge in Pennsylvania. The Kansas Board of Education voted 6 to 4 (Wilgoren, *NY Times*, Nov. 9, 2005) to adopt new science standards that are the most far-reaching in the nation in challenging Darwin's theory of evolution in the classroom. The standards move beyond the broad mandate for critical analysis of evolution and effectively redefined science to allow the teaching of *ID*.

On the other hand, federal judge John E. Jones, III (Talbot, *New Yorker*, Dec. 5, 2005; Goodstein, *New York Times*, Dec. 21, 2005) has ruled that it is unconstitutional for the Dover, Pennsylvania school district to present intelligent design as an alternative to evolution in high school biology courses, because *ID* is a religious viewpoint that advances "a particular version of Christianity." The Dover school board had also recommended that a second edition OF PANDAS AND PEOPLE: THE CENTRAL QUESTION OF BIOLOGICAL ORIGINS (Davis and Kenyon, 1993) be used as a text for teaching intelligent design. During the trial it was established that the original edition of OF PANDAS AND PEOPLE used the term creationism. When the teaching of creationism was ruled to be unconstitutional in 1987, later editions substituted intelligent design. Judge Jones's decision is legally binding only for school districts in the middle district of Pennsylvania. The decision could be appealed to the Supreme Court.

Complementary Beauty should be taught

Spirituality, the independent source of the world's religious traditions and wisdom, provides the "why," which beautifully complements the "how" of science. Science, unraveling the intricacy of nature, and spirituality, revealing its ultimate meaning and purpose, have complementary beauty.

The complementary beauty of the new story (Chapter 11) transcends national and cultural differences. It is a story of increasing complexity, specialization, and beauty emerging from simple beginnings. It is a story of increasingly interdependent communities and ultimately humans, who are conscious of beauty, have a moral conscience, and are creative. Spirituality inspired the moral laws, meaning, and purpose that enabled tribes to live together in solidarity. This coupled with scientific and technical advances led to the emergence of the great civilizations of Egypt, Greece, Rome, Islam, and modern democracies.

In the conclusion to his ORIGIN OF THE SPECIES, Charles Darwin (1859) expressed this beautiful new story as:

> There is grandeur in this view of life with its several powers, having been originally breathed by the Creator into a few forms or into one; and that, whilst this planet has gone cycling on according to the fixed law of gravity, from so simple a beginning endless forms most *beautiful* and wonderful have been and are being evolved.

The natural world has "endless forms most beautiful," which adorn natural history museums throughout the world.

The complementary beauty that comes from yoking the rigor of science with the meaning of spirituality should be taught in classes on history, social science, and world religions. Part of the intelligent design controversy comes from not teaching our children about religion and philosophy in the public schools (Grassie, 2005). There are no constitutional barriers to such curricula, as long as they are not sectarian. Children, whose families give them no religious education, can grow up to be spiritually illiterate. This ignorance is exacerbated by poor science education. The blending of poor science education with weak religious education is the root cause of many misunderstandings and controversies.

In the mid-twentieth century, everybody knew new about Albert Einstein. If a student was very bright in school, he or she would be call an "Einstein." He believed in a superior intelligence manifest through natural laws, but not in an intelligent designer. He expressed spirituality as a "cosmic religious feeling:"

> The scientist is possessed by the sense of universal causation…His religious feeling takes the form of a rapturous amazement at the harmony of natural law, which reveals and intelligence of such superiority that, compared with all the systematic thinking and acting of human beings is an utterly insignificant reflection (1954, p. 40).
>
> …To this there also belongs the faith in the possibility that the regulations valid for the world of existence are rational, that is, comprehensible to reason….I cannot conceive of a genuine scientist without this faith (1954, p. 46).

Einstein's asserted that science itself is based on the faith that the world is rational and capable of being understood. Scientists today rightly object to the Discovery Institute, when it tries to influence school boards and politicians to teach intelligent design in biology classes. However, Einstein's kind of faith should temper this opposition.

Mathematical physicist and winner of the 1995 Templeton Prize for progress in spirituality, Paul Davies' (2001) view of intelligent design is as follows.

> I do not cling to the notion of God as a miracle-working cosmic magician, who makes a big bang and then intervenes as a cosmic repairman. A God who can create a self-creating universe with laws is much more majestic. As an emergentist, I believe in a hierarchy of principles, with the laws of physics at the bottom level and emergent laws operating at higher levels. Thus, we have laws of complexity, such as self-organizing chemical cycles. There are Mendel's laws of genetics when life appears. The high-level laws do not violate the lower level laws, nor are they reducible to them. They supervene on them.

Theologian Wesley Wildman (2006) agrees with Davies in that

> *ID* presumes far too small and human a picture of God, an image unworthy of the great theistic traditions...These traditions refuse to treat God as one cause among others in the world of nature. God creates the world as a whole, with its regularities and intelligibility, and God is present to the world in part through supporting the autonomy of the natural process. This view is called theistic evolution, to distinguish it from both *ID* and atheistic evolution...Sadly, I fear the *ID* controversy will be one more blot on religion's questionable record of standing in the way of knowledge... rather than expecting to find beauty and wonder in every new scientific discovery.

"Intelligent Designer" could be a spiritual metaphor for God as the Creator in the Bible. However, this should not be taken as a literal truth that is provable by science. Theologian Paul Tillich regarded science as belonging to the horizontal dimension of relations between finite, physical objects, i.e. *what is,* and spirituality as belonging to the vertical transcendent reality, what *should be.* Proving God or an "Intelligent Designer" with science would reduce or degrade God's transcendence to finite reality and make Him/Her into an "It," or an object among other objects. Science itself is agnostic, since it neither proves nor disproves the existence of God.

Philosopher and historian, Michael Ruse, in his (2003) *DARWIN AND DESIGN: DOES EVOLUTION HAVE A PURPOSE?* explores the history of the design metaphor and ultimately concluded that it is a beneficial term. Ruse notes that Darwinian evolution does not have design built in as a premise, but design emerges as natural selection does its work. Beautiful life forms are selected that are best adapted to their environment. Evolution is analogous to the algorithm for generating the fractal triangle. The intricate design of the Sierpinski triangle containing smaller fractal triangles *emerges* as a result of applying randomness with a global law. Our rapture at seeing, for example, a beautiful butterfly, we attribute *to* a design. The evolutionary interplay between chance and law (Chapter 5), however, is not design *from* a predetermined human blueprint. Evolution is design *to,* not design *from.*

Evolution is a beautiful openness for the future, not a detailed human plan. In process thought, beauty comes from the harmonious balance between chance (freedom) and necessity (law.) Divine guidance and lure is manifest in this interdependence. The naturalist and Anglican priest Charles Raven put it this way in his 1951 Gifford Lecture:

> Here is beauty—whatever the philosophers and art critics who have never looked at a moth may say— beauty that rejoices and humbles, beauty remote from all that is meant by words like random or purposeless, utilitarian or materialistic, beauty in its impact and effects akin to the authentic encounter with God.

Similar to Anglican Charles Raven, Roman Catholic theologian Hans Urs von Balthasar (Cihak, 2005; Dubay, 1999) saw the encounter with beauty in the world as analogous to an encounter with the God. For example, on an especially clear night away from the light pollution of the city, seeing the luminous clouds in the Milky Way, made of stars so numerous and far away that we cannot resolve them, is truly amazing. The light breaking forth from this beautiful form fills the stargazer with wonder and awe. This light is not simply the light emanating from the

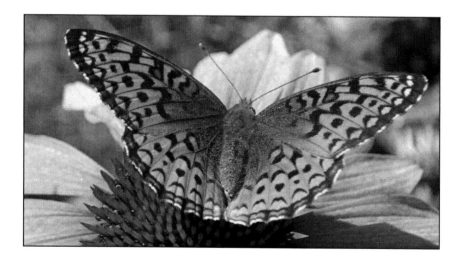

FIGURE 2.2: Echinacea blossom with lepidoptera.

stars, the result of nuclear fusion, it is the light of true Being. Transported into the depths of the form, the viewer ponders basic questions such as: Where did these stars come from? How did they evolve? Why is this form so beautiful? Why am I so moved by it? Thus, the visible form not only points to an invisible, unfathomable mystery; the form is the apparition and revelation of this mystery. The attractive force of the beautiful draws one out of oneself into the form. The beautiful Divine Mystery thereby encountered.

Beauty is the in-dissolvable union of two things: species and lumen. Beauty consists of a specific, tangible form (species) accessible to human senses with a splendor emanating from the form (lumen). Beauty has a particular form, is concretely situated in the coordinates of time and space, and thus has proportions that can be measured by science. The splendor is the attractive charm of the Beautiful, the gravitational pull that overpowers the beholder. In confronting the Beautiful, science reveals the tangible form, and spirituality the real presence of a depth and transcendent reality that points beyond itself.

The complementary beauty of science and spirituality offers a better alternative to atheistic materialism than intelligent design. Randy Isaac (2005), executive director of the American Scientific Affiliation, in his article "From Gaps to God" concluded:

> The exquisite beauty and elegance of the portion of the universe that we can explain, either by simple observations or by Maxwell's equations or Schroedinger's equations, overwhelmingly display the glory of God...

Nevertheless, where is the boundary between science and spirit? How did the oldest science, cosmology, emerge from astrology and spiritual myths?

Chapter 3

From the "Music of the Spheres" to the Big Bang's Whispers, From Hydrogen to Humans

The teleology [goal] of the Universe is directed to the production of Beauty.

—A .N. Whitehead, 1933

Ancient Cosmology: "The music of the spheres."

Even though our concepts of the universe have changed, we perceive it as awesome and beautiful. In this sense, beauty is eternal. Astronomer Mario Livio (2000) has called this the cosmological aesthetic principle. Modern astronomy, framed in the mathematical language of general relativity, gradually emerged from the beautiful stories and numerology of astrology. The deciphering of nature's mathematical code over thousands of years is an exciting detective story. It started with ancient myths and first chapter of Genesis and was continued by Pythagoras, Ptolemy, Copernicus, Galileo, Kepler, Newton, Einstein, and Guth.

The Stonehenge megalith and the Great Pyramid built about 2000 B.C. were aligned with the sun and the stars. The ancient Greeks believed that the planets revolving about the earth made the beautiful "music of the spheres." Copernicus proposed the sun to be at the center of "the most beautiful temple." Our knowledge of the planets has expanded to the billions and billions of galaxies of our modern cosmos, which has cooled from a hot Big Bang explosion in space-time over 13

billion years ago. This cooled background radiation or noise permeates the entire universe, like the whisper or hiss we hear when switching between television stations. Modern cosmology tells how hydrogen from the Big Bang evolved into humans.

The megalith Stonehenge in England is awesome and beautiful. How were the Druids, 4000 years ago, able to place these massive stones onto the precise alignment needed for them to serve as a solar and lunar calendar? For example, one of the stones is aligned with the rising sun on the summer solstice, June 21. What motivated the Druids to accomplish this massive task done before the discovery of labor-saving machines? Perhaps it was the desire to have a place for religious festivals under the beauty and majesty of the heavens. This massive calendar was a milestone in the emergence of the oldest science, astronomy (Hawkins , 1989).

Similarly, the Great Pyramid of Khufu (or Cheops), built 4,500 years ago, was aligned with the North Star. The Great Pyramid towers over the Giza plain some sixteen kilometers west of Cairo among several smaller pyramids, sixty or more of which stretch down the western bank of the Nile. The base of the Great Pyramid covers thirteen acres, or about seven midtown blocks in Manhattan. It rises in 201 stepped tiers comprised of more than two million pieces of limestone and granite, averaging two or three tons apiece to the height of a modern forty-story building. It was the tallest construction in the world until the Eiffel Tower was erected at the end of the nineteenth century.

How did the builders of this colossal structure manage to orient it with the cardinal points of the compass with such high accuracy? The eastern side of the Great Pyramid, for example, points only three minutes of arc away from a true north-south line. Studies of this yield information about the pyramid's age, as the North Star 4,500 years ago was different from our present Polaris, due to the slow wobble of the earth's axis of spin. The Great Pyramid is aligned with the heavens both symbolically and physically.

What motivated 5,000 to 10,000 skilled artisans and laborers to build this massive structure in an estimated twenty years? Their goal was to provide a tomb that would enable their Pharaoh Khufu to enter the life eternal.

The Hebrew people were slaves in Egypt until Moses led their exodus in about 1500 B.C. In 1000 B.C., King David established Jerusalem as his

capitol city. In about 550 B.C., Jerusalem was captured and the Hebrew people were taken to be slaves in Babylon. During that time, some scholars believe that the creation story in Genesis 1 was written down. This would explain why Genesis 1 is amazingly similar to the *Enuma Elish*, the Babylonian creation myth (Jacobsen, 1957). There is one important difference, however. The Babylonian myth is polytheistic while Genesis 1 is monotheistic. Genesis 1 was presumably written down to oppose the pagan polytheistic culture of Babylon and to maintain the belief in the one benevolent God (Skehan, 2000).

Is there not a certain mystic beauty in the creation story of Genesis 1, where a divine spirit moves on the face of the waters creating light from darkness and order from chaos? The creation of the world in seven days is an explanation for our seven-day week, with the seventh day being a day of rest. Our month is approximately the time that it takes for the moon to revolve about the earth. Our year is the time that it takes for the earth to revolve about the sun. We trust astronomers at the Naval Observatory to synchronize our clocks with the sun and stars.

The First Chapter of the Gospel of John, written about A.D. 90, describes the creation as: "In the beginning was the Word [*logos*], and the Word was with God and the Word was God." The *logos*, which is the root of our words, logic, theo-logy, techno-logy, etc., combines the Greek idea of a rational ordering principle with the Hebrew idea of God's creative action. The theological power of *logos* or eternal reason contributed to the emergence of the unchanging laws of modern science, as discussed in Chapter 7, "The Beauty and Power of Theology Touching Technology."

Every culture has is own creation story. Physicist and humanist V. V. Raman expresses the mystic beauty of the Hindu creation story in his poem:

THE RIG VEDIC HYMN OF CREATION

Being, non-being: naught existed then,
No sky above, and beyond, no heaven.
Who encased it and kept it where?
Was water in that darkness there?

Neither deathlessness nor decay
Nor the rhythm of night and day.
The self-existent, with breath sans air:
That, and that alone was there.

Darkness was in darkness found
Like light-less water all around.
One emerged, with nothing on.
It was from Heat that this was born.

In it, Desire its way did find:
The primordial seed born of mind.
Deep in their hearts sages found:
What is, by string, is to what isn't, bound.

Across the void, was cast the string.
Below, above: there was no such thing.
Seed-sowers and powers now came by,
Impulse below and force on high.

Who really knows, and who can swear,
How creation arose, when or where!
Even gods came after Creation's day,
Who really knows, who can truly say

When and how did Creation start?
Did He do it? Or did He not?
Only He up there knows, maybe;
Or perhaps not, not even He.

This ending of this Hindu creation story is descriptive of the mystical emergence of being from non-being. Ancient stories and myths used to explain the natural world.

The geocentric universe of Pythagoras, Plato, and Ptolemy was a milestone in the emergence of mathematical beauty from the mystical beauty of the Sun God, Helios. This cosmos, made of concentric crystalline spheres which carried the planets, accounted for the daily rising and setting of the sun as it orbited the earth. Pythagoras noted that

the spacing between the planets was the same as intervals of the musical scale. Thus, their orbital motion made the harmonious "music of the spheres." Aristotle wondered why we do not notice the music. He concluded that it is because it is there all the time. Humans have never experienced a universe without it!

The Greeks also believed the celestial bodies were circular spheres made of "quintessence," an ether-like substance different from the corruptible elements of our planet: earth, air, fire, and water. There is a certain mystic and geometric beauty in representing each of these elements by the five regular solids respectively: dodecahedron, cube, octagon, tetrahedron, and icosahedron. They can be inscribed inside a sphere and therefore regarded as approximations to its perfect symmetry. (Plato's philosophy was that existence is a shadow of the perfect essence symbolized by the sphere.) The circle or sphere has the most perfect symmetry. It symbolized both the universe and the divine. The circle forms the outer perimeter of a mandala, an intricate symmetric symbol used by Buddhism as a guide for meditation.

Ptolemy in the second century A.D. developed a mathematical cosmology of the geocentric universe. The planets and the sun were supported by crystalline spheres, which rotated about the earth. To account for the sometimes backward or retrograde motion of the planets, they were modeled as riding on an epicycle, that is, a smaller sphere whose center traveled on the larger earth-centered sphere. Astronomers used Ptolemy's cosmology to predict the motion of the planets until Nicholas Copernicus proposed a heliocentric universe and Isaac Newton the gravitational force.

The Copernican Revolution:
The sun at the center of "the most beautiful temple."

The year 1543 was a milestone in the emergence of mathematical from mystical, when Nicholas Copernicus published, shortly before his death, his *DE REVOLUTIONIBUS (ON THE REVOLUTIONS OF THE HEAVENLY SPHERES)*. He proposed our present heliocentric solar system as pleasing to the mind. It placed Mercury, the fastest moving planet, closest to the sun and Saturn, the slowest, the most distant. He said (Copernicus, 1543):

The sun, seated on its royal throne, governs the family of
planets going around it. For in this most *beautiful* temple, who
would put this lamp in any other or better place than that
from which it can illuminate all the planets?

Copernicus' new solar system did not give substantially more
accurate predictions than the Ptolemaic geocentric system. There was
also no proof that the earth was rotating about its own axis while orbiting
the sun. This, plus opposition from the church, which was grounded in
the geocentric philosophy of Aristotle, kept this new heliocentric
cosmology from being universally accepted until Newton published his
Principia, about a century later. Newton once said that he stood on the
shoulders of giants, namely Galileo and Kepler.

Copernicus' student, Rheticus, had taken the manuscript *DE
REVOLUTIONIBUS* to the printer Johannes Petreius in Nuremberg,
Germany. An anonymous *Ad Lectorem* (to the reader) was published on
the back of the title page to avoid objections from the Roman Catholic
Church. The *Ad Lectorem*, which astronomer Kepler later revealed was
written by Osiander, stated that the cosmology in the book was merely
hypothetical, and that "perhaps a philosopher will seek after truth but an
astronomer will just take what is simplest, and neither will know
anything certain unless it has been divinely revealed to him."
(Gingerich, 2004, p. 141)

In spite of religious and philosophical objections, many of
Copernicus' contemporaries regarded his cosmology as aesthetically
superior. This is because his heliocentric system eliminated Ptolemy's
"equants," in which the planets moved faster on one side of the earth
than the other. It was simpler in the sense that it reduced the number of
epicycles. Kepler's teacher, the astronomer Maestin's view of *DE
REVOLUTIONIBUS* was "the arrangement presented in this book is the sort
of structure in which all the sidereal motions and phenomena are
explained very exactly. Therefore this hypothesis recommends itself to
the intellect." (Gingerich, 2004, p. 156) Copernicus, an administrative
official or canon in the cathedral of Frauenberg, Poland, had even
painted his own portrait. Perhaps his artistic ability contributed to the
beauty of his new cosmology.

In Italy, Galileo Galilei (1564-1642) strongly supported Copernicus'
new cosmology. Galileo's observations with the newly invented telescope

showed that the moon had mountains similar to the earth and the sun had spots. This shattered the ancient myth that the heavenly bodies were perfect spheres made of "ether" in contrast to the imperfect and corruptible earth. His observation of the phases of Venus convinced him that it was orbiting the sun, just as our moon orbits the earth. He also discovered the moons that rotated about the planet Jupiter. Copernicus' heliocentric hypothesis offered a better explanation of these new phenomena. (See Chapter 10, "Creativity: Source of Beauty" for a discussion of Galileo's trial by the Roman Catholic Church.)

Galileo's quantitative studies of the dynamics of moving bodies paved the way for Newton's equations of motion. Galileo thereby contributed to the emergence of the mathematical from the mystical. He said: "Nature is a grand book written in the language of mathematics."

Johannes Kepler (1571-1630) adopted the heliocentric system, because he could place the five regular solids as spacers between the orbits of the six known planets. The fit matched the known radii of the planets with enough perfection that Kepler was convinced that it was divinely planned.

The following poem (Cedering, 1984) described the witches and smallpox of Kepler's day. His study of astronomy must have been a transforming experience.

JOHANNES KEPLER:

They say my mother is a witch.
She was arrested in the rectory.
They dragged her to prison in a trunk.
They want to put her on the rack.
For weeks she has been chained.
I am writing letters asking them to release her.
My school has been closed.
My Protestant teachers have been burned at the stake.
My youngest child died, of smallpox.

But I try to continue my exploration of a celestial science.
I have derived a musical scale
For each planet, from variations
In their daily motions around the sun.

A five-note scale for Jupiter.
Fourteen notes for Mercury, and Venus,
Repeating her one long note.
Such harmony. As I picture each planet
Floating within the geometric perfections
Of space, I think geometry was implanted in man
Along with the image of God.
Geometry indeed is God.

Kepler's is most famous for his discovery that the planets move in elliptical orbits, of which the sun occupies one focus. He formulated this with the use of both Copernicus' heliocentric cosmology and Tycho Brache's astronomical observations.

The concept of elliptical orbits was a major departure from the perfect circular motion that astronomers had from the time of the Greeks attributed to the incorruptible heavenly bodies. Kepler also discovered two additional laws of elliptical planetary motion.

Before Kepler, astronomy was mainly observational. Kepler therefore made a unique contribution in postulating that there was a magnetic force acting between the planets. He said (Cedering, 1984):

If we substitute the word "force"
for the word "soul," we shall have
the basic principle which lies at
the heart of my celestial physics.

Kepler was on the right track, but it was Isaac Newton who discovered that the force was gravitational. Newton's biographer, William Stukeley, recounts Newton's description of his original conception of gravity (Berlinski, 2000):

After dinner...the weather being warm, we went into the garden and drank tea, under the shade of some apple trees. Newton told me that he was in the same situation, when formerly the notion of gravity came into his mind. It was occasioned by the fall of an apple as he sat in a contemplative mood. Why should that apple always descend perpendicularly to the ground, thought he to himself? Why should it not go

sideways or upwards, but constantly to the earth's center? Newton then thought that there must be a drawing power between material objects. It must be in proportion to its quantity" (p. 2).

This was the beginning of Newton's concept of gravity. He later realized that the gravitational law of attraction between a terrestrial apple and the earth was same as that between the celestial moon and the earth. As the moon orbited the earth, the force of gravity caused it to continually "fall towards the earth." In contrast to Greek cosmology, Newton believed that celestial and terrestrial bodies had the same properties, and well as obeying the same laws of motion. The Newtonian synthesis of celestial and terrestrial motion is one of the great intellectual achievements of all time. Isaac Newton's laws of motion and gravity led to the acceptance of the Copernican system. The massive sun in the center was the source of gravity, which kept the planets in orbit.

Newton formulated three new laws of motion. Then he went on to show that Kepler's three Laws of Planetary Motion were but special cases of Newon's three Laws, if a force of a particular kind (what we now know to be the gravitational force) were postulated to exist between all objects in the universe. In fact, Newton went even further: he showed that Kepler's Laws of planetary motion were only approximately correct, and supplied the quantitative corrections that with careful observations proved to be valid.

In contrast to Galileo, who was condemned by the Church, Newton was greatly revered. The poet Alexander Pope in his "Epitaph intended for Sir Isaac Newton" wrote:

> Nature and Nature's laws
> lay hid in night;
> God said, Let Newton be!
> and all was light.

The poem uses the same imagery as the first chapter of Genesis. Newton regarded the universe as a mathematical mystery to be deciphered. His PRINCIPIA concluded with:

> This most *beautiful* system of the sun, planets, and comets
> could only proceed from the counsel and dominion of an
> intelligent and powerful being.

Newton had no "proof positive" that the earth moved, but his gravitational theory made no sense without a massive, comparatively immobile sun near the gravitational center. Foucault's pendulum was "proof positive," but was anticlimactic in 1851, as the Copernican system had already been accepted.

The Whispering Cosmos: From hydrogen to humans.

The final chapter in the emergence of the mathematical from the mystical occurred in the twentieth century. Modern cosmology is so comprehensive that it can explain the abundance of the elements. The hydrogen formed in the hot Big Bang is still the most plentiful element in the universe. Modern cosmology also tells us how this hydrogen evolved into stars, planets, and humans. It also explains the cool remnant radiation or afterglow of the hot Big Bang that whispers throughout the entire cosmos.

During the twentieth century, our understanding of the size and age of the universe has expanded immensely. At the beginning of the century, the physicist, Lord Kelvin, assuming that the energy from the sun was the result of chemical reactions (i. e. burning), calculated that it was 20 to 40 million years old. This implied that the earth and the other planets were of comparable age. This brought him into conflict with the geologists, who had concluded from fossil evidence that our earth was billions of years old (Skehan, 1985). Resolution came when physicists discovered nuclear fusion and concluded that the energy radiated by the sun and the stars was the result of this gigantic source of energy (also that of an atomic hydrogen bomb.) The energy density of nuclear energy is much greater than that of chemical energy. We now know that the age of the sun is about five billion years old and expect that it will last for another 5 billion before it exhausts its nuclear fuel.

In 1905 Einstein published his theory of special relativity, in which the velocity of light was invariant in reference systems moving with a constant velocity and energy was related to matter. This was followed by his theory of general relativity in which gravity caused space and time to

be curved or distorted. It was experimentally verified by observing the bending or curvature of light from a distant star as the light passed close the sun, with its large gravitational field.

Einstein, after completing his theory of general relativity, applied his new theory of gravity to the universe as a whole. In 1917, he found that it was impossible to construct a model of the universe that was static or unchanging. The gravitational attraction of the galaxies, stars, and planets would cause them be attracted towards each other and eventually collapse in a "big crunch." At that time, astronomers did not observe any motion of this type.

Unlike some theoreticians today, Einstein wanted his new theory to agree with observations and therefore inserted a "cosmological constant" into his equation to remove the attractive motion. In 1929 the astronomer Edwin Hubble discovered that the velocity of distant stars was proportional to their distance, that is, the universe is expanding. If one extrapolates this motion back to the beginning of time, then all the heavenly bodies originated from the same center. When Einstein learned about this, he remarked that his "cosmological constant" was the greatest blunder of his career.

Einstein was disappointed to learn from the Dutch astronomer Willem de Sitter that his equations of general relativity had two possible solutions instead of one (Guth, 1997). Einstein was further disappointed by a large class of solutions that were discovered by the Russian meteorologist and mathematician, Alexander Friedmann. Friedmann's papers laid the foundation for cosmology based on general relativity. He dropped Einstein's and de Sitter's assumption that the universe should be static and eliminated the cosmological constant.

Friedmann found that the solutions of the general relativity equation fall into two extreme cases with the Flat Universe case separating them (see FIGURE 3.1). In the Closed Universe case, the mass density of the universe is so high that the expansion will be eventually overcome by gravitational attraction, contract, and decrease back to zero in a "Big Crunch." The high mass density causes space to curve back on itself. In the Open Universe case, the mass density is low and the gravitational field too weak to halt the expansion. The distance between two galaxies increases forever without limit, although the velocity of separation levels off at a constant value. The Flat Universe is between these two cases. It has flat Euclidean geometry and critical density. The critical density is

about four hydrogen molecules per cubic meter, which is much lower than can be achieved with vacuum systems on earth. Measurements of the cosmic microwave background (Freedman and Turner, 2003), the Big Bang's whisper, show that the universe has critical density to an accuracy of 2%. The the Flat Universe's expansion velocity becomes closer and closer to zero, but never quite reaches it.

In the late 1920s, the civil engineer and priest, Georges Lemaître, using Einstein's general relativity theory, proposed that the universe had expanded from a "primeval atom" or "cosmic egg in space-time." Many scientists rejected this proposal initially, because little was known about matter and energy at such high densities. Besides, it seemed too much like the first chapter of the book of Genesis, which had "a beginning." Instead astronomer Fred Hoyle proposed a steady state universe in which mater was being continuously created as it expanded. Hoyle coined the term "big bang" as a term of derision for Lemaître's "primeval atom."

However, the steady state theory was gradually abandoned after 1965, because it could not explain the cosmic black body radiation or

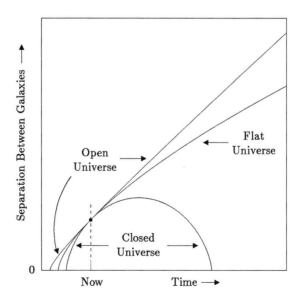

FIGURE 3.1: The evolution of Friedmann Universes.
The separation between the galaxies versus time.
(Credit: Alan Guth)

noise discovered by radio astronomers Penzias and Wilson. They, while working at the Bell Telephone Laboratory Communication Center at Crawford Hill, New Jersey were preparing their radio frequency horn for sensitive radio astronomy measurements. The discovered, to their original dismay, a new source of noise that appeared to originate from all directions of the cosmos. They tried to eliminate it, including the removal of a "white dielectric substance" deposited on their antenna by some pigeons, to no avail.

Meanwhile, at nearby Princeton University, Professor Robert Dicke was encouraging his graduate students to search for a "cool," minus 267°C remnant afterglow or whisper from the primordial Big Bang explosion, which should be permeating the universe. The cooling of the radiation from the hot Big Bang is analogous to the cooling of the radiation from an incandescent light bulb or heat lamp, whose temperature is hundreds of degrees. As this heat radiates and expands, it cools to a few degrees C, which increases the ambient temperature the room.

Though the scientific "grapevine" Penzias and Wilson, who had discovered a new source of cosmic noise they did not understand, were able to make contact with the Princeton Group, who were searching for it. They decided to publish separate papers back-to-back in the *Astrophysical Journal.* Penzias and Wilson's paper was entitled "A Measurement of Excess Antenna temperature at 4080 Mc/s" (Note that the 4080 Million cycles per seconds was the microwave frequency of their measurements. This corresponds to a microwave wavelength of 7.35 centimeters.) Dicke and his coworkers's paper was more direct, "Cosmic Black Body Radiation." As a result of this and subsequent measurements at other frequencies, Penzias and Wilson were awarded the Nobel Prize for Physics in 1978 for their discovery of the cosmic radiation of the whispering universe.

The Penzias and Wilson measurements were made at only one frequency. Final confirmations came from the Far Infrared Absolute Spectrophotometer (FIRAS) on NASA's Cosmic Background Explorer Satellite (COBE). (See Figure 3.2). The error bars on the 34 equally spaced data points are so small that they can not be seen under the black body radiation spectrum predicted for a temperature of 2.725°Kelvin. (0°Kelvin is minus 270°Celsius.)

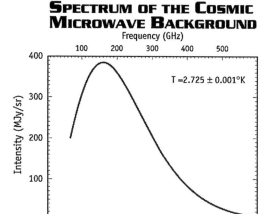

SPECTRUM OF THE COSMIC MICROWAVE BACKGROUND

FIGURE 3.2: Intensity vs. wavelength and frequency for the cosmic blackbody radiation with a temperature of 2.725°K. (Credit: FIRAS on NASA/COBE)

Beautiful satellite images of this radiation (COLOR PLATE 13 and FIGURE 3.3) reveal temperature variations or "seeds," which later, as we will explain, grew into the galaxies and stars. The microwave radiation captured in this picture shows how the universe looked only 0.4 million years after the Big Bang, over 13 billion years ago: the equivalent of

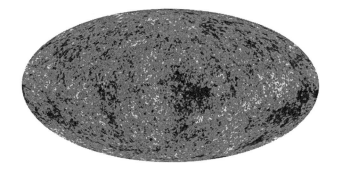

FIGURE 3.3: Image of microwave radiation from the early universe. (Credit NASA/WMAP Science Team).

taking a picture of an eighty-year-old person on the day of their birth. The Wilkinson Microwave Anisotropy Probe (WMAP) team has made the first detailed full-sky map of the oldest radiation in the universe. It is a "baby picture" of the universe. Colors indicate "warmer" (red) and "cooler" (blue) spots. The oval shape is a projection to display the whole sky; similar to the way the globe of the earth can be projected as an oval. We will see below how the inflationary model of the universe predicts the statistical distribution of these temperature fluctuations.

Similarly, the Hubble optical telescope photograph (COLOR PLATE 14 and FIGURE 3.4) enables us see thousands of galaxies, which are about 12 billion light years away. Thus we are able to visualize how the universe appeared about one billion years after its birth!

Big Bang Cosmology also predicts the relative abundance of the elements. Hydrogen and helium were fused from protons in the cosmic Big Bang explosion about 13 billion years ago. They are still the most abundant elements in the universe, about 75% hydrogen and 24% helium, in agreement with Big Bang predictions. They also predict the abundance of deuterium, which like hydrogen has one electron, but its nucleus has both a proton and a neutron.

About a billion years after the Big Bang, gravitational attraction caused clouds of hydrogen and helium to coalesce into stars and galaxies. Stars are massive nuclear fusion reactors which radiate heat and light energy obtained by fusing hydrogen into helium and higher elements in the periodic table. For example, three helium nuclei combine to form carbon, the basis of all life on earth. Carbon then combines with more helium nuclei to form higher and higher

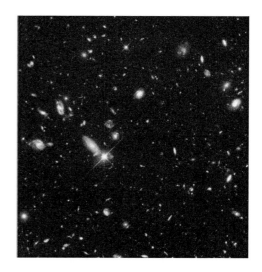

FIGURE 3.4: Deep Field Image from NASA Hubble Telescope of galaxies 12 billion light years away (January 15, 1995. STSCI, NASA).

elements in the periodic table up to iron. Stars are not hot enough to produce elements heavier than these. Higher elements such a lead and uranium are formed in the higher temperatures that occur when stars explode at the end of their life. Recent Hubble telescope photographs depict these spectacular super-novae. Our solar system, which does indeed include these higher elements, was formed when the cosmic dust from these explosions coalesced due to gravitational attraction about 5 billion years ago. Thus, we are made of stardust!

It took about a billion years for our earth to cool off enough to allow the emergence of single cells, whose fossil remains can be seen in the rocks. Single celled organisms populated our planet for about three billion years. These include protoplankton, tiny single celled plants that transformed carbon dioxide into oxygen by photosynthesis. They increased the oxygen content of our atmosphere, making it possible to support animal and human life.

About 600 million years ago, the Cambrian explosion produced multi-cellular life such as fish, reptiles, and birds. There were also life forms such as trilobites, three-lobed sea creatures, which are now extinct. The abundance of plants and trees over hundreds of millions of years has become fossilized into coal and oil. The dinosaur reptiles which once roamed the earth became extinct. This is attributed to a climate change, which reduced the large quantities of food they needed. The demise of the dinosaurs gave the mammals their chance to populate the earth. Humans are relatively recent. We and our cousins, the chimpanzees and bonobo apes, evolved from a common ancestor about 5 million years ago.

In summary, the mystical "music of the spheres" of the Greeks has over several millennia evolved into the mathematical beauty of the whispering universe. Modern cosmology exemplifies the elements of universal and scientific beauty. This cosmology is based on Einstein's beautiful theory of general relativity in which gravity causes the curvature of space-time. The universe emerged from Lemaître's "primeval atom" or "cosmic egg" in a hot Big Bang space-time explosion of trillions of degrees which occurred over 13 billion years ago. Beautiful satellite images of the remnant radiation from this explosion, cooled to minus 270°C, enable us to look back in time to only 379,000 years after the primeval event. We can see the seeds that "planted" the galaxies and stars in the whispering cosmos. The Hubble optical telescope enables us to see these galaxies a 1 billion years after their birth. The light from

these galaxies and stars has traveled through the vastness of space for 12 billion years to reach us. Stars at the end of the lifetime explode into spectacular supernova. This stardust coalesced to form our earth, the sun, and the planets of our solar system. Thus, we are made of the stardust! The hydrogen from the primordial Big Bang has evolved into humans.

The theological implications of this scientific story is discussed in Chapter 7, "A Theology for the Evolution of Forms Most Beautiful," particularly in the section "The Emergence of Life." The anthropic principle and refinements of big bang cosmology are discussed in Appendix B.

The transition from the mystical to the mathematical we have seen in cosmology is also evident in American thought, as we will see in the next chapter.

Chapter 4
Beauty: From Theology to Fractals

A leaf, a drop, a crystal, a moment of time, is related to the whole.
Each particle is a microcosm, and faithfully renders the likeness of the
world.

—Emerson

The development theory (evolution) implies a greater vital force in
nature, because it is more flexible and accommodating, and
equivalent to a sort of constant new creation.

—Thoreau (Journals B)

Let us trace the transition from mystical to mathematical beauty in American thought: from the theologian Edwards in the eighteenth century, through Emerson and Thoreau in the nineteenth, to the mathematician Mandelbrot in the twentieth, who discovered the fractal beauty of nature.

Theologian Jonathan Edwards: Nature as God's Beautifying Activity

In the eighteenth century, theologian, pastor, and missionary to Native Americans, Jonathan Edwards saw nature as evidence of God's beautifying activity. For him, the universe was an enlargement of divine being and beauty. As he walked alone in the fields, he experienced of the

beauty of God's love expressed in nature. The beauty Edwards finds in God is not passive but active beautifying. His vision is compatible with a scientific understanding of a very lively and animated universe as a living system governed by more complex relations than simply mechanical ones (Delattre,1968).

The human hunger for beauty confirms it is real experience and not just a powerful idea. That hunger is essentially a spiritual longing for an affirmative and nourishing connection with the ground and source of our being and of all of existence. It arises from an image of God's beauty— the beautifying presence of the divine life—within everyone and everything in the universe. Edwards helps us to see that we are enabled to satisfy that hunger by making ourselves at home in the universe. We are invited and enabled to experience newness of life by cordially participating in the beautifying life of God. The joyful bestowing of beauty is the deepest reality, the cosmos-shaping, reality-enlarging, life-giving, and soul-nourishing reality of the beautifying life of God.

In contrast to the notion that "beauty is in the eye of the beholder," Edwards believed that beauty originated in God, who communicated various degrees of "excellency" in creation (Marsden, 2003). The natural beauty of vines, plants, and trees he expressed as a "very complicated harmony." He noted that that the degree of beauty is determined from the rightness and excellency of their proportions, which, as we shall see, was later quantified by Mandelbrot.

Edwards concept of beauty and excellence are expressed in his understanding of music. Musical harmony was synonymous with proportion. He considered that harmony is due to the proper relations of notes to each other. Edwards (1703-1758) in Massachusetts may have never heard the music of his contemporary J. S. Bach (1685-1750) in Germany, but they had similar worldviews: the ineffable beauty that points to the divine is found in the harmonies of complex relationships. Bach expressed this in the counterpoint of his two hundred cantatas, which dramatized biblical texts. His cantatas were performed as an integral part of the service of worship in the churches including Leipzig.

The Transcendentalists Emerson and Thoreau: Finding God in Nature

The nineteenth century transcendentalists had a poetic and spiritual view of nature. Philosopher Ralph Waldo Emerson's essay "Nature" expressed the transcendental and mystical. He wrote:

> The currents of Universal Being circulate through me, I am part or particle of God....Though we travel the world over to find the beautiful, we must carry it with us or we find it not....A leaf, a drop, a crystal, a moment of time, is related to the whole. Each particle is a microcosm, and faithfully renders the likeness of the world (pp. 24-25).

The parts reflect the nature of the whole, as in fractals. In addition, Emerson noted that the parts share self-similarities with each other, bonded by kinship in Oneness. The reason for, or source of this unity, is

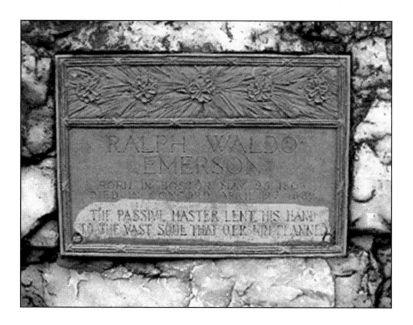

FIGURE 4.1: Ralph Waldo Emerson's epitaph:
The passive master lent his hand
To the vast soul that over him planned.

the Spirit of Oversoul, which is known in some worldviews as Tao, Consciousness, Mind, or Universal Intelligence. This is expressed in the epitaph on Emerson's marble tombstone (see FIGURE 4.1).

When philosopher and naturalist Henry David Thoreau was a student at Harvard University, his reading of Emerson's "Nature" in 1836 made a lasting impression and motivated his statement: "My profession is to be always on the alert to find God in nature, to know his lurking places, to attend all the oratorios, the operas, in nature" (Journals B).

This became the source of friendship between these residents of Concord, Massachusetts. Thoreau completed A WEEK ON THE CONCORD AND MERRIMACK RIVERS, which he published in 1849, and started WALDEN OR LIFE IN THE WOODS (1854) while living in the hut he built on Emerson's land, located on the shores of beautiful Walden Pond (COLOR PLATE 15 and FIGURE 4.2). The River was a metaphor for life. In the "Sunday" chapter, Thoreau described how, in reading a work on agriculture, he was annoyed at having to read moral reflections on the "personality of God," with which he did not agree. Thoreau (1849) wrote:

> There is more religion in man's science than there is science in their religion....A man's real faith is never contained in his creed (p. 91).

Thoreau's argument against the creeds of organized religion reflects the beliefs of his fellow transcendentalists, who wished to restore the importance of individual inspiration. The transcendentalists felt that the creeds of organized religion were burdensome anchors, which prevented the creativity of individual revelations and epiphanies.

Thoreau's mystical, philosophical, and poetic descriptions of nature expressed in "The River" and "Walden" were written at the beginning of his career. The rest of his life was spent in scientific observations of the propagation of plants described in his journal. He wrote: *"I am mystic, transcendentalist, and natural philosopher to boot."* His interest had shifted from the human world to the natural world, from the cultivated fields to the wild woods. In WALDEN, the agriculture of his bean field is a metaphor for human self-cultivation. In his later journals, edited and published by Bradley Dean in 1993 as FAITH IN A SEED, wind, water, and animals are agents for nature's self-cultivation.

FAITH IN A SEED includes Thoreau's "Dispersion of Seeds," in which Thoreau described the natural succession of plants including how they are seeded in the wild. His descriptions were quantitative and mystical. "As I was passing through a pitch-pine wood, where as usual the ground was strewn with twigs, I observed one eleven inches long and about half an inch thick, cut off close below two closed cones, the stem of one cone also being partly cut." He later explained that squirrels trim the cone-bearing twigs to transport them more easily. This attention to quantitative detail contrasts with his more mystical description of milkweed seeds. "When I release some seeds, the fine silky threads fly apart at once, opening with a spring, and then ray their relics out into a hemispherical form, each thread freeing itself from its neighbor and all reflecting prismatic tints." He watched one particular seed sailing like a balloon higher and higher until he looses sight of it. Thoreau concluded: "Who could believe in prophecies of Daniel or of Miller that the world would end this summer, while one milkweed with faith matured its seeds."

Thoreau's *FAITH IN A SEED* debunked, with his detailed observations of nature, the widely held belief that plant life emerged spontaneously, independent of seeds, roots, and cuttings. Thoreau said: "I have great faith in a seed. Convince me that you have a seed there, and I am

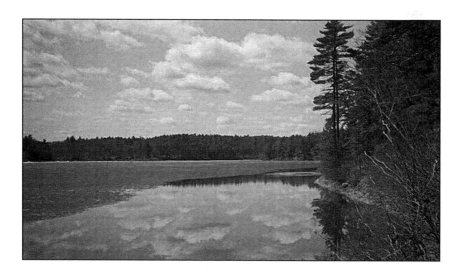

FIGURE 4.2: Walden Pond viewed from the site of Thoreau's hut.

prepared to expect miracles." Thoreau believed in the scientific observation even though in his time the word "natural philosopher" meant "scientist."

In December 1850, Thoreau became a member of Boston's new and energetic Society of Natural History. A few years later, Harvard appointed him to the Visiting Committee in Natural History, which was charged with annual evaluation of the college curriculum. He was also a member of the Harvard's eminent Professor Louis Agassiz's far-flung network of local specimen collectors. As years went by, Thoreau came to doubt Agassiz's belief in the permanence of the species. Agassiz believed that the "facts demonstrated that species were immutable," and that "species do not pass insensibly one into another, but that they appear and disappear unexpectedly without direct relations with their precursors" (Journals B). Agassiz believed that the geographical distribution of species was "regulated by the limits marked out on the first day of creation." The basis of Agassiz's belief was not scientific, despite his claims; it was theological, and has persisted as the theory of special creation.

In March 1857, Thoreau became more critical of Agassiz's claims. After dinner with Agassiz at Emerson's home, Thoreau recorded the following conversation:

"When I began to tell him of my experiment on a frozen fish, he said that Pallas had shown that fishes were frozen and thawed again, but I affirmed the contrary, and Agassiz agreed with me." In June 1858, Thoreau climbed Mount Monadnock. Observing some toad-spawn in a shallow pool near the summit, Thoreau speculated on how it got there. After considering a number of possibilities, he remarked with curt dismissal, "Agassiz might say that they originated at the top" (Journals B).

Before Thoreau died in 1862 of tuberculosis at age forty-five, he read Darwin's ORIGIN OF THE SPECIES and wrote: "The development theory (evolution) implies a greater vital force in nature, because it is more flexible and accommodating, and equivalent to a sort of constant new creation" (Journals B). Contrary to Harvard's better-known Professor Agassiz, Thoreau was one of the first Americans to accept Darwin's theory. Thoreau's "Dispersion of Seeds" argues against the concept of special creation. Instead, it makes a case for Darwin's developmental concept of continuous creation. Thoreau was a minor, but reputable,

local naturalist. Yet on the issue of Darwinian evolution, Thoreau was right and the famous European scientist, Professor Agassiz, was wrong.

Mandelbrot's Fractal Geometry of Nature

Thoreau's first books were mainly philosophical and his final journals scientific. Can Thoreau's career be thought of as a metaphor for the transition from a mystical view of nature to the mathematical beauty recently discovered by Mandelbrot in his "Fractal Geometry of Nature?" Thoreau himself said: "The most distinct and beautiful statement of any truth must take at last the mathematical form." In FAITH IN A SEED, Thoreau noted that oval or cone-shaped stands of pine trees are found in a forest of oaks and that both the tree and its fruits are cone-shaped. Even the individual seeds in the cones had a similar shape on a smaller scale. Was this a premonition of the fractal geometry of nature expressed mathematically by Mandelbrot?

Benoit Mandelbrot and researchers of chaos and complexity theory have discovered that the branching of the tubes in our lungs as well as that of plants is determined by fractal scaling. Each generation, from tree trunks to branches to twigs, is scaled down by the same fraction, such as one third. This fractal structure is more stable and error-tolerant than the more deterministic, Euclidean geometry. Mountains are not cones with straight edges and clouds are not circles but have beautiful fractal edges. Fractals are common in our bodies: from the branching of our lungs to that of our blood vessels. The variations in natural phenomena such as the flooding of the Nile River, rainfall, tree rings, noise-caused-errors in electronic transmission lines, as well as the stock market can be characterized by fractal statistics. This is like picking a card from a stacked deck, rather than one that is shuffled to be truly random.

In summary, we have seen the emergence of the mathematical beauty of nature in the twentieth century from its mystical and spiritual beauty in the eighteenth and nineteenth century. Edward's theology saw nature as a manifestation of God's beautifying activity and the transcendentalists, Emerson and Thoreau, found God in nature. Mandelbrot discovered mathematical beauty in his fractal geometry of nature, which we will discuss in the next chapter.

Chapter 5

Beautiful Fractals:
"Does God Play Dice?"

God plays dice with the universe, but they're loaded dice.

—Joseph Ford, 1987

Introduction

Albert Einstein once said: "I am convinced the Old One [God] does not play dice" (Jammer, p. 222).

The beautiful fractal geometry of nature as well as new discoveries about chaos and complexity challenge this negative statement about the statistical nature of the physical world. Einstein reflects the old metaphor: chaos and randomness are bad. Scientists have recently discovered that many phenomena, from the fluctuations of the stock market to variations in our weather, have the same underlying order.

Natural beauty in mountains, plants, and snowflakes reveal a new fractal geometry: characterized by the complex interplay between randomness (symbolized by dice) and global determinism (which loads the dice.) Darwin's theory of evolution is similar to fractal analysis: the randomness of mutations and global natural selection. We shall see how

old metaphors are being replaced by the new, such as one by chaos theorist Joseph Ford (1987): "God plays dice with the universe, but they're loaded dice."

"Noise is good," said Robert Hilborn (2001). Random noise added to a signal can increase its detectability in a system having a threshold. A familiar example is a hearing test in which one is asked to press a button as soon as the sound is loud enough to be heard. The noisy hiss adds to the coherent sound signal and enables it to trigger the hearing threshold. Thus, a lower level signal with noise can be detected better than one without noise. Of course, the noisy hiss can not be so large as to drown out the signal. "A little noise is good" is a more precise statement.

The fractal geometry of nature

What might appear as random noise has in many cases been discovered to have an underlying order. For example, the fluctuations of the stock market obey fractal statistics (Peters, 1999). A number of physicists are using this analysis as an investment strategy to make money on the market (Bass, 1994). Nature offers many examples of fractal statistics: variations in the flooding of the Nile river, of rainfall, and of tree-rings (Peters, 1999).

Fractals have the property of "self-similarity," in that the parts are in some way related to the whole. In the fractal or Sierpinski (Peters) triangle (FIGURE 5.1), the one central triangle has sides which are half that of the large one in which it is enclosed. The three second-generation triangles, have sides a quarter of the large one. The nine third-generation triangles have sides an eighth of the large triangle, etc.

We will now play the Chaos Game to generate the Sierpinski triangle or fractal triangle. *Randomly* draw a point as shown in the Figure 5.2. Next, the roll a dice to find the direction of the next point. In the Figure 5.3, the roll of a dice gave a 5 or a 6, which corresponds to vortex C. Then apply the *global* rule: draw a point half way to C(5,6). This algorithm is repeated again at each new point. A computer was programmed to apply this rule 10, 000 times to generate the points inside shown inside the Sierpinski triangle. (The first 50 points are discarded as "transients.") These 9950 points form the black granular background inside the orderly fractal or Sierpinski triangle. The Chaos Game shows

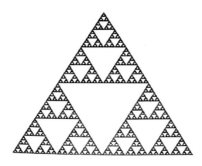

FIGURE **5.1**: Fractal
or Sierpinski Triangle

FIGURE **5.2**: Generation of Fractal Triangle

that local *randomness* and *global* determination can coexist to create an orderly, self-similar structure called a fractal (Peters).

Richard Voss has generated beautiful fractal landscapes (COLOR PLATE 12 and FIGURE 5.3) with algorithms using completely random Brownian Motion and fractional Brownian Motion, which has deterministic properties (<<*http://classes.yale.edu/Fractals/Panorama/ Art/MountainsSim/Classical/Classical.html*>>).

The branching of our lungs from the bronchi to their smaller extensions, as well as that of plants, is described by fractal scaling. For example, the diameter D(G) of our bronchial tubes is related to the diameter of our main trachea D(0) by

$$D(G) = D(0) \times 2^{(-G/3)}$$

where G represents the generation number 1, 2, 3,....

Each generation or set of smaller tubes is scaled down by this factor (Peters). Of course, not all the smaller tubes are the same size, but have a statistical distribution about the mean value given by the global equation above. All fractals have global *determinism* (average tube size) and local *randomness* (diameter of individual branches.) The fractal structure is more stable and error-tolerant than the more deterministic, Euclidean geometry. This is why fractals are so common in nature: from tree trunks and branches, the intricate vein structure of leaves, and mountain landscapes.

The variations in natural phenomena such as the flooding of the Nile River, rainfall, tree rings, noise-caused-errors in electronic transmission lines can also be characterized by fractal statistics. Hurst (1900-1978) worked on the Nile River Dam Project. Most hydrologists had assumed that water inflow is a random process. Hurst, however, studied the 847-year record that the Egyptians had kept of the Nile River's overflows, from A.D. 622 to 1469. The record did not appear random to Hurst. Larger-than-average overflows were more likely to be followed by more large overflows. Suddenly, the process would change to a lower-than-average overflow. (Joseph Effect of seven years of great plenty in the land of Egypt followed by seven years of famine.) Overall, there appeared to be cycles, but their length was nonperiodic. Hurst's

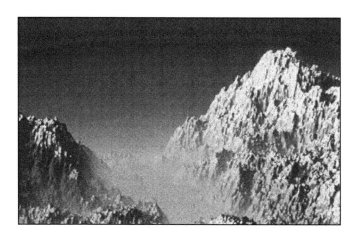

FIGURE 5.3: Fractal landscape having mathematical
and mystical beauty (Credit R. Voss).

mathematical analysis revealed that the Nile river's overflows were described by fractal statistics, which is more like picking a card from a stacked deck than from one that has been shuffled to be truly random. The stacking algorithm is the global rule that characterizes fractal statistics.

Evolution and genetic algorithms

Darwin's theory of evolution is similar to fractal analysis: the individual randomness of mutations and the global determinism of natural selection.

The engineering community has discovered that computer simulations of Darwin's evolution, called genetic algorithms, are very effective for optimizing physical devices. Edward Altshuler (1999) of the Air Force Research Laboratory has discovered that the genetic algorithm has enable him to design antennas having much better performance than he would have been able to conceive of based on his many years of conventional design experience. The genetic algorithm starts with millions of *randomized* antenna dimensions. The antenna's performance is then calculated, and the best are then *selected* as being closest to that desired. The next generation of antennas is made by "sexually mating" the best antennas: half of dimensions of each new generation are chosen from the old generation. These theoretical design predictions are in good agreement with experimental performance. Darwin's theory of evolution, discovered from nature, is very effective at optimizing the man-made world.

The development of a baby's neural system is a good example of natural selection. A baby has a number of neurons in parallel. The nerve that is dominant and used is the one that survives. The other nerves atrophy and die: "Use it or lose it."

Biochemist Arthur Peacocke, winner of 2001 Templeton Prize for Progress in Religion, states: "Instead of being daunted by the role of chance in genetic mutations as being the manifestation of irrationality in the universe, it would be more consistent with the observations to assert that the full gamut of the potentialities of living matter could be explored only through the agency of rapid and frequent randomization. This is possible at the level of DNA" (1995). Chance operating within a law-like framework is the basis of the inherent creativity of the natural order,

in its ability to generate new forms of matter and life. As in many games, the consequences of the fall of the dice depend very much on the rules of the game.

Evolutionary psychologist Nancy Etcoff (1999) in her book *SURVIVAL OF THE PRETTIEST: THE SCIENCE OF BEAUTY* observes that what we perceive as beautiful has evolutionary survival value. Babies with their large round heads, big eyes, and small limbs are perceived as being beautiful in all cultures. Walt Disney's "Mickey Mouse" has these same features. Parents see their children as beautiful. The beauty of mother and child has been portrayed in art for thousands of years as well as the beauty of the human body. Men perceive the woman they love as beautiful and visa versa.

In addition to natural selection, Darwin believed in sexual selection, which is influenced by what other species and we perceive as beautiful in the opposite sex. Biologist Stuart Kauffman (2000) of the Santa Fe Institute states: "Self-organization mingles with natural selection in barely understood ways to yield the magnificence of our teeming biosphere" (p. 2).

Steven Wolfram's best selling book *A NEW KIND OF SCIENCE* (2002) shows that randomness can evolve into order and vice versa. Wolfram uses a rule or recursion relation called "cellular automaton" to show that there are conditions under which a random set of geometric cells can evolve into an ordered set. Starting with a row of randomly ordered black and white cells, he applies the simple, deterministic "cellular automaton" rules. For example, a lower cell becomes black if either of its upper neighbors is black. By applying these deterministic rules, a row of random cells can evolve into an orderly pattern. Conversely, there are other "cellular automatons" that cause an ordered set to evolve into a random pattern.

Different cellular automata can be used to generate a multitude of patterns. Examples include the Sierpinski fractal triangle above, hexagonal snowflakes (Wolfram, Chapter 8), as well as pigmentation designs in mollusk shells. The latter, like a one-dimensional cellar automaton, grow one line at a time, with new shell material being produced by a lip of soft tissue at the edge of the mollusk. The simple local rule of a "cellular automaton" can lead to the large-scale complexity observed in nature.

Does God Play Dice?

Einstein, who published a paper on random Brownian motion, would, I believe, if he were alive today, be fascinated by the discovery of fractal statistics. His coined the metaphor "I am convinced the Old One [God] does not play dice," challenging the statistical interpretation of quantum mechanics, which physicists like Bohr and Schroedinger used to predict the properties of atoms, protons, and electrons. Einstein was working on a unified field theory, which he believed would eliminate the statistical interpretation.

Does God play dice? Yes and No. Yes, if one considers the random nature of evolution and fractal statistics. No, if on considers the nature's globally deterministic laws and rules. Chaos and complexity theorist Joseph answer to this question would be: "God plays dice with the universe, but they're loaded dice." That is, the creative evolutionary process has both randomness (symbolized by dice) and the intelligence of deterministic laws (which load the dice). Like Hindu's Shiva, God plays.

At the American Academy of Religion meeting in San Antonio, Texas on November 22, 2004, I asked Huston Smith whether he had omitted natural selection in his statement: "God could not have created us in his image using the mutations of the genes." He replied that the Darwinian process of mutation and natural selection accounts for the evolution of life from mud over billions of years. We are "mud puppies." But evolution can not account for our being made in the "Image of God." Smith then recalled how Napoleon, during a battle, lamented that his center was not holding and his flanks were in disarray. He reacted by saying: "I will attack." Smith said that religion is in the same situation today. Our center of main line churches is not holding. They are loosing members. The right flank of evangelical conservatives and the left flank of liberal New Agers are in disarray. Religion must also attack the forces of scientism and secularism that acknowledge no reality beyond that of the physical, material world.

Huston Smith's position on evolution is similar to that of the Roman Catholic Church. It accepts evolution as a scientific theory taught in its universities but rejects a Darwinian materialist philosophy that human life is reducible to a mechanistic process. The church asserts instead that humans have an immortal soul.

Theological reflections

The "dice" and "intelligence" metaphor represents the polarity of randomness and law, which characterizes the self-creating natural world. This polarity is in consonance with Taoism and contemporary theology. Paul Tillich believes we have freedom only in polar interdependence with destiny, and nature has spontaneity in polar interdependence with natural law. This interdependence is seen by theologian Gordon Kaufman as the serendipitous creativity of God. Continuing creativity is a common theme for multipolar Process Theology and theologians like Hefner and Teilhard de Chardin. Hefner believes we are created co-creators, and Teilhard de Chardin that evolution is converging toward an Omega Point.

Polarity is an intrinsic part of Taoism: good/evil, male/female, light/dark, etc. Thus, Taoism would accept randomness and deterministic rules as complementing and balancing each other in creative tension.

Theologian Paul Tillich believed that religious truth is expressed by symbol and metaphor, which should not be interpreted literally. Thus, "God plays dice, but the dice are loaded" should be understood as metaphor. Tillich emphasizes that God is not a being, who would be finite and limited, but the ground of all being (nontheistic). Being is all-encompassing and includes both deterministic (law) as well as statistical reality (dice). Evolution is a manifestation of New Being (Haught, 2002). Tillich believed that God's creativity works though spontaneity of creatures and human freedom. This should not be understood as God's miraculous interference. Humans have freedom in polar interdependence with destiny, which are analogues of randomness (spontaneity) and law.

The polar interdependence between chance and law is seen by theologian Gordon Kaufman (1993) as *serendipitous (fortunate) creativity*, which is manifest throughout the universe from the "big bang" on in trajectories. These directional movements emerge in the evolutionary development of the cosmos and of life (including human life) on planet Earth. Serendipitous creativity is a manifestation of God, as in the title of his recent book *IN THE BEGINNING...CREATIVITY.*

Mathematician Alfred North Whitehead's *PROCESS PHILOSOPHY AND THEOLOGY* (1923) is multi-polar in that events occur as the joint product of:

- The entity's past, including its genetic inheritance; (law)
- Its own action, self-creativity and freedom; (chance)
- Divine purpose

Creativity, the principle of novelty, is a universal of process theology. Our freedom eliminates a preordained determinism. God does not coerce but guides and lures the universe in the continuing process of evolution. God does not intervene in discrete events, but is present in all events in a role different from natural causes. God "acts" with and though other entities rather than acting alone (Barbour). The Creator has beautiful vision for the future rather than a deterministic plan (Haught, 2000). God has both a primordial and a consequent nature. In the latter, the creative process affects God. Divine purpose is an inherent part of the evolutionary process.

We are "created co-creators," according to Philip Hefner (1993). God through the process of evolution created us with the freedom and responsibility to contribute to the ongoing process of creation. We are to birth a future that is most wholesome for nature and the human community that birthed us.

Global laws and randomness have analogues in Christianity. Global laws are similar to liturgy, such as the tradition of the Lord's Supper. The whisper of God's grace is beyond our ability to predict and thus has an element of surprise akin to serendipitous randomness. Grace is different from Hinduism's *karma* or cause and effect (Hedrick, 1986).

Grace is when God gives you something you do not deserve,
 in contrast to:
Mercy, in which God keeps you from getting what you deserve.

Teilhard de Chardin, S. J. (1964) sees evolution occurring in the spiritual, as well as the biological realms, and converging towards the Omega Point, the final culmination of the continuing creation in God. The evolution of the earth from geosphere to hydrosphere, atmosphere, biosphere is emerging towards a world-encircling noosphere, created by human hearts and minds: "The end of the world: the wholesale internal introversion upon itself of the noosphere, which has simultaneously reached the uttermost limit of its complexity and centrality. The end of

the world: the overthrow of equilibrium (Heat Death), detaching the mind, fulfilled at last from its material matrix, so that it will henceforth rest with all its weight on God-Omega."

Does God play dice? The "yes/no" insight from fractal geometry is symbolized in the self-similar patterns of the Sierpinski triangle, which can be generated with an algorithm that has both a random and a lawful element. I am amazed that nature's spontaneity and our freedom result in a universe that can have such beauty and harmony. This self-creating universe with both randomness and law is for me a manifestation of divine creativity. Process Theology reminds us that the universe is not static but an evolving and continuing creation, whose intricacies result in continuing scientific discoveries. I pray that we will have the wisdom to use the power of scientific knowledge as responsible created co-creators and not as destroyers of our earth through the unintended consequences of our technology. As created and creating creatures, we can profit from religious wisdom. In it, I find hope that the continuing creation is converging toward its ultimate consummation in the Omega Point.

These theological reflections will be continued in the next Chapter, where we will discuss the tragic beauty that emerges from the suffering and death of the evolutionary process.

chapter 6
A Theology for the Evolution of "Forms Most Beautiful": Haught, Teilhard de Chardin, and Tillich

Life decomposes and out of its throes it recomposes:
it persists in perpetual beauty while it is perpetually perishing.

—Holmes Rolston, III, 1989

Darwin at the conclusion of his *ORIGIN OF THE SPECIES* granted that "life with its several powers, had been originally breathed by the Creator into a few forms or into one."

He nevertheless believed in the evolution of the "forms most beautiful" i.e. the complex life that we see today. Darwin's naturalistic explanation of human origins challenged a literal interpretation of the creation story in the first chapters of Genesis. This started a lively theological debate, which continues to this day.

John Haught of Georgetown University, author of numbers books in including *GOD AFTER DARWIN,* has written a paper (2002) "In Search for a God for Evolution: Paul Tillich and Pierre Teilhard de Chardin," which expresses doubt that Tilllich's rather classical theology of "being" is radical enough to account for the "becoming" of evolution.

Tillich's ontology of "being" includes the polarity of form and dynamics. Dynamics is the potentiality of "being," that is, "becoming."

"Therefore, it is impossible to speak of being without also speaking of becoming." Tillich's dynamic dialectic of being and nonbeing is a more descriptive metaphor for the five mass extinctions of evolutionary history than Teilhard's progress. This dialectic is also a more realistic description of cosmic evolution. Tillich's "Kingdom of God" within history as well as "the End of History," in contrast to Teilhard's Omega Point, does not appear to contradict the Second Law of Thermodynamics, which predicts that the universe will ultimately disintegrate. Haught's contrast/contact modes of relating science and religion would regard Teilhard's Omega Point as an expression of spiritual hope and purpose rather than a scientifically verifiable principle. Tillich saw religion as part of the *vertical dimension* of ultimate concern, and science, as part of the *horizontal dimension* of relationships between finite objects. Tillich did not share Teilhard's optimistic vision of the future. Both Tillich and Teilhard have made contributions to a theology of evolution.

It is interesting to note that Teilhard (1961) did not regard his major work THE PHENOMENON OF MAN as theology! In the introduction he wrote: "If this book is be properly understood, it must be read not as a work on metaphysics, still less of a sort of theological essay, but purely and simply as a scientific treatise." I regard it as being "on the boundary" between science and theology.

Teilhard and Tillich come from different professions and traditions. Teilhard was a geologist, paleontologist, and a Roman Catholic Jesuit who served as a French stretcher-bearer in the First World War. Tillich was a philosopher and theologian, who served as a Lutheran Chaplain in the German Army during World War I. When Hitler came to power, Tillich had the "distinction" of being the first non-Jew to be dismissed. He was head of the Philosophy Department in Frankfurt, Germany. Reinhold Niebuhr then invited Tillich to teach at the Union School of Theology, Columbia University, New York City. Similarly, Teilhard spent the last years of his life in New York City.

The evolution of life

Haught's (2002) paper "In Search of a God for Evolution" states: "Teilhard would still wonder whether the philosophical notion of *being,* even when qualified by the adjective *new,* is itself adequate to contextualize evolution theologically" (p. 539). Haught may have

overlooked Tillich's dynamic dialectic between being and nonbeing used so effectively (1952) in his COURAGE TO BE. Courage is the affirmation of one's own being in spite of the anxiety of nonbeing. The oscillation between being and nonbeing is more realistic metaphor for the mass extinctions of complex life in the evolutionary history of our earth than Teilhard's progress towards an Omega Point. In the last 500 million years, life on earth has undergone five cycles of extinction and rejuvenation, the most familiar being the extinction of the dinosaurs, 65 million years ago (Rolston, 1999). The "nonbeing" of dinosaurs must have been accompanied by massive creaturely suffering, but it made possible the "new being" and "becoming" of the mammals.

Tillich's dialectic of being and nonbeing is also consonant with the birth and explosive death or nonbeing of stars in super novae. Gravitational attraction causes the dust from these to coalesce and *become* new stars with their planets. We are made of stardust. The term "human being" derives from the root word "humus," the fertile soil, decayed organic matter, which came from the nonbeing of plants. The dynamic dialectic of being and nonbeing leads to "new being" and "becoming." (This "new being" is in contrast with Tillich's New Being, the healing power manifest in Jesus the Christ, who reunites our estranged existence with our essential being.) "Being includes and overcomes relative non-being" (Tillich, 1963, p. 25).

Tillich (1967) believed that scientists discover the nature of being: "The work of the scientists is of the highest theological interest insofar as it reveals the logos of being, inner structure of reality... In this sense the witness of science is the witness to God" (p. 458). Tillich's concept of being includes becoming. His structure of being includes the polarity of dynamics and form. There is no being without form. We human beings identify each other by the form of our bodies. Dynamics is the potentiality of being, that is, becoming. Tillich (1951) stated:

> The dynamic character of being implies the tendency of everything to transcend itself and create new forms. At the same time everything tends to conserve its own form as the basis of its self-transcendence....*Therefore, it is impossible to speak of being without also speaking of becoming.* Becoming is just as genuine in the structure of being as is that which remains unchanged in the process of becoming (p. 181).

Tillich in a dialogue with process theologian Charles Hartschorne stated: "I am not disinclined to accept the process-character of being-itself" (Kegley and Bretall, 1961, p. 339).

Tillich (1963A, pp. 15-20; James, 1995) saw the evolution of life as the actualization of potential being. It took a billion years for the inorganic realm to evolve into the organic dimension characterized by self-preserving and self-increasing cells. "The dimension of the organic was potentially present in the inorganic, its actual appearance was dependent on the conditions described by biology and biochemistry" (Tillich, 1963A, p. 20). The "Cambrian Explosion" about 600 million years ago produced conditions which enabled organic cells to actualize their potential to evolve first into animals and then into a being with language. It took tens of thousands of years for the being with the power of language to become the historical humans we know as ourselves.

Tillich's idea of evolution as the actualization potential being can be expressed by the saying:

> We can count the seeds in an apple.
> Only God can count the apples in a seed.

The potential being of a seed is actualized in many apples. The primordial atom or cosmic egg at the beginning of the "big bang" had the potential to become the present universe.

For Teilhard, life is the rise of consciousness. The cultural activity of human hearts and minds is creating a noosphere, which evolved from the biosphere, the atmosphere, the hydrosphere, and the geosphere. Teilhard if he were alive today would have regarded the Internet, which encircles our globe, as a part of the noosphere.

Suffering, death, and tragic beauty

Tillich deals with the theodicy problem of how a compassionate God could have allowed the suffering and loss of, for example, the dinosaurs and similarly for the existence of cancer cells (1951, pp. 269-270; 1963A, p. 404). Tillich believes that God is the ground of novelty and order, yet he allows for freedom in humans and spontaneity in nature. Cancer results from too much spontaneity in nature. The cells just grow wild. Yet spontaneity is the source of creativity of the evolutionary process. Death

is the price we pay for evolution of our intelligence, our complexity, and our individuality. Single cells don't really die. One cell just becomes two.

Tillich believed in a loving God, who gave both nature and us the freedom to make mistakes. Yet God is not disinterested. God suffers with us. In the Christian tradition, it is believed that God cared enough to send his Son to show us how to overcome suffering and death. The power of God's love is stronger than that of death. In summary, God, the ground of all being, which includes all forms of life, participates in the suffering through the symbol of the cross. "God as creative life includes the finite and, with it, nonbeing, although nonbeing is eternally conquered, and the finite is eternally reunited within the infinity of the divine life" (Tillich, 1951, p. 270).

This is expressed in the symbol of the resurrection. The disciples never tried to explain the resurrection but the resurrection explains what happened to them. The worldly wisdom of the Roman Empire was: "Kill the leader and the movement dies." (In a similar manner our government believed that the removal of Sadam Hussein from power in Iraq will lead to a stable democracy in Iraq.) The Jewish historian Josephus described Jesus as the leader of a marginal movement in a marginal province of the Roman Empire. Paradoxically, the resurrection marked the beginning of the Christian movement, which the Roman Empire embraced three hundred years later. The resurrection is a symbol of the power of the Divine overcoming that of death. The death of the old results in humus which seeds new life. My grandfather's dying wish was that his ashes be placed in his beloved rose garden "where it will fertilize something."

There is tragic beauty in the emergence of new life from the death of the old. Tragic beauty is also expressed in the requiems of such composers as Mozart, Brahms, Faure, and Rutter. It is also expressed in paintings of the crucifixion and in sculptor Michelangelo's *Pieta*.

The Harvard philosopher and founder of Process Theology, Alfred N. Whitehead, wrote that "The Adventure of the Universe starts with a dream and reaps tragic beauty" (Last paragraph of Whitehead's (1933) *ADVENTURES OF IDEAS*). He also wrote "Youth is life untouched by tragedy." This was truer for me than for my first wife Karin. When I was three years old, living in Cabot, Vermont, the 1938 hurricane blew down a huge pine tree in our front yard. My little neighbor girlfriends and I used to play "house" in the branches of this fallen tree. We were disappointed when it was taken away.

When Karin was the same age in Berlin, Germany, a bomb destroyed the crib she slept in. Fortunately, when this happened, she, her mother and four siblings were in a bomb shelter. Her father, a physicist like myself, was away working on radar in a German Defense Laboratory. Earlier, he had studied in Berlin where he had meet Einstein. I had to wait till the Second World War ended before I could get my new bicycle. Karin never learned to ride a bicycle. For her and her refugee family from East Germany, getting adequate food and shelter was higher priority.

Karin expressed her sense of tragic beauty by introducing me to Robert Schumann's "Frauenliebe and Leben" ("Women's Love and Life," text by Chamisso). She recorded this after performing as soprano soloist for the Salem Symphony. This song-poem or *lieder* starts with "his ring is on my finger," a joyful celebration of her engagement. Then came the fulfillment of a happy home with beautiful children. For Karin, she had the satisfaction of being able to give her five daughters a more wonderful childhood than she had had herself. She was also writing a book "Dragons from the Sky," which described how the bombs of World War II looked to her as a child. She wanted to document how German children suffered during World War II. "Women's Life and Love" ends with the cruel fate of the husband's untimely death. I experienced the tragedy of her untimely death due to leukemia at age forty-six, after twenty-five years of fruitful and fulfilling marriage. Her death had a tragic beauty, and brought me the challenge of raising our five beautiful daughters ages twelve to twenty-four (see COLOR PLATE 1 and FIGURE 6.1).

Teilhard (1961), in a three-page Appendix to THE PHENOMENON OF MAN, discusses the problem of suffering and death and concludes: "Even in the view of a mere biologist, the evolutionary epic resembles nothing so much as the way of the Cross" (pp. 311-313).

Four ways of relating science and religion

For interpreting Teilhard, Haught's contrast/contact mode, analogous to Barbour's (1977, pp. 77-103) independence mode, is best. Particularly, when Teilhard asserts that a transcendent power drives evolution to higher levels of complexity converging in an Omega Point. Haught's (1995) ways of relating science and religion are: conflict, contrast, contact, and confirmation.

1) Conflict: science and religion are irreconcilable, such as creationism vs. scientism.
2) Contrast: no genuine conflict as they are independent and deal with different questions.
3) Contact: dialogue, interaction, and possible consonance.
4) Confirmation: religion supports and nourishes the scientific enterprise.

In the contrast/contact view, Teilhard's Omega Point is a religious expression of spiritual hope, which motivates and gives meaning to our living. If taken scientifically, it violates the Second Law of Thermodynamics for the increase of cosmic entropy (or disorder) as well as modern cosmology's prediction that the universe will "freeze" as it continues to expand. The metabolism that makes life possible increases the overall entropy of the cosmos. A metaphor for understanding the Second Law of Thermodynamics is the hapless Humpty Dumpty. W. B. Yeats (1921) put it this way: "Things fall apart; the center cannot hold."

In the contrast/contact view, the Omega Point transcends the space-time dimensions of the physical world, and is therefore not subject to the

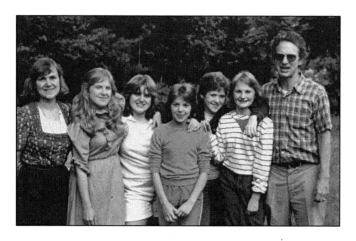

FIGURE 6.1: The author's first wife, Karin Hansen Carr, died at age 46.

The Adventure of the Universe starts with a dream and reaps tragic Beauty.
—Whitehead, 1933

Second Law. The conviction that the universe has direction is not capable of being demonstrated by science according to Teilhard. He believed in spiritual evolution as well as material evolution. He said: "The end of the world: the wholesale introversion upon itself of the noosphere, which has simultaneously reached the uttermost limits of its complexity and its centrality. The end of the world: the overthrow of equilibrium (heat death), will detach the mind, fulfilled at last, from its material matrix, so that it will henceforth rest with all its weight on God-Omega" (1961, p. 287).

```
            R
    S C I E N C E
            L
            I
            G
            I
            O
            N
```

Tillich (1958; 1963B) saw religion as part of the *vertical dimension* of depth, ultimate concern, meaning, and purpose. He regarded science, as part of the *horizontal dimension* of relationships between finite objects. Tillich (1967) states: "Science lives and works in another dimension and therefore cannot interfere with the religious symbols of creation, fulfillment, forgiveness, and incarnation, nor can religion interfere with scientific statements" (p. 456).

"Dimensions cross without disturbing each other; there is no conflict between dimensions" (1963A, p. 15).

Tillich's "End of History" versus Teillhard's "Omega Point"

Tillich's "Kingdom of God" as both the "End of History" and within history is analogous to Teilhard's Omega Point. Tillich's metaphor does not appear to contradict the Second Law of Thermodynamics. The Kingdom of God overcomes historical struggle between being and nonbeing, for power is the symbol for the eternal possibility of resisting non-being, and God exercises this power. Every victory of the Kingdom of God in history is a victory over the disintegrating consequences of the

struggle between being and nonbeing. The final conquest, however, raises the eschatological question, and this is answered by the symbol "End of History," in which the aim of history is achieved. The divine memory judges history by evaluating the negative as negative and the positive as positive. In an eschatological pan-en-theism, all returns to God, its source and ground.

The history of the universe will be remembered in the mind of the eternal. The eternal is not endless time, but is part of the vertical dimension, which transcends space and time. Humanity's eschatological fulfillment is its ongoing existential participation in the "eternal now." We can experience the eternal vertical dimension as a transcendent quality of the present. The fragmentary nature of these transcendent experiences is part of our finitude. This is in contrast with Teilhard's view that history is being drawn by the future Omega Point towards higher and higher consciousness and complexity.

Tillich (1963A) after reading Teilhard's THE PHENOMENON OF MAN, wrote:

> It encouraged me greatly to know that an acknowledged scientist had developed ideas about the dimensions and processes of life so similar to my own. Although I cannot share his rather optimistic vision of the future, I am convinced by his description of the evolutionary process of nature. Of course, theology cannot rest on scientific theory. But it must relate its understanding of man to an understanding of universal nature, for man is a part of nature and statements about nature underlie every statement about him (p. 5).

Tillich reminds us of the danger of having theology rest on scientific theory, which is continually revised and updated as new discoveries are made.

Since Tillich was Protestant and Teilhard, Roman Catholic, it is good to recall Tillich's "Protestant Principle" as being in dialogue with "Catholic Substance." Tillich's Protestant Principle is critical of all forms of absolutism, and this chapter is a critique of Haught's doubt that Tillich's theology of being is radical enough to account for evolution. "Catholic Substance" is the concrete embodiment of spiritual presence, which Teilhard exemplified in his practice of Ignatius' spiritual tradition

of seeing God in all things as well as his writings on evolution. These were so radical that his Jesuit superiors forbade their publication during his lifetime. Tielhard's worldview was contrary to the absolutism of his superiors and thereby an example of the Protestant Principle!

Conclusion

Both Teilhard and Tillich have made contributions to a theology of evolution. However, Tillich did not share Teilhard's optimistic vision of the future. Tillich's "Kingdom of God" within history as well as "the End of History," in contrast to Teilhard's Omega Point, does not appear to contradict the Second Law of Thermodynamics, which predicts that the universe will ultimately disintegrate. Tillich's dynamic dialectic of being and nonbeing is a more descriptive metaphor for the five mass extinctions of evolutionary history than Teilhard's progress towards an Omega Point. Haught's contrast/contact mode of relating science and religion would regard Teilhard's Omega Point as an expression of spiritual hope and purpose in contrast to a scientifically verifiable principle. The contrast/contact position is also consonant with Tillich's *vertical dimension* of religion and *horizontal dimension* of science.

Why do some still doubt Darwin? Could it be that he does not give meaning to death? Yet Darwin knew that the fertile soil, which seeds new life, comes from the death and decay of plants and animals. The death of loved ones can be expressed in the tragic beauty of, for example, a Mozart "Requiem." Thus, Darwin's "evolution of forms most beautiful" is seeded by the death of the old and is hence "tragic beauty."

On a more optimistic note, in the next chapter, we will use Tillich's understanding of theology and culture to illuminate the interactive nature of theology and technology.

chapter 7
The Beauty and Power of Technology Touching Theology

Culture (technology) is the form of religion. Religion (theology) is the substance of culture.

—Paul Tillich, 1963A

The beauty of cathedrals shows the power of technology touching theology. The theology of a transcendent God inspired the construction of these magnificent stone structures, which fill us with reverence and awe. The technology of flying buttresses on the outside walls enabled them to reach "celestial" heights without collapsing. The modern technology of concrete reinforced with a steel skeleton enabled the construction of the beautiful tree-like branches at the top of the columns supporting Gaudi's Sagrada Familia cathedral in Barcelona, Spain. These tree-like structures combined with concrete leaves and sunflowers create a sacred space having the beauty of nature.

Technological know-how and theology, the rational structure of spirituality and religion, have complementary beauty, as expressed in theologian Paul Tillich's (1963A) statement:

> Culture (technology) is the form of religion.
> Religion (theology) is the substance of culture (p. 158).

He meant that our technological culture is the milieu and situation in which the meaning and vision of religion and theology are actualized and implemented (Bulman and Parrella, 2001, p. 235). Tillich believed in correlating questions raised by new technology with answers derived from eternal theological wisdom. He also believed in dialectic relationships, which can be expressed as:

1. Technology touches and influences theology.
2. Theology touches and teaches technology.
3. Technology and theology can interact with beauty and power.

Technology touches theology

Technology touches and influences theology. Science and its resulting technology provide a means for the promulgation of religious

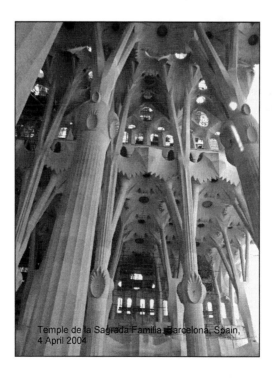

FIGURE 7.1: Gaudi's Sagrada Familia Cathedral, Barcelona, Spain.

beliefs and theology. The roads and maritime technology of the Rome Empire provided the means for missionaries like St. Paul to spread the teachings of Jesus, the leader of a Jewish movement in a minor province of the Roman Empire, throughout its regions. Christianity survived persecution as well as competition from numerous religions to emerge as the state religion under Emperor Constantine in the fourth century. The invention of the printing press fueled the fires of Luther's Protestant Reformation. In a similar manner, modern transportation and communications technology including satellites, optical fiber networks, and the Internet break down national barriers and make religious pluralism the issue of our day. The world religions are all represented on the Internet. The distributed, ubiquitous nature of the Internet has led some to propose it as a model or metaphor for God. "Give me that on-line religion!" (With apologies to the Afro-American hymn "Give me that Old Time Religion.")

The technological conquest of space has challenged theology to revise its metaphor of heaven as a place above the earth. Darwin's theory of evolution as the interplay between chance and necessity, mutation and natural selection has caused theology to reinterpret the creation stories in the first chapters of Genesis. Modern theologians such as Whitehead, Hartschorne, Tillich, Hefner, and Haught have met these challenges in contrast to creationists who still support a literal interpretation of the Bible.

Theology touches and teaches technology

Theology also touches and nurtures technology. Old Testament theology provided a milieu for the goodness of the material world, in contrast with the inner contemplation and enlightenment. A monotheistic God created the material world as "good" and therefore worthy of being investigated. "It was good," is a recurring theme in the first chapter of Genesis. The God of the Bible was consistent and honored His covenant, in contrast with the capriciousness of polytheistic gods. This consistency contributed to the emergence of the natural laws of science, whose fruit is technology. For example, Isaac Newton's laws of motion and gravity are always present and can not be "turned off" to explain something new. Newton himself was motivated by a desire to decipher the clues about God's creation. The created natural world is

contingent and therefore non-deducible from logical principles. The world must therefore be discovered and investigated by empirical science.

Theology has nurtured technology by establishing colleges and universities. The Congregationalist Pilgrim Fathers established Harvard University in 1636 to train ministers in the New World rather than in the Old. Harvard University has matured to produce many Nobel Prize winners in the sciences. Roman Catholics have established many institutions of higher learning: Notre Dame, Georgetown University, Boston College, Loyola Marymount, and Holy Cross; Methodists have established Boston University and Drew, etc.

The Roman Catholic Church supports the Vatican's astronomical observatory located both in Italy and Arizona. In the sixteenth century it also supported research to better align the date of Easter with the spring equinox and the full moon, giving rise to our current Gregorian calendar (Heilbron, 1999).

Mohammed's theology and leadership transformed Islam into a predominant medieval culture (Smith, 1991, p. 222), which made substantial contributions to mathematics and astronomy. Muslim scholars (Ahmad, 1992) developed the "Arabic Numerals" we use today, which include the use of zero as a place-holder, a concept that that came from India. Abu al-Uqlidisi of Damascus introduced the idea of decimal fractions in A.D. 950. The world "algebra" derives from the Arabic word *al-jabr.*

The Muslims were leaders in empirical astronomy. Their observation did not always agree with those predicted by the Ptolemaic system. The Muslim empirical natural philosophy differed sharply from the Greek deductive philosophy, which asserted that natural observations could be derived from foundational principles. Thus, the empiricism of Bacon and the astronomy of Copernicus, Kepler, and Galileo had their roots in Islamic Science nurtured by Mohammed's theology.

Theology can provide a future vision for technology. The hymn "Turn Back, O Man, Foreswear Thy Foolish Ways," ends with "Earth shall be fair, and all her folk be one!" Clifford Bax, born in 1886, wrote this hymn. Anthropologist Margaret Mead at the Institute of Religion in an Age of Science Conference (IRAS, 1969) Star Island, Portsmouth, New Hampshire said that this hymn was written long before we had the global electronic communications technology to enable "all her folk be one" (1970). Teilhard de Chardin envisions the universe as evolving

towards greater complexity, culminating in an Omega Point. Thus, theology touches and teaches technology.

Technology and theology interact with beauty and power

Technology and theology can interact resulting in beautiful cathedrals described in the introduction. Technology and science are also influencing our concepts of artistic beauty, as described in Chapter 2. Modern technology and science, which was nurtured by theology, has given us the nuclear power as well as the ability to fly and explore space.

The interactive power of technology and theology is expressed in physicist-psychologist K. Helmut Reich's (2002) Relational Contextual Reasoning (RCR) and in physicist-theologian Robert Russell's (2001, p.261) Method of Creative Mutual Interaction (MCMI). RCR emphasizes the interdependence between theology and technology, the links between them, and the situation and context in which they interact. Reich's RCR is grounded on physicist-philosopher Niels Bohr's complementary principle, which resolved apparent conflicts between the wave and particle nature of light as well as that of electrons and other fundamental particles. The wave nature of light explains the diffraction maxima and minima of light passing through two slits. The particle nature of light is evident from the pulses or bursts from an electric device detecting low intensity light. The wave nature of light complements the particle nature. They are context dependent. Both are needed for a complete description. Niels Bohr also said that the opposite of a deep truth also contains a deep truth.

Reich's RCR expands complementarity to recognize the complexity of interactions, transcends binary logic (either/or), and shares components with dialectical and analogical reasoning. The RCR method consists of: (1) listing all possible explanations and descriptions, (2) looking for links and interactions which may lead to new explanation sand insights, and (3) resolving conflicting explanations. RCR rules out black and white, binary, thinking. RCR can resolve issues of nature versus nurture as well as human versus mechanical error in nuclear reactor accidents.

Physicist-theologian Robert Russell's (2001, p. 261) method of Creative Mutual Interaction (MCMI) expands Paul Tillich's Method of correlating existential questions with eternal religious truth and wisdom.

MCMI also builds upon Ian Barbour's (1997, p. 106) similarity between scientific and theological methodology. Scientific theories influence decisions as to what new data are relevant. Imagination and creative insights synthesize the data into new and or modified theories. The criteria for evaluating theories are coherence, scope, fertility, prediction of new phenomena, and beauty. Similarly, theological doctrines influence the interpretation of life experiences. Revelation and creativity give new meaning to life experiences, which lead to new and modified doctrines. The criteria for deciding between rival doctrines are tradition, scripture, wisdom, beauty, popular credibility and acceptance, and unfortunately conflicts and war. Religious doctrines deal with matters of ultimate concern. Historically, the different doctrines of Roman Catholics and Protestants, coupled with nationalistic and economic issues, have led to conflicts and wars, most recently in Northern Ireland. Relational Contextual Reasoning's method for resolving cognitive conflicts needs to be expanded to mediate religious conflicts.

Creative Mutual Interaction is needed to resolve the ethical issues that arise from new technology. Technology by itself is morally ambiguous: it can be used for good or evil. Theology promotes ethical norms and values. Cell phone technology can enable a person who has a heart attack on a busy highway to get life saving help. Cell phones can also interrupt the serenity of a worship service or a symphony concert. These disturbances can be mediated by the ethic of "loving your neighbor as yourself."

The discovery of nuclear fission led to the development of both nuclear reactors and of bombs. The ethic "an eye for an eye, and a tooth for at tooth," may have justified the use of the dropping of the atom bomb on Japan, which ended World War II. The ethic "love your neighbor as yourself," helped motivate the nuclear nonproliferation treaty.

Conclusion

Technology and theology interact with beauty and power. Technology touches theology and visa-versa. Technology provides the communications infrastructure for the promulgation of religious beliefs from the roads and maritime technology of the Roman Empire to the Internet.

Theology touches technology by creating metaphors for the goodness of the material world and for consistency and openness. Theology has motivated the establishment of universities, which have birthed new science and resulting technology. Mohammed's theology and leadership transformed Islam to a predominant medieval culture, which developed the Arabic number system we use today.

A final example of the power of technology and theology to beautify human relations was the abolishment of slavery. Technology now performs most of the tasks formerly done by slaves. Household examples include washing and sewing machines, vacuum cleaners, and dishwashers. During the American Civil war, religious leaders in the North were influential in motivating soldiers to fight to free the Afro-American slaves in the South. This was done in spite of the fact that the Bible accepted slavery as part of the way of living in the Roman Empire. The apostle Paul, in his Epistle to the Colossians, stated: "Slaves, obey in everything your earthly masters, not with eye service, as men-pleasers, but in singleness of heart, fearing the Lord" (3:22). In the Epistle to Philemon, Paul sends the slave Onesimus back to serve Philemon, his original master: "No longer as a slave but more than a slave, as a beloved brother" (1:16). Technology played a major role in releasing "beloved brothers" from the laborious tasks that slaves were required to perform. Theology helped to motivate and justify the difficult transition from slavery to freedom during the American Civil War.

Dr. Martin Luther King, Jr., who did his doctoral thesis on Paul Tillich at Boston University School of Theology in 1955 and in the 1960s led the Afro-American movement for social and economic equality, gave us the challenge (1965):

> Through our scientific genius we have made the world a neighborhood; now through our moral and spiritual development, we must make of it a brotherhood. In a real sense, we must learn to live together as brothers, or we will perish together as fools.

In the next chapter we will see the complementary beauty of technology and theology in the Holy Land, which has contributed so much to our moral and spiritual development.

Chapter 8
The Beautiful Holy Land:
Spirituality and Science

The people were all so amazed.

—Mark 1:27

In Israel, spirituality (theology) and science (technology) collaborate with beauty and power. Spirituality, theology, and historical tradition helped to motivate the establishment of the democratic Israel to provide a homeland for the Jews. Modern science and technology enable its defense. Israel's "high-tech" weapons were key to winning the wars, which threatened its existence. Modern irrigation technology enables the distribution of water from the beautiful Lake of Galilee to make the desert bloom with enough food to support the expanded population of six million people.

Seeing the abundant fields of yellow mustard blowing in the wind from the Mount of the Beatitude (see COLOR PLATE 16 and FIGURE 8.1) I could hear Jesus saying: "Consider the lilies of the field, how they grow; they neither toil nor spin; yet I tell you, even Solomon in all his glory was not arrayed like one of these" (Matt. 6:28).

I had this mountain-top experience in March 1997 during a Gordon College Pilgrimage, in which we followed the path of Jesus from Galilee to Jerusalem. This pilgrimage to the sites of Jesus' ministry was my "Galilean Experience," along the shores of the beautiful blue, mountain-

surrounded Lake of Galilee. The March flowers were breathlessly beautiful. We visited religious sites and the ancient cities, Megido, Beth-Shean, and Jericho, which go back to the beginning of civilization, 10,000 years ago. Israel is indeed a land of contrast between the ancient and the modern, spirituality and science, and beauty and terror.

In February 1993, the U.S. Embassy and the Israeli Ministry of Defense guided our Rome Laboratory delegation in developing cooperative research and development programs. We visited a wide variety of organizations: from the Weitzman Institute of Science doing basic research and the Technion, Israel Institute of Technology, to companies like Elta Electronic Industries, which produce airborne radars. This "high tech" science and technology tour will be described in more detail after the following account of my 1997 Pilgrimage.

Spirituality, my pilgrimage

On my 1997 Gordon College Pilgrimage, I walked where Jesus walked, sailed on the Sea of Galilee, and was inspired by beautiful sunrises. I visited historic Capernaum on the lake near the place were Jesus called fishermen to be his disciples, healed Peter's mother-in-law,

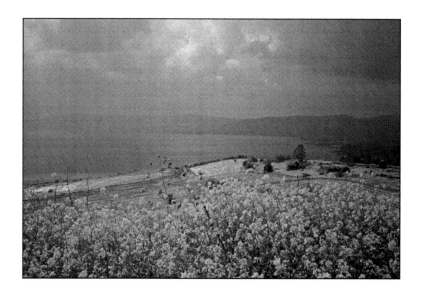

FIGURE 8.1: Lake of Galilee from the Mount of the Beatitudes.

and preached in the synagogue. I stood among the remaining columns of the synagogue that was built over the one in which He taught. I was deeply moved by singing in the church at nearby Tabgha, which has a beautiful mosaic commemorating the miracle of Jesus feeding the Multitude of Five Thousand Men. At the Mount of the Beatitudes, I could envision Jesus teaching the crowds from the steep hillsides that form a natural amphitheater above the lake. The climax of our Pilgrimage was a communion service held among the blooming flowers and shrubs of the Garden Tomb in Jerusalem, which is a beautiful setting for the resurrection stories commemorated at Easter. The Bible Stories seemed more real than they ever did before.

Scholars have varying opinions as to the historical validity of religious sites. Opinions range from provable, probable or possible, to preposterous. After the Roman Emperor Constantine converted to Christianity in the fourth century, he sent his mother on a trip to the Holy Land. Christians told her the location of sites; where, for example, the Church of the Nativity in Bethlehem was built.

Excavations from *tels* or mounds next to ancient cities like Megido, (above the plains of Armageddon), Beth-Shean, and Jericho go back about 10,000 years to the beginning of civilization. These cities were strategically located along trade routes, had sources of water, were defensible, and had fertile fields for the emergence of agriculture. Recent excavations near *Tel Dan*, at the base of snow-capped Mt. Hermon in Northern Israel, reveal the gate of an ancient city walled with mud bricks. Abraham may well have entered the "Promised Land" in about 1700 B.C. through this gate. We later visited the beautiful Jerusalem Mosque of Omar, known as the "Dome of the Rock," built A.D. 691 over the rock where Abraham was prepared to sacrifice Ishmael (Muslim) or Isaac (Jewish). The mosaics on the walls and floors were exquisite. In the tunnel along the Western Wall at the site closest to this rock, our young Jewish guide spoke reverently about which she believed was the "Holy of Holies" of Herod's Temple. This was destroyed in A.D. 70 by the Romans as they quelled the Machabee revolt. The conflicts between the Jews and the Palestinians, which make the front page of our newspapers, is a daily reminder of the continuing need of reconciliation between Jews, Muslims, and Christians. They all acknowledge Abraham as their father.

St. Paul states: "God was in Christ, reconciling the world to himself" (2 Cor. 5:19). Even though Jesus' Kingdom was not "of this world," it is

noteworthy that he was closest to, or had the greatest dialogue with, the Pharisees. Indeed, St. Paul himself was a Pharisee, who had a conversion experience on the road to Damascus where he intended to arrest Christians! The Pharisees took a middle position in reacting to the Roman rule. The Sadducees cooperated with the Romans, and gained worldly wealth and power thereby. The Essenes and the Zealots expressed the "flight" and "fight" response respectively. The former withdrew to the monastic solitude of Qumran on the Dead Sea, while the latter lead the unsuccessful revolt of A.D. 70, which ended with the Romans destroying the temple in Jerusalem and capturing Herod's fortress of Masada. The night before its capture, the Jewish defenders all committed suicide to avoid torture and slavery.

Our 1997 pilgrimage was ably led by Gordon Professors Roger Green and Marvin Wilson. The latter authored (1989) *OUR FATHER ABRAHAM: JEWISH ROOTS OF THE CHRISTIAN FAITH*. As we passed from Israel to areas controlled by the new Palestinian Authority, such as Jericho and Bethlehem, I was glad to have such experienced and knowledgeable leaders, as well as our guide from Jerusalem. He was a scholar in the Hebraic background of the Scripture. His reading of Bible passages at the places where they happened was most meaningful and inspiring. His reading of Psalm 23, "The Lord is my Shepherd," as we watched the Bedouins graze their sheep and goats, gave it a deeper meaning. The pilgrimage also included Masada and the Dead Sea Scrolls discovered at Qumran in 1947. Israel is indeed a land of contrast: between Jerusalem and Galilee, the modern and the ancient, beauty and terror, and the sacred and science, which we will now discuss.

Science and technology

The US Embassy and the Israeli Ministry of Defense, Directorate of Defense Research and Development, guided our Rome Laboratory Delegation in developing cooperative research and development with industry and universities in February 1993. In Haifa, I made contact with scientists at the Rafael Company. They were familiar with my research on Surface Acoustic Waves (SAW) from papers that I had presented at the International Ultrasonics Symposium in the United States. I also visited Professor Koren, at the Technion, Israel Institute of Technology, Haifa. He described his world-class research on high-temperature

superconducting diodes. This visit resulted in a cooperative research program with my Component Technology Branch. In 1995, we published a jointly authored paper in the *Journal of Superconductivity*.

In 1993, at the Elta Electronic Industries LTD, Ashdod, I met an antenna engineer, who is the daughter of Walter Rotman of my laboratory. He is the inventor of the "Rotman Lens," which is used in many microwave systems. His daughter worked as an antenna engineer on an advanced Airborne Warning and Control System (AWACS). I also visited the Soreq Research Center, the Weizmann Institute of Science, and the El-Op and Elbit Companies. Our Rome Laboratory Delegation was ably led by Dr. Harold Roth, then head of the Solid-State Sciences Directorate. He learned Hebrew as a boy and had previously visited Israel with his family. I also met a Brigadier-General (and Ph.D.), who was Director of Israel's Defense Research and Development, at a reception held at the U.S. Air Force Attaché's home north of Tel Aviv. After he escorted the Brigadier-General to the door at the end of the evening, the Air Attaché exclaimed: "He had a gun in the pocket of his jacket!"

Israeli science is indeed world class. Israeli scientists visit American and European laboratories and teach in our universities. They serve as hosts for reciprocal visits. Israelis own many American small businesses. Israel is also the site of international scientific meetings, such as the International Conference on High-Power Electromagnetics: EUROM '98, Tel Aviv, June 14-19, 1998. These international meetings symbolize the global nature of the scientific quest of knowledge and truth, which transcend barriers of nation, culture, tradition, and religion.

Modern science arose in the West, rather than the East. This development may well be traceable to the affirmation of the first chapter of Genesis that the material world is good. Its goodness implies that it is worth studying.

The beauty and power of spirituality and science

In democratic Israel, the beauty and power of spirituality (theology) and science (technology) is evident in its rich religious and technological diversity. Jewish diversity ranges from conservative, rule-following Hasidic Jews to the liberal secular. Many Arabs have become citizens of Israel. Some Jews have been converted to Christianity. The

ancient walled section of Jerusalem is divided into four communities: Jewish, Christian, Armenian Christian, and Moslem. There is wide technological diversity, from the Weizmann Institute of Science, doing basic research, and the Technion, Israel Institute of Technology, to companies like Elta Electronic Industries, which produce airborne radars. Science and technology thrive in a society that allows freedom of thought.

The world needs the global quest for truth symbolized by international scientific meetings, which transcend barriers of nation, culture, tradition, and religion. Science has its changing paradigms and revolutions (Kuhn, 1970), but at least they have been bloodless. Nevertheless, as funding for research and development is downsized, the scientific community has become more sensitive to the political activity of the creationists and of pseudo scientists. This is expressed in Carl Sagan's (1997) book THE DEMON-HAUNTED WORLD: SCIENCE AS A CANDLE IN THE DARK.

The threat of demons is not new. The first chapter of Mark, written about A.D. 70, describes the following encounter that occurred in Capernaum, on the shores of Lake Galilee, as Jesus was teaching in the synagogue:

> Just then a man with an evil spirit in him came into the synagogue and screamed: "'What do you want with us, Jesus of Nazareth? Are you here to destroy us? I know who your are: you are God's holy messenger!" Jesus commanded the spirit, "Be quiet, and come out of the man!" The evil spirit shook the man, gave a loud scream, and came out of him. The people were all so amazed... (1:23-27).

Healing stories such as this are difficult to understand to terms of modern science. They are paradoxical, not what is expected in ordinary human experience. It is easier for me to relate to theologian Paul Tillich's definition of the demonic as "creativity turned negative." Tillich himself encountered the power of the demonic in 1933, when the Nazis dismissed him from his position the philosophical faculty in Frankfurt, Germany. Tillich's SYSTEMATIC THEOLOGY, written in America, describes the basic Christian message as paradoxical. His obituary in 1965 read: "love is stronger than death (or the demonic)." Truth can be paradoxical and multidimensional. We can still be open to amazement!

The Holy Land, where the cooperation between spirituality and science is so productive, is in stark contrast to the next chapter, where technology is working without spiritual and moral constraint.

Chapter 9
The Beauty of Nature versus Its Utility: The Environmental Challenge

We are learning by bitter experience that the organism which destroys its environment destroys itself.... This can only be corrected by the enormous discovery of those relations in nature, which make up the beauty of nature

—Gregory Bateson, 2004

The intrinsic beauty and value of nature is continually being ignored by those who want to use it. For example, consider the proposal to drill more oil wells in Alaska. The environmental challenge is to balance ecology with economics. Technology working without theological moral constraint can destroy nature's beauty. Conservation and stewardship are needed to find an appropriate balance between the preservation of the intrinsic beauty of nature in its pristine state with its use. Knowledge of the earth sciences coupled with the forces of spiritual values can hopefully lead to a new global ethic and vision to conserve nature's beauty for future generations. The consecration and conservation of Thoreau's Walden Pond is an environmental success story.

The challenge: EARTH ON EDGE

Bill Moyers' (2001) report EARTH ON EDGE documented how the world's six billion people are challenging the earth's ability to support

nature and civilization. We have already depleted 70% of the world's major marine fisheries and chopped down half of the world's forests. According to the articles "End of Cheap Oil" (Campbell, 1998; Appenzeller, 2004) and the book BEYOND OIL (Deffeyes, 2005), we have already used a significant fraction of our nonrenewable oil and gas energy sources, which took hundreds of millions of years to form. The recent increases in the cost of oil and gasoline will continue in the next decades, because the limited supply is being depleted as the world's demand increases.

From 1973 to 1980, the tripling of oil prices, together with waiting in line to buy gasoline, got people's attention and caused them to conserve and be more energy efficient. For example, during this time the United States increased the average gas mileage of passenger cars from 15 to 24 miles per gallon. At the same time, federal and state tax incentives increased the use of solar hot water heaters (See FIGURE 9.1).

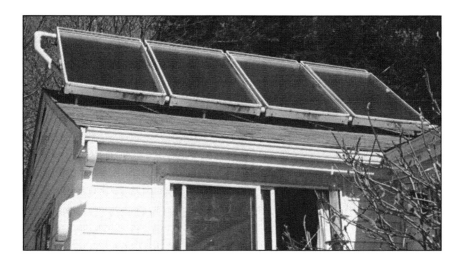

FIGURE 9.1: Solar collectors for hot water heating, installed on the author's home, April 1980. Sunlight, passing through glass on the top, is absorbed by blackened copper plates on the bottom of the collectors. The heat or infra-red radiation is trapped by the glass plate and is absorbed by antifreeze that is circulated through channels in the copper plates. The antifreeze is circulated to a heat exchanger in a hot water tank in the cellar.

Have we been "cooking" in complacency? From 1980 to 2000, oil prices have been relatively stable. This, together with the Reagan Administration's repeal of the solar tax rebates, has discouraged the installation of new collectors. In addition, the fuel economy of our vehicles has decreased from 26 miles per gallon in 1986 to 24 mpg in 2000 because people have been buying more and more light trucks and sport utility vehicles. Have we responded like a frog thrown into a pot of hot water? The temperature shock makes him jump out, however, if the water temperature is increased slowly, he will cook. Hopefully the doubling of gasoline prices in the last few years will keep us from being "cooked" in complacency. (Note: Al Gore uses this same analogy in his movie and book, AN INCONVENIENT TRUTH, 2006).

The United States per capita oil consumption averages 3 gallons per day, compared to 1.4 gallons among other industrialized nations (EPA 2000, 2006). The U.S. and Canada are the only countries that use more oil for transportation than heat or power. Apart from issues of social justice and sustainability, the large dependence on fossil fuels makes the United States economy most vulnerable to prices increases. Japan, Sweden, and Switzerland have modern, efficient railroads as well as substantial hydropower. As the cost of energy increases, the cost of constructing a more energy efficient, low carbon emitting infrastructure will increase (Bedec and Wendling, 2005).

According to the story of Noah in Genesis 6, the Lord saw how wicked and evil everyone was. He was so filled with regret for having made humans that He destroyed them with a flood. Noah saw the rainbow in the sky as the seal of the covenant that God would never flood the earth again. There were so few humans then that it was impossible for them to impact their environment and thereby break their responsibility to the covenant. Now with the world's six billion people polluting our atmosphere with seven billion tons of carbon dioxide per year, we have the potential to create our own flood. Carbon dioxide traps the sun's heat at the Earth's surface like the glass in a greenhouse. In February 2001, the United Nations Intergovernmental Panel on Climate Change concluded (Houghton et al, 2001): "There is new and stronger evidence that most of the warming observed over the last fifty years is due to human activities."

The burning of fossil fuels produces the seven billion tons of carbon dioxide. Every automobile driver is involved. For every 10,000 miles driven, the automobile emits tons of carbon dioxide.

In the past two decades, average temperatures have climbed as much as 7°F in the arctic. "The Big Meltdown" article in the September 4, 2000 issue of *TIME* Magazine (Linden, pp. 53-56) reported that sea ice is 40% thinner and covers 6% less area than in 1980. Permafrost is becoming less permanent. The glaciers are retreating as we turn up the heat. If this and the melting of the polar icecaps continue, the sea level will rise and flood low-lying islands and peninsulas, such as Cape Cod, Massachusetts and most of Florida (Gore, 2006). When this happens, the loss of valuable shoreline real estate will cause us to take drastic measures. Unfortunately, it will take a century for these measures to reverse the present trends. Climate models show that the increased energy of global warming can cause weather extremes, like excessive flooding, draughts, crop failures, and hurricanes (Carr, 2004).

The United States, with only 5% of the world's population, produces 23% of the world's carbon dioxide emissions. The United States emission of 6.6 tons of greenhouse gases per person per year is the largest in the world: twice that of Japan, and three times that of Sweden and Switzerland. How could we meet the requirements of the Kyoto Accord that the US decrease its greenhouse gas emissions by 7% before 2010?

We should support the United Nations Environmental Program, whose director, Adnan Z. Amin, (2000) states:

> The UN Environmental Program aims at transforming our fundamental relationship with the earth from one of destruction to redemption by combining our knowledge of the earth sciences with the forces of spiritual values.

Knowledge of the Earth Sciences

Science, whose technology has unintentionally caused the environmental crisis, should cooperate with the forces of spiritual values to conserve nature's beauty and resources. Science can give the expertise. The forces of spiritual values can contribute the wisdom, motivation, and global ethic for rectification.

Science tells us that we can reduce the emission greenhouse gases by using passive and active solar energy for heating and by generating electricity with windmills, semiconducting solar cells, and hydropower. Windmills are more economical than solar cells at present. Europe gets more electricity from wind than the United States. Organizations, which regard wind farms as an unsightly change in the natural environment, have delayed their development on the shoals between Cape Cod, Massachusetts and Nantucket.

Nuclear fission power plants do not emit greenhouse gases, although the disposal of nuclear waste, which is radioactive for centuries, remains a challenge. Fusion power by combining hydrogen and deuterium nuclei to form helium and higher elements, as in our sun, has no nuclear waste. Containers are needed that do not melt at solar temperatures at which fusion takes place. The international research and development effort to use nuclear fusion for generating electricity projects that a prototype will be available in 2030.

Cold fusion, the electrolysis of deuterium, was first proposed by Fleischmann and Pons in 1989. They claimed that excess energy was generated at the palladium electrode. This potential of cold fusion to produce energy without the high temperatures of hot fusion and the waste problems of nuclear fission reactors motivated many laboratories to reproduce the Fleischmann and Pons results. These attempts were initially unsuccessful. However, small scale efforts have continued and been reported at international conferences over the last ten years, as described by Charles Beaudette's book EXCESS HEAT: WHY COLD FUSION RESEARCH PREVAILED. The production of excess heat is critically dependent on the preparation of the surface of the palladium electrode. The apparent ability of palladium to catalyze the fusion of two deuterium nuclei into helium will hopefully be understood and reproduced well enough to make cold fusion a practical source of energy at some time in the future.

New hybrid electric automobiles are more fuel-efficient than our present internal combustion engines, but batteries are expensive. The ideal way to generate energy without carbon dioxide is to combine hydrogen with oxygen. The only byproduct is water. Fuel cells based on this same reaction can store electrical energy in a smaller space than conventional lead-acid batteries. Technology for the economical generation, storing, and distribution of hydrogen must be developed. At

present, the most economical method for generating hydrogen is the gasification of coal.

Lawrence Berkeley National Laboratory made a study (Koomey, 2001) and concluded that a sense of urgency resulting in: (1) the sale of tradable carbon emission permits of $50/tC, (2) conservation, and (3) increased research and development can enable us to stabilize our increasing carbon emissions. The carbon emission tax gives an economic incentive to develop and favor nonpolluting solar, hydro, wind power, and fuel cells. It also discourages the use of coal, which emits twice as much carbon dioxide as natural gas as well as the radioactive pollutants in acid rain.

The United Nations Intergovernmental Panel on Climate Change estimates that the industrialized countries could achieve these goals at a cost of no more than 2% of the gross national product. Chet Raymo (2001) spends about 2% of the value of his home in the Bahamas for hurricane insurance. He recommends that we as a nation do the same "to protect ourselves against the potentially severe economic and environmental consequences of global warming."

The forces of spiritual values

Dr. Martin Luther King, Jr., who earned his Doctorate in Systematic Theology from Boston University in 1955, said in a commencement address at Oberlin College (1965):

> Through our scientific genius we have made the world a neighborhood; now through our moral and spiritual development, we must make of it a brotherhood. In real sense, we must learn to live together as brothers, or will perish together as fools.

This statement intended for the brotherhood between the races is equally valid for our brotherhood and sisterhood with all the species and our communion with nature and the earth. Martin Luther King's activism, as well as the sacrifice of his life for the brotherhood in which he believed, can be a model for what we must do to prevent environmental disasters. Martin Luther King, in his social activism, was influenced by Henry David Thoreau

As the world's population increases, the supply of drinking water decreases. The water used for baptism symbolizes cleansing from our sins. Process theologian Marjorie Hewitt Suchocki (1982), defines sin as: (a) the violation of relationships, (b) the absolutizing of the self and the denial of *interdependence*, and (c) the rebellion against the creation. This environmentally responsible interpretation of sin should be incorporated into our liturgy as well as our religious education. Our environmental sin is that of omission rather than commission, of ignorance and neglect rather than bad intention. Nevertheless, ignorance of the law is no excuse.

How are we to interpret this passage from Genesis?

> Then God said, "Let us make man in our image, after our likeness, and let them have dominion over...every living thing that moves upon the earth" (1:26-28).

Does "dominion" lead to conscience and moral responsibility for our environment? Consider three answers to this question.

1) *No.* "Dominion" has not led us to an environmental ethic. Biblical "dominion" can be interpreted as self-centered, self-serving, and anthropocentric. This has led us to plunder our environment. In the twentieth century, we have depleted a significant portion of nonrenewable fossil fuels that took hundreds of millions of years to form. The burning of these fuels contributes to global warming. The biblical story has got us in trouble and needs to be replaced by the scientific story of the origin and evolution of the cosmos and the earth (Swimme and Berry, 1992; Rue, 2000). The global scientific community is the source of this story, which transcends national, cultural, and religious differences.

2) *YES, BUT:* The creationists say that the Bible is the inspired word of God and is literally true. *BUT* when its ancient cosmology disagrees with modern science, the creationists question science and try to suppress it.

3) *YES.* Dominion leads to consciousness and moral responsibly for the beauty of the earth.

As creating creatures (or beings,) our covenant with God requires us to be responsible stewards of all nature, which is God's creation. Modern science is increasing our knowledge and power. The scientific community is called back to a re-evaluation of its complicity in creating a system that has fostered dominion over the environment rather than cooperation with it. Technological advancements have often been void of public concern and the theological precepts voiced in Genesis. By re-establishing a connection with the original ideas of conventional theology, the scientific community can reclaim the moral high ground.

A global ethic and vision

The challenge of global warming and environmental destruction requires a global ethic. Holmes Roltson, III (1989, 1999), the father of environmental ethics and winner of the 2003 Templeton Prize for Progress toward Spiritual Realities, rejects anthropocentrism in the ethical and philosophical analysis of natural history.

He believes instead that respect for nature's intrinsic value should lead to reverence (Jansen, 2005). Life is generated and regenerated in the birth of the new from the death of the old. Live is also a gift, which suggests a giver. The origin of life is also a mystery and a source of scientific discovery. Rolston believes that nature is the vast miracle that moves us from respect to reverence.

Ursula Goodenough (1988) in her *THE SACRED DEPTHS OF NATURE* states:

> If religious emotions can be elicited by natural reality... then the story of Nature has the potential to serve as the cosmos for the global ethos that we need to articulate
>
> It must be a global project. I am convinced that the project can be undertaken only if we all experience a solemn gratitude that (1) we exist at all, (2) share a reverence for how life works, and (3) acknowledge a deep and complex imperative that life continue. A global ethic must be anchored

both in an understanding of human nature and in an understanding of the rest of Nature.

"Reverence for Life" was Albert Schweitzer's (1931) global ethic. Schweitzer was famous as an organist and a Bach musicologist. He performed on all the famous organs of Europe. His seminal book THE QUEST FOR THE HISTORICAL JESUS established him as a well-known theologian. For most of us, this worldly recognition would have been enough, but not for Schweitzer. His desire to help people in a "hands-on" manner, prompted him to obtain a M.D. degree and to become a medical missionary in Lambarene, Gabon, Africa.

He was not welcomed with open arms, however. The conservative missionary commission was critical of his liberal theological views. The only way he could obtain their approval was to promise that he would do medicine and not theology. This led him to say that if you want to do good in the world, do not expect others to roll stones out of your path. They may do just the opposite. During the World War I, he and his wife almost died in a prisoner of war camp, because they were of German nationality in a French Colony. Having experienced two World Wars, he developed his ethic of *The Reverence for Life*, which shows to all with the will-to-live the same reverence as he did to his own life. His hope was that this "reverence for life" would prevent further world wars and bloodshed.

> I am life which wills to live, in the midst of life which wills to live. If I am a thinking being, I must regard life other than my own with equal reverence. Therefore, I see evil is what annihilates, hampers, or hinders life. Goodness, by the same token, is the saving or helping of life, the enabling of life so it can to attain its highest development.
>
> Once man begins to think about the mystery of his life and the links connecting him with the life that fills the world, he cannot but accept, for his own life and all other life that surrounds him, the principle of Reverence for Life. He will act according to this principle of the ethical affirmation of life in everything he does.

Albert Schweitzer's *Reverence for Life* is similar to Brian Swimme's *Comprehensive Compassion*. Brian Swimme, Ph.D. is a mathematical cosmologist and co-author of THE UNIVERSE STORY (1992). *Comprehensive Compassion* is the activation of concern and care beyond that of our evolutionary kin-affinity. It is like "So what if you love your friends, but what about those you do not know or even your enemies?" The challenge is to care for and love all of humanity, not only now but 10,000 years into to future.

Cosmologist Brian Swimme believes we need a new cosmic vision for wisdom to stop our destruction of the *macrosphere* by pollution and consumerism. We focus too much on new-term *microsphere* issues. The difficulty is that the human species has *macrophase* power and is attempting to organize it with the *microphase* wisdom of our evolutionary past. The universe has in a real sense assembled us. We must now learn to take on the mind of the universe and to deepen our souls. This results in a deeper awe of existence. We must experience a different form of energy that is transmaterial. It doesn't decrease when you share it, like a commodity. As a matter of fact, it increases. As we develop the skill through the imagination for accessing this ocean of energy that we call awe or zest, it will multiply as we share it. As we do, it will lessen our need for commodities.

An ethical norm for the United Nations is deference to the integrity of nature. Scientists have ways of measuring the integrity of nature. If human modifications were to completely destroy a native species, then the integrity of nature would be broken and modification would be unethical. On the other hand, if the species could return to its native state, then modification would be ethical. Deference to the integrity of nature is an ethical basis for conserving nature's beauty.

The international Forum on Religion and Ecology (Tucker and Grim, 2006) has explored how all the world's religions can develop a comprehensive ethic of respect for nature.

Consecration and conservation: Walden Pond as a sacred site

Thoreau, after walking through his neighborhood of Concord, Massachusetts, wrote in his journal the following account of a summer evening, July 21, 1851 at 8:30 PM:

The streets of the village are much more interesting to me at
this hour of a summer evening than by day. Neighbors, and
also farmers, come a-shopping after their day's haying, are
chatting in the streets, and I hear the sounds of many musical
instruments, and of the singing from various houses. For a
short hour or two, the inhabitants are sensibly employed. The
evening is devoted to poetry, such as the villagers can
appreciate (1936).

Let us compare in our minds this beautiful, pastoral and culturally
rich image of what Concord was like in 1851 with what it is like now.
What do we do on warm summer evenings? Many of us sit in air-
conditioned homes and watch television. Has the higher energy
consumption of our present lifestyle produced greater happiness?

Thoreau (1854) in WALDEN, noting that our lives are frittered away
by detail and are ruined by luxury and heedless expense, concluded:
"Simplify, Simplify." He lived simply by building a hut on Walden Pond
in 1845 for a cost of $28.125. (Boards cost $8.03, shingles $4.00, and
nails $3.90.) He met the cost of his frugal lifestyle by working six weeks
per year. This allowed him ample time to write, meditate, and confront
"the essential facts of life." Thoreau knew the difference between needs
and endless wants. Duane Elgin (1998) in his book VOLUNTARY
SIMPLICITY: TOWARD A WAY OF LIFE THAT IS OUTWARDLY SIMPLE,
INWARDLY RICH exhorts us to reduce our mass consumptive lifestyles by
"living with balance in order to find a life of greater purpose." We should
be poor in things and rich in soul rather than rich in things and poor in
soul. We should be happy with being rather than having.

Thoreau's WALDEN imbues natural features such as the pond and
trees with symbolic meaning and sacred power. It renders natural life-
processes and mundane practices religiously significant by ritualizing
them (see COLOR PLATE 15 and FIGURE 9.2). Thoreau demarcated
Walden Pond as a sacred place (Page, 2001):

- *Scientifically:* surveying, sounding and charting, recording
 natural features.
- *Narratively:* trees that stand "like temples" and serve as
 "shrines."

- *Physically:* marking the site through construction of his hut and his bean field.
- *Ritually:* commemorating physical features consecrating mundane objects through mythic and ritual performance.

In the mid-1980s, two large tracts of land near Walden Pond were endangered when developers sought to construct an expansive office building and condominium complex. To conserve this area, recording artist Don Henley founded the Walden Woods Project in 1990. The Project embarked on a national campaign to raise public awareness and the funds necessary to purchase and preserve the endangered areas. The project was successful and in 1998 President Clinton dedicated the Thoreau Institute at Walden Woods.

The Institute is a center for research and education focused on Henry David Thoreau. Through the archives of the Henley Library, the most comprehensive Thoreau research collection in the world, the Institute provides opportunities for lifelong learning about Thoreau's life and work. Each year 600,000 people visit Walden Pond. The Walden Woods Project emphasis ecological conservation and stewardship of nature's beauty.

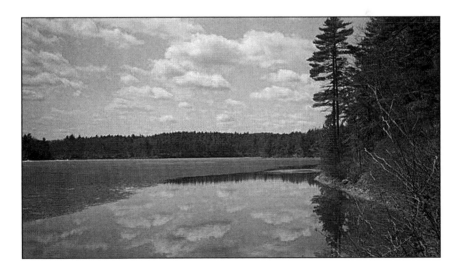

FIGURE 9.2: Ice melting on Walden Pond as viewed from the site of Thoreau's hut.

What we can do

The Interreligious Sustainability Project of Metropolitan Chicago (supported by a grant from the United Church of Christ) is organizing discussion groups called Circles, which have the following goals:

A. To pray, learn, reflect, and act to protect our children and grand-children's future.
B. Walking lightly on the earth and cutting the use of natural resources by ten percent. About two thirds of greenhouse-gas emissions come from automobiles. Substantial savings can be achieved by trading a SUV for a gas-electric Honda Insight (61 mpg) or Toyota Prius (52 mpg). People can move closer to work to reduce their commuting distance.
C. "Green Zone" churches as models of sustainability.
D. Effective regional transit systems to reduce congestion and air pollution.

The evangelical community is asking: "What would Jesus drive?" One possible answer is: "Jesus would have driven a Honda Accord, because Acts, Chapter 2 states that all the Disciples were in one accord." Reverend Jim Ball, Ph.D. (2006), editor of *Creation Care Magazine*, is critical of this answer, because the new Honda Accord six cylinder hybrid uses this new technology to increase the horsepower rather than the fuel economy. A better answer to this question would be: "Jesus would drive a Toyota to 'Prius' from our sins."

In the Boston, MA area, "Clean Air—Cool Planet," is building an alliance of institutions, business, faith-based organizations, and individuals to reduce greenhouse gas emissions. It includes Shaw's Supermarkets, which has also reduced its energy usage, as well as the Tufts University Climate Initiative, which is committed to "meet or beat" the targets of the Kyoto climate accord (see *http://www.tufts.edu/tie/tci/*). The University has accurately determined an emissions baseline and is working to bring its emissions down and to educate students and staff about climate change and energy efficiency. MIT President Susan Hockfield (2006) has established an Energy Research Council to determine how MIT can offer leadership on "one of the most urgent

challenges of our time: finding clean, affordable energy to power up the developed and the developing world."

Conclusion

Science, whose technology has unintentionally caused the environmental crisis, should work together with the forces of spiritual values to preserve the intrinsic beauty of nature. Science can give us the knowledge. The forces of spiritual values contribute the motivation, global ethic, wisdom, reverence, and vision. God's covenant with Noah never to flood the earth again is part of the Hebraic spiritual tradition. With the tremendous increases of technological power and population comes the vital obligation to uphold our responsibility to this covenant. Martin Luther King's courage, as well as the sacrifice of his life for what he believed, can be a model for what we must do to prevent environmental disasters. Environmental activism requires courage, which we will discuss in the next chapter.

Thoreau read Wordsworth, John Muir read Thoreau, Teddy Roosevelt read John Muir. Teddy Roosevelt established our National Parks. It took a century, but hopefully we'll have them for centuries more.

—William Sloane Coffin, 2003

Chapter 10
The Courage to Create Beauty

In creativity, mind is brought together (from various levels.)
This integration is a close synonym of beauty.

—Gregory Bateson, 2004

Beautiful art and music are not only expressions of creativity, they inspire creativity. Creativity in a scientific context is called insight, aha!, or eureka! Creativity in a spiritual and religious context is known as transformation, epiphany, or revelation. Creativity gives birth to new ideas and styles that can challenge established organizations, conventions, and paradigms. This tension requires the *courage-to-create*. Spirituality and religious faith can be a source of this *courage*.

Creativity: scientific insight

The mathematician Henri Poincaré noted that we prove with *logic* but discover through *insight*. Psychologist Rollo May describes the creative experience in science, religion, literature, and art in his book THE COURAGE TO CREATE (1975). Dr. May interprets the myth of the Greek God Prometheus as a symbol of the creative process. Prometheus stole fire from the gods on Mount Olympus to give to humankind. Zeus was outraged. He punished Prometheus by having him bound to Mount Caucasus. Here a vulture came out each morning and ate away his liver, which would grow again at night. Is this not a metaphor for creative people, who are often so exhausted at the end of the day, that they forget

their vision? During the night they recover their vision, and arise in the morning full of energy.

Archimedes' "eureka experience" is an example of scientific insight. He became *immersed* in his relative, the King of Syracuse's, problem. The king suspected that his jeweler had cheated him by not making his crown from pure gold and asked Archimedes to investigate. Archimedes knew that the density (mass divided by volume) of gold was different from less expensive metals. He could obtain the mass of the crown by weighing it, but how could he calculate the volume of the irregularly shaped crown? During the *incubation* period, he spent many days trying to solve this problem. Then unexpectedly, as Archimedes was getting into his bath, he noticed that the level of the water rose. His *illumination* came as he realized that the volume of the displaced water was equal to the volume of his irregularly shaped body. Similarly, he could use the displaced water to determine the volume of the crown. He was so elated by this insight that he ran into the street naked shouting: "Eureka!" (I have discovered it!) He then calculated the density of the crown to *verify* that it was not pure gold and that his king had indeed been cheated.

Archimedes' creative insight is consistent with Rollo May and physicist Murray Gell-Mann (1994) description of the creative process:

1) *Immersion:* encounter, saturation, and intense concentration on a problem;

2) *Incubation:* due to a logical impasse, where conscious thought is useless; and finally,

3) *Illumination:* "aha!" and the "Eureka Moment" (Cavenau, 1994). New insights or "eurekas" come when we least expect them. Einstein observed that he got his best insights when he was shaving in the morning.

4) *Verification:* determine if the new idea confirmed by empirical measurements and experiments.

Creativity: spiritual transformation

Religious symbols can inspire creativity. The 1987 Nobel Laureate, Alex Muller of the IBM Research Laboratory, Zurich, Switzerland, conceived the idea of investigating cubic peroskovite cuprate crystals as

high temperature superconductors while meditating on the Dharmaraja mandala, a highly symmetric symbol of the universe in Hinduism and Buddhism (Holton, Chang, & Jurkowitz, 1996; Matthews and Varghese, 1993).

The medieval German theologian, Meister Eckhart (1260-1328) described a similar four-step process for spiritual transformation (de Libra, 1997). It happens through being:

1) *Informed (ingebildet):* saturation, knowledge of the divine, meditation.
2) *Unformed (entbildet):* incubation, tragedy, sickness, repentance, openness to grace.
3) *Transformed (uberbildet):* illumination, born-again, oneness with God within the depths of our souls.
4) *Truth-testing and discernment.*

For spirituality, truth-testing comes from:

- Tradition and history: the collective community experience
- Reference to expert opinion and "authorities"
- Relation to previous personal experience, faith and doubt resulting in discernment.

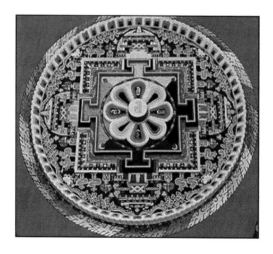

FIGURE 10.1: Mandala inspires creativity
(Courtesy: *Brandeis University Magazine*).

John Newton (1725-1807), the captain of a sailing ship transporting slaves from Africa to America, had a life transforming experience that resulted in his writing the hymn "Amazing Grace." His epiphany led him to give up the slave trade and become the pastor of a church in England. The transformation came after his slave ship passed through such a severe storm that Newton lost all hope of surviving. He was miraculously saved! Newton attributed his experience of "amazing grace" to a divine providence, which transcended his power and led him to change his profession. In our time, his hymn "Amazing Grace" has become, paradoxically, very popular in African-American churches.

The similarity between the structure of scientific insight, in the context of problem solving (Gell-Mann, 1994; May, 1975) and of spiritual transformation (Eckhart), is an illustration of how creativity connects science and religion (see TABLE 1). Dr. Francis S. Collins, Director, National Center for Human Genome Research expressed it this way, "I find those rare dramatic moments of scientific discovery in my own experience to be moments of worship also, where a revelation about some new intricacy of God's creation is appreciated for the first time."

TABLE 1
CREATIVITY

SPIRITUAL TRANSFORMATION *Eckhart*	SCIENTIFIC INSIGHT *Gell-Mann*
1. *In*formed	1. Immersion
2. *Un*formed	2. Incubation
3. *Trans*formed	3. Illumination
4. Discernment & Truth-Testing	4. Verification

I have had my own experiences of scientific insight and religious revelation. I once had an Eureka experience in my post-doctoral research (Carr and Slobodnik, Jr., 1967) on nonlinear phenomena recently popularized as chaos (Cohen and Stewart, 1994). We had come to a real impasse. The nonlinearities in quartz we were seeing on our oscilloscope were much too slow. We could not explain them from our coherent

nonlinear equations. After an intense day in the laboratory, I was spending a lovely June evening in my garden. As I was trimming my roses, I had a sudden insight. The slow phenomena we observed with our oscilloscope were probably a heating effect. The next morning, I hurried to the laboratory and eagerly searched for the much faster coherent effect. I found it by using a much shorter time scale! I could now observe the scattering from the fast-coherent-acoustic-wave nonlinearities to the slow thermal effect we had been observing before. I derived new equations for the heating effect and, through a number of diagnostic experiments, verified that this theory described our original observations (Carr and Slobodnik, Jr., 1967, 1970).

At the time of this Eureka experience, I had a tremendous feeling of relief that our experimental-theoretical impasse had been overcome. Partly because of the compartmentalization of my life, I did not attribute this scientific insight to divine action. However, the revelations I had at the time of my wife's death from leukemia, I can only describe as a divine spiritual presence.

My wife Karin's condition at the hospital had deteriorated in spite of the heroic measures being used in the intensive care unit. After visiting her on May 13, 1986, I stopped by my laboratory to share the bleak news with my friends. On my way home, I walked through green meadows, abundantly covered with yellow dandelions. At home, I rested on her side of the bed and contemplated the breeze-blown leaves of the white birch I had planted years ago with our youngest daughter. Suddenly, a strong inner voice told me there were two options for my wife: (1) she would be miraculously healed, or (2) she would die and go to heaven. This revelation prepared me to accept her impending death. I had previously been convinced that my fervent prayers for her life would be answered. She died two days later at 3:45 PM, age forty-six, leaving me responsible for bring up our daughters, ages twelve, fourteen, sixteen, twenty-one, and twenty-four. I attribute this inner voice and my dream about three crosses to a divine presence that gave me courage in spite of her untimely death. Language seems inadequate to express such mystical, religious revelations.

Dreams are creative in both science and spirituality. The chemist, F. A. Kekule, discovered the hexagonal structure of benzene, C_6H_6, after dreaming of a circular snake holding its tail in its mouth. In Genesis 41, Joseph interpreted the Pharaoh's dream about the seven fat and seven

thin cows as seven years of plenty followed by seven years of famine. When this actually happened, the Pharaoh then appointed Joseph governor over the food supplies of Egypt.

The unity of spirituality and science was evident in antiquity when there was little distinction between the sacred and secular. The divine was not supernatural and the physical world was not natural. For the Greeks, the divine was ever present, working out the destiny of man. The course of events and the actions of the gods were one and the same. The Latin word *scientia* was applicable to any system of belief characterized by rigor and certainty. It was common in the middle ages to refer to theology as a science (*scientia*) (Lindberg, 1992).

The monotheistic Hebrew-Judaic creation story of Genesis 1-2 contains the recurring theme: "And God saw everything that he had made, and behold it was very good." The "goodness" of the material world may be one reason why modern science arose in the West rather than in the East. Eastern religions have placed a greater emphasis on "inner" contemplation rather than the "outer" world. Scientists like Galileo and Newton were motivated by the fact that they could learn about Creation by studying the physical universe. Why study physical reality if it is not "good"?

Newton maintained the original unity between religion and science by saying (Hummel, 1986): "No sciences are better attested than the religion of the Bible." Newton was motivated by a desire to understand the mystic clues about God's Creation. In 1687, physics was a branch of natural philosophy. Newton's great treatise on mechanics and gravitational theory was entitled PHILOSOPHIAE NATURALIS PRINCIPIA MATHEMATICA (THE MATHEMATICAL PRINCIPLES OF NATURAL PHILOSOPHY), which synthesized the motion of celestial and terrestrial bodies.

Conflict and tension: differences between science and spirituality

The estrangement between science and spirituality is evidenced by conflict, tension, and ambiguity under the conditions of our existence. Newton's motivation to learn and understand God's laws in the universe resulted in a paradox. His deterministic cosmology worked so well that many thought that God was needed only to start the planets moving. Napoleon, after reviewing La Place's extension of Newton's cosmology,

CELESTIAL MECHANICS, asked about the need for a creator. La Place replied: "I have no need of that hypothesis." Descartes' separation of mind from body contributed to the separation of religion from science.

Conflicts between religion and science arise from such differences as:

- *Language:* Physical science strives for quantitative and mathematical language. Galileo said: "Natural philosophy is written in the grand book of the universe, which stands continually open to our gaze... It is written in the language of mathematics." Our language is inadequate to express mystical spiritual experiences, but poetry and symbol are approximations.

- *Dimension:* Science is the *horizontal* dimension of quantitative relations between measurable reality. The *vertical* spiritual dimension is a holistic ultimate concern for the meaning and purpose of life (Tillich, 1960, 1988). Science understands the material universe and results in technology. Religion motivates and guides our living.

- *Interpretative style:* People have varying perceptions of reality, a spectrum of tolerances to uncertainty, and Biblical interpretations that range from literal to symbolic. (Creationists versus Evolutionists)

- *Reproducibility:* Scientific hypotheses are validated by data that can be reproduced in suitably equipped laboratory. Many religious experiences are of a personal, once-in-a-lifetime nature. Kierkegaard once said: "Life can only be understood backwards; but it must be lived forwards."

- *Ambiguity:* Science is based on logic, which avoids contradiction and ambiguity. Religion uses paradoxes like "The first shall be last, and the last shall be first" to describe a spiritual reality, which transcends the rational order. Theology is a rational treatment of the religious experience.

Differences between science and spirituality are illustrated by the language used to describe creative experiences. Psychology attributes creative insights to the action of the subconscious mind (May, 1975;

Goodenough, 1993; Cavanaugh, 1994). Accounts of spiritual revelation are attributed to supernatural sources like visions and "God speaking," and often expressed poetically and symbolically. Cavanaugh states, "The eureka transition from subconscious to conscious applies whether one is doing science or writing poetry.... Whether we call it science or literature depends on what happens to it after the eureka moment."

Courage to create

Historic conflicts, such as between Galileo and the Roman Catholic Inquisition require the Courage to Create (May, 1975). Galileo and Einstein exemplify creative courage and Gandhi *moral and social courage.*

The trial of Galileo was a confrontation between the creativity of new science and the traditions and paradigms of "the religious establishment." Galileo's observations with the newly invented telescope showed that the moon had mountains similar to the earth and the sun had spots. This shattered the ancient myth that the heavenly bodies were perfect spheres made of "ether" in contrast to the imperfect and corruptible earth. His observation of the phases of Venus convinced him that it was orbiting the sun, just as our moon orbits the earth. He also discovered the moons that rotated about the planet Jupiter. Copernicus' heliocentric hypothesis offered a better explanation of these new phenomena.

The ambiguity of history is illustrated by the fact that the Roman Catholic Church was scientifically correct in saying that Galileo had no proof that the earth rotated about its axis as orbited around the sun. Tycho Brahe, the great astronomical observer, never accepted the Copernican system, because he could not observe the stellar parallax due to the earth's motion around the sun. Galileo's argument that the tides result from the earth's rotation later turned out to be correct, but at time on one know enough about gravity and centrifugal forces. The whole confrontation might have been avoided if Galileo had been more diplomatic. In 1633 he published a "best-seller" in Italian: *DIALOGUE ON THE TWO PRINCIPAL WORLD SYSTEMS—PTOLEMIC AND COPERNICAN.* This asserted that the sun was at the center of the solar system and not the earth. The Pope was convinced that he was satirized for supporting the earth-centered system proposed by Ptolemy in A.D. 150. This, plus

the Protestant Reformation in Germany, led to the Roman Catholic Church bringing Galileo to the trial in which he was convicted.

At age sixty-nine, Galileo courageously argued (Hummel, 1986): "The Bible tells us how to go to heaven, not how the heavens go." Galileo, although deeply hurt by this conviction, did not withdraw from the church. He believed himself to be a good Catholic who had sought to keep his church, for its own good, from making a mistake. (The Roman Catholic Church, in an act of reconciliation recently admitted this.) While under "house arrest," Galileo courageously went on praying and asking his friends to pray for him. He said:

> I have two sources of perpetual comfort: first, that in my writings there cannot be found the faintest shadow of irreverence toward the Holy Church; and second, the testimony of my own conscience, which I and God in Heaven thoroughly know. And He knows that in this cause for which I suffer...none have spoken with more greater zeal for the Church than I (Hummel, 1986).

Galileo continued his writings, which were smuggled to Holland for publication. A month before his seventy-eighth birthday, he "rendered up his soul to its Creator."

A source of Galileo's courage was his unwavering faith in "God in Heaven."

Tillich in THE COURAGE TO BE describes the source of courage as the "God above God." By this he meant the God who transcends the God of theism or of organized religion. The theistic objectivation of a God who is *a being* must be transcended by the "God above God," the ground of all that has being and the source of all existence. Making God into *a being* would make him finite. If God were a being, an invincible tyrant, he, being all knowing and powerful, could threaten our freedom and personhood. "The 'God above God' is present in all mystical longing, yet mysticism must be transcended in order to reach him The 'Courage to Be' is rooted in the God who appears when God has disappeared in the anxiety of doubt" (Tillich, 1952). In completely accepting the possibility that God does not exist, one discoverers that there is still something there, the "God above God."

In our twentieth Century, Albert Einstein exemplifies *creative courage*. Einstein's theory of relativity helped create a new paradigm: the invariance of the velocity of light (Gardner, 1993). For Newton, both length and time were invariant.

The influence of religion on Einstein's creativity is as follows:

> "Science without religion is lame, religion without science is blind." So Einstein once wrote to explain his personal creed: "A religious person is devout in the sense that he has no doubt of the significance of those super-personal objects and goals which neither require nor are capable of rational foundation." His was not a life of prayer and worship. Yet he lived by a deep faith—a faith not capable of rational foundation—that there are laws of Nature to be discovered. His lifelong pursuit was to discover them. His realism and his optimism are illuminated by his remark: "Subtle is the Lord, but malicious he is not."
>
> When asked by a colleague what he meant by that, he replied: "Nature hides her secret because of her essential loftiness, but not by means of ruse" (Pais, 1982).

Einstein (1939) delivered an address "On Religion and Science" which stated his disbelief in a "Personal God who interferes with natural events." Tillich (1940) agreed with Einstein in the following sense:

> The concept of a 'Personal God,' intervening with natural events, or being 'an independent cause of natural events,' makes God a natural object beside others, an object among objects, a being among beings, maybe the highest, but nevertheless *a being*.... No criticism of this distorted idea of God can be sharp enough...
>
> But why must the symbol of the *personal* be used at all?
>
> The answer can be given through a term used by Einstein himself: the *supra-personal*.

In summary, Tillich answered Einstein's disbelief in a "Personal God" by defining "Personal God" as a *supra-personal* symbol of an "I—Thou" (rather than an "I—It") relation (Buber, 1974). For Tillich, God can not

be less than personal or "I—Thou." God is the source and ground of being itself.

Einstein won the 1905 Nobel Prize by using the quantum properties of light to explain the photoelectric effect. Later in his life, however, he showed *creative courage* in opposing the statistical interpretation of atomic and nuclear phenomena described by Bohr and Schroedinger's Quantum Mechanics. He expressed his opposition by saying: "God does not play dice with the universe" (see Chapter 5). He believed that statistics was employed only because we do not comprehend the underlying law. Einstein struggled valiantly, but unsuccessfully, to construct a unified field theory which would synthesize relativity and quantum theory.

After meeting Gandhi, Einstein said: "Generations to come will scarce believe that such a one as this in flesh and blood walked the earth" (Gardner, 1993). Gandhi freed India from England with militant nonviolence. He was a model for Martin Luther King, Jr. Gandhi drew *moral and social courage* from his devout Hindu faith, which was so intense that many regarded him as a saint. He was able to mobilize the Indian masses, both spiritually and politically by concentrating on local grievances of high symbolic value—a method that distinguished Gandhi from the charismatic figures of the post-World War I period.

Gandhi shrugged off worldly possessions, ate and drank abstemiously, wore few pieces of clothing and lived with as few creature comforts as possible. Gaining substance from his self-restraint, Gandhi once remarked: "I own no property and yet I feel that I am perhaps the richest man in the world." Gandhi's most extreme form of restraint involved fasting. In abstaining from eating, he was revisiting a practice of purification with a long tradition in India. Fasting was one of his powerful nonviolent methods of political persuasion. Yet perhaps his greatest power was his charismatic hold on people through his manner, reputation and *moral and social courage*.

Conclusion

The ancient unity of science and spirituality was expressed in beautiful art and story. Scientific insight and spiritual revelation are both creative. Nevertheless, creativity can lead to tension with established paradigms and conflict with organized religion. Galileo's faith in his

"God in Heaven" gave him the courage at age sixty-nine to suffer through his conviction of "suspected heresy," to keep on praying, and to continue his creative research while under "house arrest." Conflict met with courage blazes a path for the creativity of others. Galileo's courage contributed to the great synthesis of Newton's PRINCIPIA. Conflict met with courage results in dialogue between science and spirituality (Barbour, 1989-1991).

When conflict is met with courage, a new cycle of creativity is possible. Einstein's faith in laws-to-be-discovered contributed to his creativity. He showed creative courage in opposing the statistical nature of quantum mechanics. Gandhi drew moral and social courage from his devout Hindu faith. Religious faith and yearning for beauty can motivate our creativity and give us the courage to overcome conflicts. By meeting conflict with courage, we can integrate science and spirituality and fulfill our potential to become created *co-creators* (Hefner, 1993).

Spirituality looks for meaning and science for order beyond the present moment (Johnson, 1995). Science looks for *invariance* or properties that do not change. One example is Newton's law of conservation of momentum in non-relativistic mechanics. The conservation of mass-energy in chemical and nuclear reactions is another. Spirituality seeks for the *eternal,* such as the symbol of the presence of God in the Creation as well as in history. Spirituality also deals with issues that defy and transcend logical analysis, such as the meaning of suffering and death. Science and spirituality are both searching for truth. The integration of science and spirituality is giving birth to a beautiful new story, described in the next chapter, which transcends national and cultural differences.

Chapter 11
A Beautiful New Story

Every civilization has a cosmic world view—a Story by which all is understood and evaluated. The prevailing Story shapes a culture's attitudes, integrates its knowledge, dictates its methodology, and directs its education.

—Augros and Stanciu (1984)

The old nurtures the new

"The modern Christian inherits an intellectual tradition of faulty cosmology..." John Updike (1999, p. 5) is referring here to a literal interpretation of Bible passages such as "And God made the firmament and separated the waters which were under the firmament from the waters which were above the firmament" (Gen. 1:7). This statement is consistent with the cosmology of ancient times, when people believed that rain came from the waters above the earth. How can this ancient cosmology be reconciled with the modern big bang?

The first cosmologist to propose a "big bang," the priest George Lemaître (1933), was once asked how he reconciled his faith in the Bible with his general relativistic theory of the universe, which emerged from a "primeval atom."

"There is no conflict," he replied. "Once you realize that the Bible does not purport to be a textbook of science, the old controversy between religion and science vanishes There is no reason to abandon the Bible

because we now believe that it took perhaps ten thousand million years to create what we think is the universe. Genesis is simply trying to teach us that one day in seven should be devoted to rest, worship, and reverence—all necessary to salvation."

My reconciling hope is that the mystical beauty of ancient stories can nurture the mathematical beauty of a New Story (see Appendix C, "A Creation Story for the 3rd Millennium"). The symbol "let there be light" can be a metaphor for the hot big bang space-time explosion of trillions of degrees, which occurred over 13 billion years ago. Beautiful satellite images of the fossil radiation from this explosion, cooled to minus 270°C, enable us to look back in time to only 379,000 years after the primeval event (COLOR PLATES 13 and 14 and FIGURES 11.1 and 11.2). We can see the seeds that "planted" the galaxies and stars in the whispering cosmos. The Hubble optical telescope enables us to see these galaxies one billion years after their birth. The light from these galaxies has traveled through the vastness of space for 12 billion years to reach us. Even though our concepts of the universe have changed, we perceive it as awesome and beautiful. In this sense, beauty is eternal. Astronomer Mario Livio (2000) has called this the cosmological aesthetic principle.

Modern cosmology tells us how the elements evolved from the primordial hydrogen that is still the most abundant element. The stars are massive fusion reactors in which hydrogen atoms are fused to form helium, lithium and all the elements in the periodic table up to iron. As

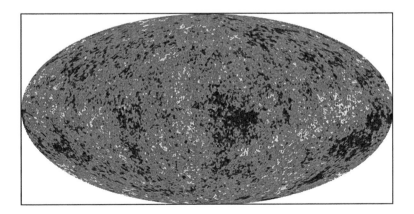

FIGURE 11.1: Image of microwave radiation from the early universe. (Credit NASA/WMAP Science Team).

the nuclear fuel was expended, the stars exploded at the end of their lifetime into spectacular supernovae. Higher elements up to lead and uranium were formed in the higher temperatures present in these giant supernovae. The stardust from these massive explosions coalesced under gravitational attraction to form the sun, our earth, and the planets. Thus, we are made of stardust from the heavens.

The cosmic creation of new galaxies, stars, and planets from the dust of the old is similar to what we see on earth. The fertile soil or humus comes from the death and decay of earlier life. The word "human" derives from "humus." The creation story in the Bible says, "The Lord God formed man of dust from the ground, and breathed into his nostrils the breath of life" (Gen. 2:7). The name Adam means "of the earth." The death of the old nurtures the new.

The account in Genesis of God making order out of chaos has a certain mystical beauty. There is aesthetic and mathematical beauty in the fractal branching of plants and our lungs. The old story of order emerging from chaos can nurture a story based on the fractal beauty of nature, which is also characterized by the interplay of randomness and lawful order. Fractals are also models of whole to part relations. Perhaps that is why the fractal mandala has been used by Buddhists as a guide to meditation. Spiritual transformations are characterized by a relationship to a transcendent whole.

The narrative in Genesis 1, where God made order out of chaos and light from

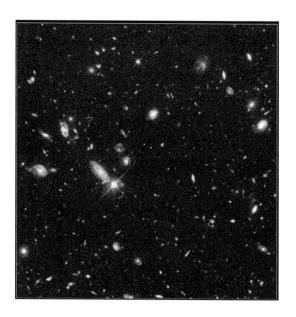

FIGURE 11.2: Deep Field Image from NASA Hubble Telescope of galaxies 12 billion light years away (January 15, 1995. STSCI, NASA).

darkness, has led to the discovery of a whispering (Big Bang) cosmos and the evolutionary interplay between chance and necessity. The Old Story can seed the emerging New Story. The New Covenant (New Testament) of Christianity had its roots in the Old Covenant (Old Testament) of Judaism, just as Buddhism grew out of Hinduism. The scientific story of the origin and evolution of the cosmos has intrinsic beauty and transcends national and cultural differences.

In the New Story, technology and theology can interact with beauty and power. Technology touches theology and visa-versa. Technology provides the communications infrastructure for the promulgation of religious beliefs from the roads of the Roman Empire to the Internet.

Theology touches technology by creating metaphors for the goodness of the material world and for consistency and openness. Theology has motivated the establishment of universities, which have birthed new science and technology. Mohammed's theology and leadership transformed Islam to a predominant medieval culture, which developed the Arabic number system we use today. Technology and theology worked together to abolish slavery and beautify the human condition. Technology and theology are working together to make the desert of the beautiful Holy Land bloom.

The New Story should be of help to people who doubt Darwin, because the new scientific account of the origin of the universe and of humans does not agree with a literal interpretation of biblical accounts (Adler, 2005, p. 5). The scientific and the biblical accounts can both be beautiful in their own ways. Both can express harmony and coherence.

However, the purpose of scientific theories and spiritual stories is different. The purpose of scientific theories is to explain "how" and to give a coherent rational account of empirical observations and measurements. This complements the purpose of spiritual stories, which is to answer "why," to express meaning, to meet human needs, and to give moral guidance for living. Spiritual stories also are the basis of worship, ritual, celebration, and thanksgiving. Beauty is a part of worship, as in hymns like "All Things Bright and Beautiful" and "For the Beauty of the Earth." Spiritual stories and scientific theories have a complementary beauty. The complementary beauty of science and spirituality offers a better alternative to materialism than intelligent design.

The myths that used to explain the natural world satisfied our human need to know. They reflected the state of scientific knowledge in their

day. They are like the "first naivete" of our childhood, when we believed that creation stories were literally true. Many of us in our adulthood have come to a "second naivete" (Wallace, 1990). This is like the Native American storyteller, who began telling his tribe's story of creation by saying, "Now, I don't know if it happened this way or not, but I know this story expresses truth."

We are between stories, according to Thomas Berry (1999, 2003). The old story was functional because it shaped our emotional attitudes, and provided us with life purpose and moral direction. It consecrated suffering, integrated knowledge, and guided education.

Brian Swimme and Thomas Berry have written a New Story of how things came to be, where we are now, and how our human future can have meaningful direction. Their UNIVERSE STORY (1992) sets forth a model for the telling of a common creation story. This can become the basis of a more comprehensive ecological and social ethics that sees the human community as dependent upon and interactive with the earth community. Only such a perspective can result in the flourishing of both humans and the earth. As Berry has stated, humans and the earth will go into the future as one single multiform event or we will not go into the future at all.

This new universe story is a story of personal evolution against the background of cosmic evolution, and of one person's intellectual journey in relation to Earth history. It is a story awaiting new tellings, new chapters, and ever-deeper confidence in the beauty and mystery of its unfolding. This story provides a comprehensive context for orienting human life toward the "Great Work" of our time, which challenges humans to reinvent their role in the evolutionary process. As Berry (1999) suggests, history calls us in the early twenty-first century to create new, life sustaining human-earth relations. The life, beauty, and diversity of the planet need to be preserved and enhanced for future generations. This is the "Great Work" to which we are each called.

IN THE BEGINNING...CREATIVITY

Theologian Gordon Kaufman's IN THE BEGINNING...CREATIVITY (2004) proposes creativity as a beautiful metaphor for the divine.

Serendipitous creativity is a mystery that somehow was involved in the initial coming into being of the universe, in evolutionary processes, and in human symbolic creativity. With this modern understanding of God, we can reflect on life in new ways. It provides a framework where the Divine is more than Protestant, Catholic, Jew, Muslim, Buddhist, or Hindu. Kaufman wants people to continue with their religious traditions, but with a bigger understanding of God. The foundation of our moral life will be the protection of the intrinsic beauty of the environment.

Beautiful art and music are not only expressions of creativity, they inspire creativity. Creativity connects science and spirituality. The four-part structure of scientific insight, in the context of problem solving, is similar to that of spiritual transformation. Dr. Francis S. Collins, (1997) Director, National Center for Human Genome Research expressed it this way, "I find those rare dramatic moments of scientific discovery in my own experience to be moments of worship also, where a revelation about some new intricacy of God's creation is appreciated for the first time" (p. xi).

The New Story renews Plato's vision that beauty is our way of experiencing the spiritual. As Thomas Mann said, "Beauty alone is…the only form of the spiritual which we can receive through the senses" (1912). In our present existence, our experience of beauty, like truth and justice, is an imperfect and fragmentary experience of the beauty's perfect essence. Yet our existence in community can, over time, be a better approximation to the ideal of beauty within us, just as the mystical beauty of the ancients has matured through the mathematical beauty of modern science.

The New Story is one of increasing complexity, specialization, and beauty emerging from simple beginnings. It is a story of increasingly interdependent communities and ultimately humans, who are conscious of beauty, have a moral conscience, and are creative. Spirituality inspired the moral laws, the meaning, and the purpose that enabled tribes to live together in solidarity. This coupled with scientific and technical advances led to the emergence of the great civilizations of Egypt, Greece, Rome, Islam, and modern democracies.

The New Scientific Story is beginning to be expressed in religious liturgy, as in the following hymn:

PRAISE TO THE LIVING GOD
Curtis Breach, 1966

Praise to the living God,
From whom all things derive,
Whose Spirit formed upon this sphere the first faint seeds of life;
Who caused them to evolve, unwittingly, towards God's goal,
Till humankind stood on the earth,
As living, thinking souls.

It is amazing that nature's spontaneity and human freedom result in a universe that can have such beauty and harmony. This self-creating universe with both randomness and law can be a manifestation of divine creativity. Our rapture at seeing, for example, a beautiful butterfly, we can attribute *to* a design. The evolutionary interplay between chance and law, however, is not design *from* a predetermined human blueprint. Evolution is design *to*, not design *from* (Ruse, 2003). Evolution is a beautiful vision for the future, not a detailed plan. Beauty comes from the harmonious balance between chance and necessity. In addition to natural selection, there is sexual selection, which is governed by what other species and we perceive as beautiful in the opposite sex.

Process thought asserts that the universe is not static but an evolving and continuing creation, whose intricacies result in continuing scientific discoveries. "The universe is not a place where evolution happens. It is evolution happening" (Rue, 2000, p. 43). Let us pray for the wisdom to use the power of scientific knowledge as responsible co-creators and not as destroyers of our earth through the unintended consequences of our technology. As created and creating creatures, we can profit from religious wisdom. In it, there is hope that the continuing creation is converging toward its ultimate consummation, expressed by Whitehead (1933):

The teleology (goal) of the Universe is the production of beauty.

THE PROCESS VISION*

Because everything is related;
Because the decision of each event matters for all events;
Because freedom is a reality;

The greatest power is not coercive force,
But patient, creative, persuading, redeeming, gracious love.
This is God's power,
Which continually works to lure the whole creation:

To bring enriching diversity and intensity out of struggle;
To overcome destructive conflict with greater harmonies;
To redeem the evil wrought in death and
Disaster with new life.

*CREATIVE TRANSFORMATION, 9:4, (Claremont, CA: Process and Faith, Summer 2000), back page. Also retrieved Aug. 4, 2006 [On-line journal] at www.processandfaith.org/CT/.

The universe—the totality of what is, which includes our subjective impressions as well as objective data—composes a narrative and contains a poem, which our own stories and poems echo.

—John Updike, 1999

ICONOCLASH: BEYOND THE IMAGE WARS IN SCIENCE, RELIGION, AND ART

The power of religious symbols is illustrated in the book *ICONOCLASH: BEYOND THE IMAGE WARS IN SCIENCE, RELIGION, AND ART* (Latour, 2001). *Iconoclash* occurred when fireman had to break through the case surrounding the sacred Shroud of Turin to prevent it from being burned. The case had been built to protect it from being stolen by people who believed that it had wrapped the body of Christ after his crucifixion.

"We cannot do without images" conflicts with "If only we could do without images."

This first appeal is to respect images as sources of mediation, to become an iconophile. The second appeal is to become an iconoclast, a destroyer of images. Liturgical religions, such as the Roman Catholic and Eastern Orthodox, have been traditionally iconophiles. Many protestant denominations have been iconoclasts. This book advocates dialogue between iconophiles and iconoclasts. Iconophiles, if pushed to extremes, can become idol worshippers. If iconophiles avoid this extreme, their art can symbolize of the ineffable experience of spiritual transformation. Truth is image, but there is no image of truth.

THE ANTHROPIC PRINCIPLE AND THE INFLATIONARY UNIVERSE

The Anthropic Principle

Mathematical physicist Paul Davies, 1995 Winner of the Templeton Prize for Progress in Religion, shares Einstein's cosmic religious feeling, a sense that the order in nature revealed by science is neither arbitrary nor absurd, and that there is "something going on" in the universe, something deeply ingenious and elegant. The laws of physics marvelously permit the universe to create itself with space and time in a "Big Bang," arising from quantum fluctuations. St. Augustine was right; the universe was made with time not in time. Shortly after its explosive origin about 13 billion years ago, the universe was so hot that only gas could exist. As it cooled, protons, electrons, hydrogen atoms, stars, planets, and galaxies formed. Life on earth evolved from single cells 4 billion years ago to complex humans like us.

The first life could have arisen in the warm springs deep under the ocean's surface (Russell, 2006). If the physical forces, such as gravity and electromagnetism, as well as the nuclear cross section of carbon had been slightly different, it is doubtful that any sort of life would have been possible. This "fine tuning" of the physical constants for life is known as the Anthropic Principle. Scientists, who do not believe that a deity could have designed these laws to create conscious life, postulate a cosmic lottery of multiple universes with different laws and physical constants. Our universe is the one where the values were right for intelligent life to emerge.

Dr. Davies does believe in a cosmic lottery of multiple universes. It requires an infinity of unseen universes just to explain the one we do see. It contradicts the principle of Ockham's razor, according to which the simplest and least number of assumptions is best. The cosmic lottery is scarcely an improvement over theism, with its hypothesis of an unseen creator, God. While the lottery may explain why we observe the known laws, it does not explain why there are laws in the first place. Until we can observe the existence of such multiple universes, their existence is as

much a matter of faith as the existence of a divine designer. (Davies 1983)

The inflationary universe: refining the Big Bang

In 1981, Prof. Alan Guth of MIT proposed a new cosmological model, which he called inflation, which explained many features of our universe, including how it came to be so uniform on a large scale and why it began so close to the critical density. Inflation is a modification of the conventional big bang theory, proposing that a repulsive gravitational force, generated by an exotic form of matter, propelled the expansion of the universe. After more than twenty years of development and scrutiny, the evidence for the inflationary universe model now looks better than ever.

Energy is conserved during the rapid inflationary period because mass energy is positive and gravitational energy is negative. The mass energy

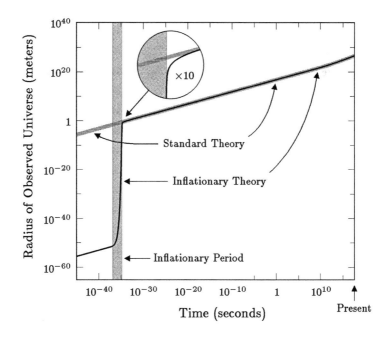

FIGURE A.1: The Radius of the Universe versus Time.
(Credit: Alan Guth).

is positive, since it takes energy to create a fundamental particle with mass or a sun with mass (mass = Energy divided by square of the velocity of light). Gravitational energy, on the other hand, is negative. Consider an apple, which falls to the ground because of its positive attraction to the earth. Energy is transferred from the gravitational field into the kinetic energy of the falling apple. This is in contrast to forcing two electrically charged bodies closer to together. Since like charges repel each other, one must supply energy to them to push them together. The energy of the electric field is therefore positive. (Gravitation energy is negative since gravitational masses attract.)Since gravitational energy is inversely proportional to distance, expansion reduces gravitational energy, which is available to create masses and heat. Energy is transferred from the gravitational field to matter and heat.

One of the intriguing consequences of inflation is that quantum fluctuations in the early universe can be stretched to astronomical proportions, providing the 'seeds' for the galaxies and stars. Guth and others calculated the spectrum of these fluctuations in 1982. The amplitude of these faint ripples is only about one part in 100,000. Nonetheless, they were detected by the COBE satellite in 1992, and they have now been measured to much higher precision by the Wilkinson Microwave Anisotropy Probe (WMAP) satellite and other experiments (2002). A plot of these ripple have a certain aesthetic beauty. They enable us to visualize the universe only 400,000 years after the Big Bang. Guth's theory of inflation proposes that these ripples resulted from quantum fluctuations in the early universe, and the predicted spectrum of the ripples is in excellent agreement with microwave measurements.

The mass density of the universe has been measured to be equal to the critical density to an accuracy of 2%. The tremendous expansion of the universe one second after the Big Bang requires its mass density to be equal to the critical density to an accuracy of one part in ten to the fifteenth power. This tremendous precision is known as fine-tuning. As we saw above, the mass density is critical to the fate of the universe. If the mass density were higher than the critical value, the universe would have contracted or recollapsed. If the mass density were lower than the critical value, it would have continued to expanded and gravity would not have been strong enough to cause the hydrogen and helium gas to form galaxies, stars, and planets.

Recent Wilkinson Microwave Anisotropy Probe satellite data (2002) reveals that only 4% of the mass energy content of the universe consists of the atomic mater, so familiar on earth. This is also the building block of plants and stars. Luminous stars are only a small fraction of this 4%. Dark matter comprises 22% of the universe. This matter, different from atoms, does not emit or absorb light. It has only been detected indirectly by its gravity. It is evident in gravitation lensing, the bending and focusing of starlight expected from general relativity. The gravitation attraction of this dark matter is need to prevent the centrifugal force caused by the rotation of the galaxies from tearing them apart. The remaining 74% of the Universe, is composed of "dark energy", that acts as a sort of an anti-gravity. This energy, distinct from dark matter, is responsible for the recent acceleration of the expansion of the universe. Explaining the nature of "dark energy" is a major challenge.

Another intriguing feature of inflation is that almost all versions of inflation are eternal—once inflation starts, it never stops completely. Inflation has ended in our part of the universe, but very far away one expects that inflation is continuing, and will continue forever. Is it possible, then, that inflation is also eternal into the past? Recently Guth has worked with Alex Vilenkin (Tufts) and Arvind Borde (Southampton College) to show that the inflating region of spacetime must have a past boundary, and that some new physics, perhaps a quantum theory of creation, would be needed to understand it.

A CREATION STORY FOR THE THIRD MILLENNIUM
by Derek Pursey, 1998*

In the beginning, God. There was no space, and time had not begun. Then God said, "Let there be a cosmos"; and there was a cosmos, smaller than a grain of sand. And God saw that the cosmos was good; and in it God separated space from time, and caused both to grow. Space was very hot, and God filled it with quarks, gluons, electrons, photons, and other creations. And there was a beginning and a growing, the first stage.

And God said, "Let there be light"; and as the space grew, it cooled, and the quarks and gluons condensed like the dew into protons and neutrons, and as the space expanded further, the protons and neutrons and electrons condensed into atoms of hydrogen and helium, and then there were no more free electrons to trap the photons, and the photons became light. And there was continuing beginning and growing, the second stage.

As the space continued to grow, it became very cold. And God said, "Let the atoms be gathered together, and let stars and galaxies appear"; and wrinkles in space caused the atoms to be gathered into stars and the stars into galaxies. And as space crushed the atoms together into stars, the stars became hotter than the hottest furnace, and the hydrogen was cooked to make helium, and the helium to make other elements, and in this way was all matter created. And God saw that it was good. And there was continuing beginning and growing, the third stage.

Then God said, "Let there be planets, not fiercely hot like the stars, yet not cold like space, but each one warmed by a star"; and the wrinkles in space caused some stars to collect clouds of dust, and the dust to gather together into planets, and the planets to move in orbits round their stars. Since the planets were not hot, their atoms combined into molecules, creating stuff of many different kinds. And one star in one galaxy was called "Sun," and one planet belonging to Sun was called "Earth." And

* Copyright © 1998 by Derek L. Pursey and the Presbyterian Association on Science, Technology and the Christian Faith. First published in *SciTech*, 7: 3, (August 1998). Used with permission.

God saw that it was good. And there was continuing beginning and growing, the fourth stage.

When it was first formed, Earth was a place of chaos. As the Spirit of God moved over the chaos, God said "Let dry land appear." And the water on Earth gathered into seas and oceans, and the dry land formed continents. Then God said, "Let Earth bring forth life." And there developed some molecules capable of self-replication, and these eventually evolved into single celled creatures. From these evolved all the plants of the oceans and the dry land, all the fish of the sea, all the birds of the air, and all the animals on dry land. And God saw that it was good. And there was continuing beginning and growing, the fifth stage.

Then God said, "Let us make humankind in our image, according to our likeness." And God selected creatures which were very close to God's design for humankind, and from these evolved new creatures called Man and Woman. God blessed Man and Woman, and God gave them care over and responsibility for the part of God's cosmos called Earth. God saw everything that God had made, and indeed it was very good. And there was continuing beginning and growing, the sixth stage.

A commentary by Derek Pursey on "A Creation Story for the Third Millennium"

Why write this "creation story for the third millennium"? Should it replace Genesis 1? Of course not! I make no claim to divine inspiration! However to understand the motivation for this effort, one needs to look carefully at the Genesis 1 story.

Genesis 1 tells of the creation of the universe by God. However one cannot tell about creating something without describing that thing in some way. Thus Genesis 1 is written in terms of a cosmology, that is, an understanding of the nature of the universe. The Genesis 1 cosmology is very similar to that common in Babylon at the time of the captivity, the period when many scholars believe that Genesis 1 received its final written form. Thus, the question is what is the message of Genesis 1 regarded as holy scripture? Is it that God created the universe? Surely so.

But is the message also that the universe is accurately described by Babylonian cosmology? This cosmology is completely at odds with that developed by science during the past five centuries, and especially in the twentieth century. If we are faithful Christians or Jews, are we forced to

believe the cosmology of Genesis 1 and Babylon and therefore to deny the findings of contemporary physics, astronomy, chemistry, or biology? I do not believe so.

I believe that the message of Genesis 1 is simply that God is Creator, and that the cosmology of Genesis 1 is only the medium by which scripture conveys the message. Written for a people in exile or just returned from exile in Babylon, Genesis 1 describes God's creation of the universe in terms of the cosmology with which the people were familiar, the cosmology which was taken for granted as part of common knowledge. If God inspired the writing of Genesis 1 today, would not God describe the creation of the universe in terms of the cosmology which is today's "common knowledge," at least among educated people? Cosmology whether Babylon's or today's, is the medium, not the message!

That said, the "creation story for the third millennium" can and probably will be criticized for many gross oversimplifications and even inaccurate representations of contemporary cosmology. That misses my point, however. The cosmology is not the message. Indeed, creation by God is not even a part of modern cosmology, and neither should it be. Cosmology is science, not religion, and we may thank God for that! In the "creation story for the third millennium," the cosmological assumptions are used metaphorically rather than literally, as I believe is also the case in Genesis 1. An expression of religious faith in this case, faith in God as Creator should never be confused with a statement of scientific orthodoxy.

Lastly, why a "creation story for the third millennium"? The Genesis 1 story proved very adequate for at least two millennia, and still conveys its message if one does not confuse message with medium. However, the generally accepted cosmology has changed in two and a half millennia. I fully expect that the current "big bang" cosmology will appear quite as unacceptable two millennia hence as the Babylonian cosmology is today. Therefore, I may be excessively optimistic in hoping that my "creation story for the third millennium" will remain adequate even for as long as one thousand years.

SCIENCE AND RELIGION AT THE DAWN OF THE THIRD MILLENNIUM

Saturday, June 19, 1999 Session
at the International Paul Tillich Society Conference,
New Harmony, Indiana, June 16-20, 1999:
"The Religious Situation at the Dawn of the Millennium."

Theologian Paul Tillilch's picture appeared on the cover of the March 16, 1959 issue of *TIME* Magazine. The feature story caption was "From the Old World to the New Being." Forty years later, from June 16 to 20, 1999, the North American Paul Tillich Society organized the International Conference on "The Religious Situation at the Dawn of the Millennium." This theme reflects the spirit of Tillich's famous volume *THE RELIGIOUS SITUATION,* first published in 1926 in Germany. The conference took place in historic New Harmony, Indiana, site of the Paul Tillich Memorial Park.

According to the *TIME* article: "Tillich has succeeded in erecting a towering structure of thought...an edifice densely packed and neatly shaped against the erosion of intellectual wind and wave." The conference illustrates *TIME's* observation with world-recognized scholars such as Langdon Gilkey, Rosemary Radford Ruether, Gordon Kaufman, and Jose Miguez Bonino. The meeting was meant to reflect the spirit of Paul Tillich's lifelong work in the theological interpretation of culture. Participants attended sessions on (1) science and religion; (2) religion and the arts; (3) women and religion; (4) economy, society, and religion; and (5) spirituality and inter-religious dialogue. The Blaffer Trust, the Lilly Endowment, the John Templeton Foundation, and St. John's University New York supported this conference.

The goal of the Science and Religion Session was to use Paul Tillich's thought to deepen conversations between scientists and people of faith. The John Templeton Foundation provided a grant to support this session organized by Prof. Paul H. Carr, University of Massachusetts Lowell and Air Force Research Laboratory Emeritus.

Papers presented at this conference were published in the book *RELIGION IN THE NEW MILLENNIUM: THEOLOGY IN THE SPIRIT OF PAUL*

TILLICH. Raymond F. Bulman and Frederick J. Parrella, (Mercier Univ. Press: 2001).

Purpose

Show how Tillich's systematic theology can encourage dialogue between scientists and theologians by means of the following papers which were to be published in the Conference Proceedings. Selected papers were also published in *ZYGON: Journal of Religion and Science, 36,* June 2001

Correlating theology and science

- Professor Donald E. Arther, Webster University, Religion Dept., St. Louis, Missouri: "Paul Tillich's Perspective on The Ways of Relating Science and Religion"
- Professor Robert J. Russell, Director, Center for Theology and the Natural Sciences (CTNS): "The Relevance of Tillich for the 'Theology and Science' Dialogue"
- Dr. Anne Foerst, MIT Artificial Intelligence Lab and Harvard Divinity School: "Paul Tillich, Cybernetics, and Theology: an Unexplored Connection"

Panel discussion: Paul Tillich's "now" and our "now"

- Professor Ted Peters, Pacific Lutheran Theological Seminary and Center for Theology and Natural Sciences: "Eschatology: 'Eternal Now' or Cosmic Future"
- Professors J. Mark Thomas, Au Sable Institute of Environmental Studies, Mancelona, Michigan: "Ambiguity in our Technical Society"
- Professor Ronald B. MacLennan, Bethany College, Lindsborg, Kansas: "Realism in Science and Realism in the Thought of Paul Tillich"
- Professor Paul H. Carr, Philosophy Dept., Univ. of Massachusetts Lowell: "Science and Religion: Original Unity and 'Courage To Create'"

Keynote speaker: Professor Gordon Kaufman

Edward Mallinckrodt, Jr., Professor of Divinity, Harvard Divinity School, Emeritus: "Re-conceiving God and Humanity in Light of Today's Evolutionary-Ecological Consciousness."
Respondent: Michael Drummy, Fordham University

Outcome

Tillich's theological breadth encompasses Ian Barbour's four ways of relating science and religion: conflict, independence, dialogue and integration. Tillich's 1963 address at Berkeley was prophetic: "The period of conflict is in principle over between science and religion." Director of Berkeley's Center for Theology and Natural Sciences, Robert Russell, stressed importance of Tillich's method of correlation for the science-religion dialogue. Ronald MacLennan noted that Tillich's search for faith as "belief-ful realism" consistent with historical and scientific realism is much easier to achieve today than in Tillich's day, with its empirical Logical Positivism. Science and religion are complementary dimensions of the human spirit.

> *Scientific and technological culture is the form in which religion expresses itself. Religion as ultimate concern is the meaning-giving substance of scientific culture.*

Summary: Correlating theology and science

The theology of Paul Tillich (1886-1965) is foundational for the science-religion dialogue. **Donald Arther** showed how Tillich's theological breadth encompasses Ian Barbour's four ways of relating science and religion: conflict, independence, dialogue, and integration. Tillich's 1963 address at Berkeley was prophetic: "The period of conflict is in principle over between science and religion." This was a good lead into Director of Berkeley's Center for Theology and Natural Sciences, **Robert Russell's**, talk on the importance of Tillich's method of correlation for the science-religion dialogue. Correlation can be seen as a precursor of the "method of creative mutual interaction." **Anne Foerst** described papers that Tillich presented at MIT when he was University

Professor at Harvard (1955-62). These included "The Absurdity of the Question 'Does God Exist?'"

Summary of panel discussion: Paul Tillich's "now" and our "now"

The panel compared issues in Tillich's day with those of today. Ted Peters combined Tillich's idea of the ETERNAL God being present in the NOW with Pannenberg's conception of eternity as the wholeness and fulfillment of time. Our spiritual future is not cessation of being but the fullness of being in contrast to cosmology, which predicts the heat death of the universe. **J. Mark Thomas** cited Tillich's 1954 address " The Spiritual Situation in our Technological Society," in which he identified capitalism, communism, and fascism as ambiguous quasi-religious responses to an ambiguous reality. Thomas believes that postmodern multiculturalism (recognizing the power of racial and ethnic origins) and liberalism (upholding the rights of individuals) are similarly ambiguous secular religions. **Ronald MacLennan** noted that Tillich's search for faith as "belief-ful realism" consistent with historical and scientific realism is much easier to achieve today than in Tillich's encounter with empirical Logical Positivism of his day. The realism of modern physics includes the uncertainty principle, wave-particle dualism, and the predictability limits of chaotic systems. "Religion as ultimate concern is the meaning-giving substance of scientific and technological culture, and culture is among the totality of forms in which the basic concern of religion expresses itself." **Paul H. Carr** hoped that Tillich's insight of the "God above God" as the ground of courage and creativity will, in the next millennium, enable religion to be reunited with science, as it was in antiquity. Reconciliation and reunion characterize the New Being and Creation. Science and religion are complementary dimensions of the human spirit.

Keynote: "Re-conceiving God and Humanity in Light of Today's Evolutionary-Ecological Consciousness"

Gordon Kaufman noted that the Christian tradition out of which Tillich worked had a strong anthropocentric slant, which should be updated by the following:

a) We humans should *understand ourselves as basically biohistorical beings;*

b) *God should be understood* as neither a kind of "cosmic person" nor the "ground of being" but as the *serendipitous creativity manifest* throughout the universe from the "big bang"

c) *In the trajectories (or directional movements) that emerge in the evolutionary development of the cosmos and of life* (including human life) on planet Earth.

Respondent **Michael Drummy** agreed with the anthropocentricism of Tillich's day, but given this, felt that Tillich was prophetic in forcefully maintaining "the interdependence of everything with everything else in the totality of being includes a participation of nature in history and demands a participation of the universe in salvation."

REFERENCES

Adler, Jerry. "Doubting Darwin." (*Newsweek*, Feb. 7, 2005).

Ahmad, Imad-ad-Dean. *SIGNS IN THE HEAVENS: A MUSLIM ASTRONOMER'S PER-SPECTIVE ON RELIGION AND SCIENCE.* (Beltsville, MD: Writer's Intl, 1992).

Altshuler, E. E. and D.S. Linden. "Design of wire antennas using genetic algorithms." In Y. Rahmat-Samii and E. Michielssen, eds., *ELECTROMAGNETIC OPTIMIZATION BY GENETIC ALGORITHM*, pp. 211-248.

Amin, Adnan Z. In John T. Brinkman and Kusumita P. Pedersen, eds., *EARTH AND FAITH: A BOOK OF REFLECTION FOR ACTION*, p. 4.

Appenzeller, Tim. "End of cheap oil." (*National Geographic Magazine,* June 2004).

Arianrhod, Robyn. *EINSTEIN'S HEROES: IMAGINING THE WORLD THROUGH THE LANGUAGE OF MATHEMATICS.* (New York: Oxford Univ. Press, 2005).

Augros, Robert M. and N. Stanciu. *THE NEW STORY OF SCIENCE: MIND AND THE UNIVERSE.* (New York: Bantam, 1984).

Ball, Jim. "Walk the walk…and drive the talk." (*Creation Care Magazine.* Fall, 2002) and retrieved Aug. 4, 2006 [Issue posted on-line] www.whatwouldjesusdrive.org.

Barbour, Ian. *RELIGION AND SCIENCE: HISTORICAL AND CONTEMPORARY ISSUES.* (San Francisco: Harper Collins, 1997).

Bass, Thomas A. "Black box." (*The New Yorker*, Apr. 26, 1999).

Bateson, Gregory and Rodney E. Donaldson, eds. *SACRED UNITY: FURTHER STEPS TO AN ECOLOGY OF MIND.* (Cresskill, NJ: Hampton Press, 2004), p. 263.

Beaudette, Charles G. *EXCESS HEAT: WHY COLD FUSION RESEARCH PREVAILED, 2ND ED.* (South Bristol, ME: Oak Grove Press, 2002).

Bedec, Roger H. and Robert M. Wendling, "Fuel efficiency and the economy." (*American Scientist* 93:2, Mar.-Apr. 2005), p. 132.

Behe, Michael. *DARWIN'S BLACK BOX: THE BIOCHEMICAL CHALLENGE TO EVOLUTION.* (New York: The Free Press, 1998).

Berlinski, David. *NEWTON'S GIFT: HOW SIR ISAAC NEWTON UNLOCKED THE SYSTEM OF THE WORLD.* (New York: The Free Press, 2000).

Berry, Thomas *NEW STORY* [Audio CD]. (Canadian Broadcasting Corp., 2003).

Berry, Thomas. *THE GREAT WORK: OUR WAY INTO THE FUTURE*. (New York: Bell Tower, 1999).

Brinkman, John T. and Kusumita P. Pedersen, eds. *EARTH AND FAITH: A BOOK OF REFLECTION FOR ACTION*. (New York: Interfaith Partnership for the Environment / United Nations Environmental Program, 2000).

Buber, Martin. (1923) *I AND THOU [ICH UND DU]*. trans. Walter Kaufmann. (New York: MacMillan, 1974).

Bulman, Ray F. and Frederick J. Parrella, eds. "Science and religion," in *RELIGION IN THE NEW MILLENNIUM: THEOLOGY IN THE SPIRIT OF PAUL TILLICH*, pp. 235-345.

Bulman, Ray F. and Frederick J. Parrella, eds. *RELIGION IN THE NEW MILLENNIUM: THEOLOGY IN THE SPIRIT OF PAUL TILLICH*, (Macon, GA: Mercer Univ. Press, 2001).

Bumiller, Elizabeth. "Bush remarks roil debate on teaching of evolution." (*New York Times*, Aug. 3, 2005).

Bush, George W. In Elizabeth Bumiller, "Bush remarks roil debate on teaching of evolution."

Campbell, Laherrere. "The end of cheap oil: global production will decline in 10 years." (*Scientific American*, Mar. 1998).

Carr, Paul H. and Andrew J. Slobodnik, Jr. "Method of microwave rectification and mixing using piezoelectric media." (U.S. Patent No. 3,513,390, May 19, 1970).

Carr, Paul H. and Andrew J. Slobodnik, Jr. "Microwave rectification using piezoelectric quartz and zinc oxide." (*Journal of Applied Physics, 38,* Dec. 1967), pp. 5153-5164.

Carr, Paul H. "Science and religion: original unity and courage to create." (*Zygon, 36,* June 2001), pp. 255-259.

Carr, Paul H. "Science and religion: original unity and courage to create." In Ray F. Bulman and Frederick J. Parrella, eds., *RELIGION IN THE NEW MILLENNIUM: THEOLOGY IN THE SPIRIT OF PAUL TILLICH*, pp. 313-317.

Carr, Paul H. "Sacramental water and the challenge of global warming." (*Journal of the Faith and Science Exchange, 5,* 2001), pp 97-100.

Carr, Paul H. "Does God play dice? Insights from the fractal geometry of nature." (*ZYGON, 39:* 4, Dec. 2004), pp 933-940.

Carr, Paul H. "Four assessments of global warming from the NES-APS meeting, Oct. 22, 2004: Christy, Weart, Lindzen, and Rock." (*New England Section Newsletter of the American Physical Society, 11: 25,* Spring 2005) and retrieved Aug. 4, 2006 [Article in on-line newsletter] from http://www.aps.org/units/SNENG/news/news-spring05.cfm

Carr, Paul H. "A theology for evolution: Haught, Teilhard, and Tillich" (*Zygon, 40:* 3, Sept. 2005), pp 733-738.

Cavanaugh, Michael. "The precursors of the eureka moment as a common ground between science and theology." (*Zygon, 29,* June 1994), pp. 191-204.

Cedering, Siv. *LETTERS FROM A FLOATING WORLD.* (Pittsburgh, PA: Univ. of Pittsburgh Press, 1984).

Church, F. Forrester. *THE ESSENTIAL TILLICH: AN ANTHOLOGY OF THE WRITINGS OF PAUL TILLICH.* (New York: Collier, 1987).

Cihak, John R. "Love alone is believable: Hans Urs von Balthasar's apologetics" (*Ignatius Insight,* May 5, 2005). Retrieved August 4, 2006 [Article in on-line newsletter], from http://www.ignatiusinsight.com/features2005/jcihak_hubapol_may05.asp.

Clear Air—Cool Planet. For current activities see [website] retrieved August 4, 2006 from http://www.cleanair-coolplanet.org.

Cohen, Jack and Ian Stewart. *THE COLLAPSE OF CHAOS: DISCOVERING SIMPLICITY IN A COMPLEX WORLD.* (Harmondsworth, UK: Penguin, 1994).

Coffin, William Sloane. *CREDO.* (Westminster: John Knox Press, 2003).

Collins, Francis S. In Foreword to Ted Peters, *PLAYING GOD: GENETIC DETERMINISM AND HUMAN FREEDOM.*

Copernicus, Nicholas (1543). *ON THE REVOLUTIONS OF THE HEAVENLY BODIES [DE REVOLUTIONIBUS].* trans. Edward Rosen, (London: MacMillan, 1972).

Corrington, Robert S. and John Deely, eds. *SEMIOTICS 1993.* (New York: Peter Lang, 1995).

Darwin, Charles (1859). *THE ORIGIN OF THE SPECIES.* (New York: Gramercy, 1995).

Darwin, Charles (1871). *THE DESCENT OF MAN AND SELECTION IN RELATION TO SEX.* (Princeton, NJ: Princeton Univ. Press, 1981).

Davies, Paul, "A cosmic religious feeling." Paper presented at Science and the Spiritual Quest Conference, Cambridge, MA, Harvard Univ., Oct. 21, 2001.

Davies, Paul. *THE MIND OF GOD: THE SCIENTIFIC BASIS FOR A RATIONAL WORLD.* (New York: Simon & Schuster, 1992).

Davies, Paul. *GOD AND THE NEW PHYSICS.* (New York: Touchstone Books, 1983), pp. 164-189.

Davies, Paul. *SUPERFORCE: THE SEARCH FOR A GRAND UNIFIED THEORY OF NATURE."* (New York: Touchstone, 1984).

Davies, Paul. *THE COSMIC BLUEPRINT: NEW DISCOVERIES IN NATURE'S CREATIVE ABILITY TO ORDER THE UNIVERSE.* (New York: Simon & Schuster, 1988).

Davis, Percival and Dean Kenyon. *OF PANDAS AND PEOPLE: THE CENTRAL QUESTION OF BIOLOGICAL ORIGINS,* 2nd Ed. (Richardson, TX: Foundation for Thought and Ethics, 1993).

Dawkins, Richard. *THE BLIND WATCHMAKER: WHY THE EVIDENCE OF EVOLUTION REVEALS A UNIVERSE WITHOUT DESIGN.* (London: Longman, 1986).

Dean, Bradley, ed. *FAITH IN A SEED: THE DISPERSION OF SEEDS AND OTHER LATE NATURAL HISTORY WRITINGS.* (Washington, DC. Island Press/Shearwater Book, 1993).

Deffeyes, Kenneth S. *BEYOND OIL: THE VIEW FROM HUBBERT'S PEAK.* (New York: Hill and Wang, 2005).

De Libra, Alain, "Philosophical aspects of Meister Eckhart's Christian theology." Presented at Jesuit Institute Seminar, Boston Chestnut Hill, Sept. 10, 1998.

Delattre, Roland A. *BEAUTY AND SENSIBILITY IN THE THOUGHT OF JONATHAN EDWARDS: AN ESSAY IN AESTHETICS AND THEOLOGICAL ETHICS.* (New Haven, CT: Yale Univ. Press, 1968).

De Santillana, Geogio. *THE ORIGINS OF SCIENTIFIC THOUGHT: FROM ANIXAMANDER TO PROCULUS, 500 B.C TO A.D. 500.* (New York: Mentor Books, 1961).

Dembski, William A. and Michael Ruse, eds. *DEBATING DESIGN: FROM DARWIN TO DNA.* (New York: Cambridge Univ. Press, 2004).

Dubay, Thomas. *THE EVIDENTIAL POWER OF BEAUTY: SCIENCE AND THEOLOGY MEET.* (San Francisco, Ignatius Press, 1999).

Einstein, Albert. "On Religion and Science." (*New York Times Magazine,* Nov. 9, 1930), pp. 1-4. Also in Max Jammer, *EINSTEIN AND RELIGION,* p. 73.

Einstein, Albert (1939). "Science and religion." In Carl Selig, ed., *IDEAS AND OPINIONS: ALBERT EINSTEIN,* pp. 36-40.

Einstein, Albert (1949). "Autobiographical notes." In Phillip A. Schlilp, ed., ALBERT EINSTEIN: PHILOSOPHER-SCIENTIST.

Einstein, Albert (1954). In Carl Selig, ed., IDEAS AND OPINIONS: ALBERT EINSTEIN.

EPA (United States Environmental Protection Agency), "Global warming—emissions—individual," (updated Jan. 7, 2000). Retrieved Aug. 4, 2006 from [Government report posted on-line] http://yosemite.epa.gov/oar/globalwarming.nsf/content/EmissionsIndividual.html.

EPA (United States Environmental Protection Agency), "US emissions inventory 2006: inventory of U.S. greenhouse gas emissions and sinks: 1990-2004, USEPA #430-R-06-002," (Apr. 2006). Retrieved Aug. 4, 2006 from [Government report posted on-line] http://yosemite.epa.gov/oar/globalwarming.nsf/content/ResourceCenterPublicationsGHG EmissionsUSEmissionsInventory2006.html

Emerson, Ralph Waldo. THE SELECTED WRITINGS OF RALPH WALDO EMERSON. Brooks Atkinson, ed. (New York: Modern Library, 1968).

Etcoff, Nancy. SURVIVAL OF THE PRETTIEST: THE SCIENCE OF BEAUTY. (New York: Anchor Books, 1999).

Ford, Joseph. In James Gleick, CHAOS: MAKING A NEW SCIENCE. (New York: Penguin Books, 1987).

Freedman, Wendy L. and Michael S. Turner. "Colloquium: measuring and understanding the universe." (Reviews of Modern Physics, 75: 4, 2003), pp. 1433-1447.

Gardner, Howard. CREATING MINDS: AN ANATOMY OF CREATIVITY SEEN THROUGH THE LIVES OF FREUD, EINSTEIN, PICASSO, STRAVINSKY, ELIOT, GRAHAM, AND GANDHI. (New York: Basic Books, 1993).

Gell-Mann, Murray. THE QUARK AND THE JAGUAR: ADVENTURES IN THE SIMPLE AND THE COMPLEX. (New York: W. H. Freeman, 1994).

Gingerich, Owen. THE BOOK NOBODY READ: CHASING THE REVOLUTIONS OF NICHOLAS COPERNICUS. (New York: Walker, 2004).

Gleick, James. CHAOS: MAKING A NEW SCIENCE. (New York: Penguin Books, 1987).

Goodenough, Ursula W. THE SACRED DEPTHS OF NATURE. (New York: Oxford Univ. Press, 1988).

Goodenough, Ursula W. "Creativity in science." (Zygon, 28, Sept. 1993), pp. 399-414.

Goodstein, Laurie. "Judge rejects teaching Intelligent Design." (*New York Times,* Dec. 21, 2005).

Gore, Al. *AN INCONVENIENT TRUTH.* (New York: Rodale Books, 2006). See also links to video at http://www.climatecrisis.net.

Gould, Stephen J. *ROCKS OF AGES: SCIENCE AND RELIGION IN THE FULLNESS OF LIFE.* (New York: Ballantine Books, 1999).

Grassie, William. "Beyond Intelligent Design." (*Metanexus,* May 5, 2005). Retrieved Aug. 4, 2006 from [On-line magazine] http://www.metanexus.net/metanexus_online/printer_friendly.asp?ID=9284.

Guth, Alan H. *THE INFLATIONARY UNIVERSE: THE QUEST FOR A NEW THEORY OF COSMIC ORIGINS.* (Cambridge, MA: Perseus Books, 1997).

Haught, John F. *SCIENCE AND RELIGION: FROM CONFLICT TO CONVERSATION.* (New York: Paulist Press, 1995).

Haught, John F. *GOD AFTER DARWIN: A THEOLOGY OF EVOLUTION.* (Boulder, CO: Westview Press, 2000).

Haught, John F. "In search for a god for evolution: Paul Tillich and Pierre Teilhard de Chardin." (*Zygon, 37,* Sept. 2002), pp. 539-553.

Hanson, Robert W., ed. *SCIENCE AND CREATION: GEOLOGICAL, THEOLOGICAL, AND EDUCATIONAL PERSPECTIVES.* (New York: Free Press, 1986).

Hawking, Stephen W. *A BRIEF HISTORY OF TIME: FROM THE BIG BANG TO BLACK HOLES.* (New York: Bantam Books, 1988).

Hawkins, Gerald S. *STONEHENGE DECODED: AN ASTRONOMER EXAMINES ONE OF THE GREAT PUZZLES OF THE ANCIENT WORLD.* (New York: Barnes & Noble Books, 1989).

Hedrick, Samuel. Sermon preached at Parkway Methodist Church, Milton, MA on August 1986. Rev. Hedrick discovered this saying at Christ Church, Oxford, UK, where John Wesley was educated.

Hefner, Philip. *THE HUMAN FACTOR: EVOLUTION, CULTURE, AND RELIGION (THEOLOGY AND THE SCIENCES).* (Minneapolis, MN: Fortress Press, 1993).

Heilbron, J. L. *THE SUN IN THE CHURCH: CATHEDRALS AS SOLAR OBSERVATORIES.* (Cambridge, MA: Harvard Univ. Press, 1999).

Heller, Eric J. "Resonance Fine Art" [website]. Retrieved Aug. 4, 2006 from http://EricJHellerGallery.com. See also the image "Bessel 21" Retrieved Aug. 4, 2006 from http://ericjhellergallery.com/index.pl?page=image;iid=25

Henderson, Bobby. *THE GOSPEL OF THE FLYING SPAGHETTI MONSTER.* (New York, Random House, 2006). See also the humorous website associated with this book, "The Church of the Flying Spaghetti Monster." Retrieved Aug. 4, 2006 from http://www.venganza.org/.

Hilborn, Robert C. *CHAOS AND NONLINEAR DYNAMICS: AN INTRODUCTION FOR SCIENTISTS AND ENGINEERS.* (New York: Oxford Univ. Press, 2000).

Hilborn, Robert C. "Nonlinear dynamics and pattern formation," presented at the New England Section of the American Physical Society Meeting, Middlebury Coll., Middlebury, VT, Mar. 31, 2001.

Hockfield, Susan. "MIT and the Challenge of Energy," [opening remarks] MIT Energy Forum, Cambridge, MA, May 3, 2006. Retrieved Aug. 4. 2006 from http://web.mit.edu/newsoffice/2006/energy-sh-speech.html.

Hofstadter, Douglas R. *GÖDEL, ESCHER, BACH: AN ETERNAL GOLDEN BRAID.* (New York: Basic Books, 1979).

Holton, G., H. Chang and E. Jurkowitz. "How a scientific study is made: a case history." (*American Scientist*, 84, 1996), pp. 364-373.

Holloran and Clayborne Carson, 1 -20, (New York: IPM-Warner Books).

Houghton, J.T., Y. Ding, D. J. Griggs, M. Noguer, P. J. van der Linden, and D. Xiaosu, eds. *UNITED NATIONS INTERGOVERNMENTAL PANEL ON CLIMATE CHANGE. CLIMATE CHANGE 2001: THE SCIENTIFIC BASIS.* (Cambridge, UK: Cambridge Univ. Press, 2001). This report is also published on-line and was retrieved Aug. 4, 2006 from http://www.grida.no/climate/ipcc_tar/wg1/index.htm

Hummel, Charles E. *THE GALILEO CONNECTION: RESOLVING CONFLICTS BETWEEN SCIENCE AND THE BIBLE,* (Downers Grove, IL: InterVarsity Press, 1986).

Hutchins, R. M. and M.J. Adler, eds. *GREAT IDEAS TODAY.* (Chicago: Encyclopaedia Britannica, 1963).

IRAS, Institute of Religion in an Age of Science Conference, 1969. http://www.iras.org/pastconf.html.

Isaac, Randy, "From Gaps to God: perspectives on science and Christian faith." (*Journal of the American Scientific Affiliation*, 57, Sept. 2005), pp. 230-233.

Jackson, William J. *HEAVEN'S FRACTAL NET: RETRIEVING LOST VISIONS IN THE HUMANITIES,* (Bloomington, IN: Indiana Univ. Press, 2004).

Jacobsen, Thorkild. "Enuma Elish-The Babylonian Genesis" in Milton K. Munitz, ed. *THEORIES OF THE UNIVERSE: FROM BABYLONIAN MYTH TO MODERN SCIENCE,* (Glencoe, IL: The Free Press, 1957).

James, Robison B. "Irony and comedy in Empiricists' efforts to understand Tillich's theory of religious symbolism." In Robert S. Corrington and John Deely, eds., *SEMIOTICS 1993,* pp. 160-168.

Jammer, Max. *EINSTEIN AND RELIGION.* (Princeton, NJ: Princeton Univ. Press, 1999).

Jansen, Howard. "Rolston urges care for nature." (*SciTech, Journal of the Presbyterian Association on Science, Technology, and the Christian Faith, 14:* 3, Aug. 2005).

Johnson. George. *FIRE IN THE MIND: SCIENCE, FAITH, AND THE SEARCH FOR ORDER.* (New York: Alfred A. Knopf, 1995).

Kauffman, Stuart. *AT HOME IN THE UNIVERSE: THE SEARCH FOR THE LAWS ON SELF-ORGANIZATION AND COMPLEXITY.* (New York: Oxford University Press, 1995).

Kauffman, Stuart. *INVESTIGATIONS.* (New York: Oxford University Press, 2000).

Kaufman, Gordon D. *IN FACE OF MYSTERY: A CONSTRUCTIVE THEOLOGY.* (Cambridge, MA: Harvard Univ. Press, 1993).

Kaufman, Gordon D. *IN THE BEGINNING...CREATIVITY.* (Minneapolis, MN: Augsburg Fortress, 2004)

Keats, John. 1819. "Ode on a Grecian Urn." In Arthur Quiller-Couch, ed. *THE OXFORD BOOK OF ENGLISH VERSE: 1250–1900.* (Oxford: Clarendon, 1919).

Kegley, Charles W. and Robert W. Bretall. *THE THEOLOGY OF PAUL TILLICH, VOL. 1.* (New York: Macmillan, 1961).

King, Martin Luther Jr. "Remaining Awake Through a Great Revolution." Commencement Address for Oberlin College, Oberlin OH, June 1965.

Klee, Paul. *PAUL KLEE: THE DJERASSI COLLECTION.* (San Francisco Museum of Modern Art, 1997), Fig. 47, *Insecten,* p. 61.

Koomey, Jonathan. "Costs of reducing carbon emissions in the U.S.: Some recent results." Lawrence Berkeley National Laboratory. Presented at AAAS Meeting, San Francisco, CA (February 20, 2001). Retrieved Aug. 4, 2006 from http://enduse.lbl.gov/SharedData/CEFsummary020215.pdf.

Krutch, Joseph Wood, ed. WALDEN AND OTHER WRITINGS BY HENRY DAVID
 THOREAU. (New York: Bantam, 1986).

Kuhn, Thomas S. THE STRUCTURE OF SCIENTIFIC REVOLUTIONS, (Chicago: Univ.
 of Chicago Press, 1970).

Latour, Bruno and Peter Weibel, eds. ICONOCLASH: BEYOND THE IMAGE WARS IN
 SCIENCE, RELIGION, AND ART. (Cambridge, MA: MIT Press, 2002).

Lemaître, Georges. In Duncan Aikman "Lemaître follows two paths to truth."

Lesmoir-Gordon, N., W. Rood and R. Edney. INTRODUCING FRACTAL GEOMETRY.
 (Lanham, MD: Totem Books, 2001).

Lindberg, David C. THE BEGINNINGS OF WESTERN SCIENCE. (Chicago: Univ. of
 Chicago Press, 1992).

Linden, Eugene. "The big meltdown." (TIME Magazine, Sept. 4, 2000).

Livio, Mario. THE ACCELERATING UNIVERSE: INFINITE EXPANSION, THE
 COSMOLOGICAL CONSTANT, AND THE BEAUTY OF THE COSMOS. (New York:
 Wiley, 2000).

Livio, Mario. THE GOLDEN RATIO: THE STORY OF PHI, THE WORLD'S MOST
 ASTONISHING NUMBER. (New York: Broadway Books, 2002).

Mandelbrot, Benoit. THE FRACTAL GEOMETRY OF NATURE. (New York: W. H.
 Freeman, 1983).

Mann, Thomas (1912). DEATH IN VENICE. trans. by Kenneth Burke. (New York:
 Bantam, 1971).

Marsden, George M. JONATHAN EDWARDS: A LIFE. (New Haven, CT: Yale Univ.
 Press, 2003).

Matthews, Clifford N. and Roy A. Varghese, eds. COSMIC BEGINNINGS AND
 HUMAN ENDS: WHERE SCIENCE AND RELIGION MEET. (LaSalle, IL: Open
 Court., 1995).

May, Rollo. THE COURAGE TO CREATE. (New York: Norton, 1975).

McAllister, James W. "Is beauty a sign of truth in scientific theories?"
 (American Scientist, 86, Mar.-Apr. 1998), pp 174-183.

Miller, Kenneth. "The Flagellum Unspun: The Collapse of Irreducible
 Complexity." In William A. Dembski and Michael Ruse, eds., DEBATING
 DESIGN: FROM DARWIN TO DNA.

Moyers, Bill. *EARTH ON EDGE* [TV broadcast series]. (Public Broadcasting System, June 19, 2001). See also links to video and companion book at http://www.pbs.org/earthonedge.

Page, Torvis. "Consecration and conservation: Walden Pond as a sacred site." (*Journal of the Faith & Science Exchange, 5,* 2001).

Pais, Abraham. *SUBTLE IS THE LORD: THE SCIENCE AND LIFE OF ALBERT EINSTEIN.* (New York: Oxford Univ. Press, 1982).

Peacocke, Arthur. "Chance and law in irreversible thermodynamics, theoretica, biology, and theology," in *CHAOS AND COMPLEXITY: SCIENTIFIC PERSPECTIVES ON DIVINE ACTION.* (Notre Dame, IN: Notre Dame Press, 1995), pp. 123-143.

Peacocke, Arthur. "Welcoming the 'disguised friend'—Darwinism and divinity." Presented at Templeton Boston Workshop on Science and Religion, MIT, Cambridge, MA. June 15, 1998 and later published in Robert T. Pennock, ed., *INTELLIGENT DESIGN CREATIONISM AND ITS CRITICS: PHILOSOPHICAL, THEOLOGICAL AND SCIENTIFIC PERSPECTIVES.*

Pennock, Robert T., ed. *INTELLIGENT DESIGN CREATIONISM AND ITS CRITICS: PHILOSOPHICAL, THEOLOGICAL AND SCIENTIFIC PERSPECTIVES.* (Cambridge, MA: MIT Press, 2001).

Peters, Edgar E. *FRACTAL MARKET ANALYSIS: APPLYING CHAOS THEORY TO INVESTMENT & ECONOMICS.* (New York: Wiley, 1994).

Peters, Ted. *PLAYING GOD: GENETIC DETERMINISM AND HUMAN FREEDOM.* (New York: Routledge, 1997).

Planck, Max. *WHERE IS SCIENCE GOING?* trans. James Murphy. (New York: W. W. Norton, 1977).

Poincaré, Henri. *THE VALUE OF SCIENCE.* (New York: Dover, 1958).

Rahmat-Samii, Y. and E. Michielssen (Eds.), *ELECTROMAGNETIC OPTIMIZATION BY GENETIC ALGORITHM,* (New York: Wiley, 1999).

Raven, Charles [1951]. Gifford Lectures, published as *NATURAL RELIGION AND CHRISTIAN THEOLOGY: FIRST SERIES* and *SCIENCE AND RELIGION: SECOND SERIES.* (Cambridge, UK: Cambridge Univ. Press, 1953).

Raven, Peter H. [Chairman]. "AAAS Board Resolution on Intelligent Design Theory." (American Association for the Advancement of Science, Nov. 6, 2002). Retrieved [on-line news archive] Aug. 4, 2006 from http://www.aaas.org/news/releases/2002/1106id.shtml.

Raymo, Chet. "Bush is not looking at the big world" (*Boston Globe*, Apr. 24, 2002).

Reich, K. Helmut. *DEVELOPING THE HORIZONS OF THE MIND: RELATIONAL AND CONTEXTUAL REASONING AND THE RESOLUTION OF COGNITIVE CONFLICTS.* (Cambridge, UK: Cambridge Univ. Press, 2002).

Rolston, Holmes III. *PHILOSOPHY GONE WILD: ENVIRONMENTAL ETHICS.* (Buffalo, NY: Prometheus Books, 1989), p. 259. See also "The Pasqueflower," retrieved Aug. 4, 2006 from http://lamar.colostate.edu/~hrolston/Pasqueflower.pdf.

Rolston, Holmes III. *GENES, GENESIS, AND GOD: VALUES AND THEIR ORIGINS IN NATURAL AND HUMAN HISTORY.* (New York: Cambridge University Press, 1999).

Rue, Loyal D. *EVERYBODY'S STORY: WISING UP TO THE EPIC OF EVOLUTION.* (Albany: State University of New York Press, 2000).

Ruse, Michael. *DARWIN AND DESIGN: DOES EVOLUTION HAVE A PURPOSE?* (Cambridge, MA: Harvard University Press, 2003).

Russell, Michael. "First Life." (*American Scientist. 94*:1, Jan. - Feb., 2006), pp. 32-39.

Russell, Robert "The Relevance of Tillich for the Theology & Science Dialogue." In Ray F. Bulman and Frederick J. Parrella (Eds.), *RELIGION IN THE NEW MILLENNIUM: THEOLOGY IN THE SPIRIT OF PAUL TILLICH*, pp. 261-311.

Sagan, Carl, and Ann Druyan. *THE DEMON-HAUNTED WORLD: SCIENCE AS A CANDLE IN THE DARK.* (New York: Ballantine Books, 1997).

Schlilp, Phillip A., ed. *ALBERT EINSTEIN: PHILOSOPHER-SCIENTIST.* In *THE LIBRARY OF LIVING PHILOSOPHERS, VOL. VII.* Trans. Phillip A. Schlilp. (Evanston, IL: Open Court Pub. Co., 1949).

Schweitzer, Albert. [1931]. *OUT OF MY LIFE AND THOUGHT.* Trans. Antje Bultmann Lemke. (Baltimore, MD: Johns Hopkins Univ. Press, 1998), pp. 223-245).

Schweitzer, Albert. *THE QUEST FOR THE HISTORICAL JESUS.* Trans. Antje Bultmann Lemke. (Baltimore, MD: Johns Hopkins Univ. Press, 1998).

Selig, Carl, ed. *IDEAS AND OPINIONS: ALBERT EINSTEIN.* Sonja Bargmann, trans.. (New York: Crown, 1954).

Shlain, Leonard. *ART AND PHYSICS: PARALLEL VISIONS IN SPACE, TIME AND LIGHT.* (San Francisco: Harper Perennial, 2002).

Skehan, James W. [1985]. "The Age of the Earth, of Life and of Mankind: Geology and Biblical Theology versus Creationism," in Robert W. Hanson, ed, SCIENCE AND CREATION: GEOLOGICAL, THEOLOGICAL, AND EDUCATIONAL PERSPECTIVES, pp. 10-32.

Skehan, James W. "Modern science and the book of Genesis." Chapter 1 of THE CREATION CONTROVERSY: THE SCIENCE CLASSROOM. (Arlington, VA: National Science Teachers Association, 2000).

Smith, Huston. THE WORLD'S RELIGIONS: OUR GREAT WISDOM TRADITIONS. (San Francisco: Harper, 1991).

Smith, Huston. "Why Religion Mattters: The Fate of the Human Spirit in and Age of Disbelief." Special Topics Forum, American Academy of Religion Meeting, Nashville, TN, Nov. 19, 2000. See also *Science and Theology News* [on-line edition] "Science and Religion at the American Academy of Religion" by Thomas Jay Oord, January 1, 2001 retrieved Aug. 4, 2006 from http://www.stnews.org/News-2306.htm.

Suchocki, Marjorie Hewitt. GOD, CHRIST, CHURCH: A PRACTICAL GUIDE TO PROCESS THEOLOGY, MARJORIE HEWITT. (New York: Crossroad, 1982).

Swimme, Brian and Thomas Berry. THE UNIVERSE STORY: FROM THE PRIMORDIAL FLARING FORTH TO THE ECOZOIC ERA—A CELEBRATION OF THE UNFOLDING OF THE COSMOS. (San Francisco: Harper, 1992).

Talbot, Margaret. "Darwin in the dock: Intelligent Design has its day in court." (*New Yorker,* Dec. 5, 2005).

Margaret Talbot, Teilhard de Chardin, Pierre. THE DIVINE MILIEU. (New York: Harper Torchbooks, 1960).

Teilhard De Chardin, Pierre. THE PHENOMENON OF MAN. (New York: Harper Torchbooks, 1961).

Teilhard de Chardin, Pierre. THE FUTURE OF MAN. (New York: Harper and Row, 1964).

Thomas, J. Mark., ed. THE SPIRITUAL SITUATION IN OUR TECHNOLOGICAL SOCIETY. (Macon, GA: Mercer Univ. Press, 1988).

Thoreau, Henry David (1854). WALDEN AND OTHER WRITINGS BY HENRY DAVID THOREAU.

Thoreau, Henry David [Journals A] in Francis H. Allen, ed.. MEN OF CONCORD.

Thoreau, Henry David [1849]. A WEEK ON THE CONCORD AND MERRIMACK RIVERS. (Orleans, MA: Parnassus Imprints, 1987).

Thoreau, Henry David [Journals B] in Bradley Dean, ed. *FAITH IN A SEED: THE DISPERSION OF SEEDS AND OTHER LATE NATURAL HISTORY WRITINGS.*

Tillich, Paul. "Science and Theology: A Discussion with Einstein." *The Union Review,* Nov 1940. Reprinted in Chap. IX. *THEOLOGY OF CULTURE.* Oxford Univ. Press. 1959.

Tillich, Paul. *SYSTEMATIC THEOLOGY, VOL 1.* (Chicago: Univ. of Chicago Press, 1951).

Tillich, Paul. *THE COURAGE TO BE.* (New Haven, CT: Yale Univ. Press, 1952).

Tillich, Paul. *Parade Magazine* in the Sunday *Star Ledger,* (Newark, NJ), Sept. 1955.

Tillich, Paul. "The nature of religious language." *The Christian Scholar.* Sept. 1955. Reprinted in Paul Tillich, *THE THEOLOGY OF CULTURE.*

Tillich, Paul. "The Lost Dimension in Religion." *The Saturday Evening Post,* June 14, 1958, pp. 29, 76, 78-79. Reprinted in F. Forrester Church, ed., *THE ESSENTIAL TILLICH: AN ANTHOLOGY OF THE WRITINGS OF PAUL TILLICH,* pp. 1-8.

Tillich, Paul. *THE THEOLOGY OF CULTURE.* Robert C. Kimball, ed. (New York: Oxford Univ. Press, 1959).

Tillich, Paul. *LOVE, POWER AND JUSTICE: ONTOLOGICAL ANALYSIS AND ETHICAL APPLICATIONS.* (Oxford Univ. Press, 1960).

Tillich, Paul [1960]. "The relationship today between science and religion," in J.M. Thomas, *THE SPIRITUAL SITUATION IN OUR TECHNOLOGICAL SOCIETY,* pp. 151-172.

Tillich, Paul [1963A]. *SYSTEMATIC THEOLOGY: LIFE AND THE SPIRIT, HISTORY AND THE KINGDOM OF GOD, VOL. 3.* (Chicago: Univ. of Chicago Press, 1963).

Tillich, Paul [1963B]. "Has man's conquest of space increased or diminished his stature? A Symposium" in R.M. Hutchins and M.J. Adler, eds. *GREAT IDEAS TODAY.* (Chicago: Encyclopaedia Britannica, 1963), pp. 49-59. Reprinted in J. Mark Thomas, ed., *THE SPIRITUAL SITUATION IN OUR TECHNOLOGICAL SOCIETY.*

Tillich, Paul. *A HISTORY OF CHRISTIAN THOUGHT: FROM ITS JUDAIC AND HELLENISTIC ORIGINS TO EXISTENTIALISM.* Carl E. Braaten, ed. (New York: Simon and Schuster, 1967).

Tucker, Mary Evelyn and John Grim. Forum on Religion and Ecology. For information on activities see [website] retrieved Aug. 4, 2006 from http://environment.harvard.edu/religion/main.html.

Updike, John. ROGER'S VERSION. (New York: Alfred A. Knopf, 1986).

Updike, John in James Yerkes, ed., JOHN UPDIKE AND RELIGION: THE SENSE OF THE SACRED AND THE MOTIONS OF GRACE.

Von Balthaser, Hans Urs. LOVE ALONE IS CREDIBLE. (San Francisco: Ignatius Press, 1963).

Wallace, Mark. THE SECOND NAIVETE: BARTH, RICOUR, AND THE NEW YALE THEOLOGY. (Macon, GA: Mercer University Press, 1990).

Weinberg, Steven. DREAMS OF A FINAL THEORY. (New York: Pantheon Books, 1992).

Whitehead, Alfred N. PROCESS AND REALITY: AN ESSAY IN COSMOLOGY. (New York: MacMillan, 1929).

Whitehead, Alfred N. ADVENTURES OF IDEAS. (New York: MacMillan, 1933), pp. 309-352.

Wildman, Wesley. "Intelligent design: pseudoscience, bad theology." (Bulletin of the Boston Theological Institute, 5.2, Spring 2006), p. 15.

Wilgoren, Jodi. "Kansas board approves challenges to evolution." (New York Times National Desk Late Edition, Nov. 9, 2005), p. A5.

Wilkinson microwave anisotropy probe, [WMAP]. "Science and Instrument Papers First Year Data Release." A collection of technical papers released by NASA in February 2002 and retrieved Aug. 4, 2006 can be found at http://map.gsfc.nasa.gov/m_mm/pub_papers/firstyear.html. For updates and maps see also http://map.gsfc.nasa.gov/index.html.

Wilson, Marvin R. OUR FATHER ABRAHAM: JEWISH ROOTS OF THE CHRISTIAN FAITH. (Grand Rapids, MI, Eerdmans, 1989).

Wolfram, Steven. A NEW KIND OF SCIENCE. (Champaign, IL: Wolfram Media, 2002). Also [on-line book] retrieved August 4, 2006 from www.wolframscience.com/nksonline/.

Yeats, William B. [1921]. "The second coming," in ROUTLEDGE LITERARY SOURCEBOOK ON THE POEMS OF W. B. YEATS. (Oxford, U.K.: Routledge, 2003).

Yerkes, James, ed. JOHN UPDIKE AND RELIGION: THE SENSE OF THE SACRED AND THE MOTIONS OF GRACE. (Grand Rapids, MI: Eerdmans, 1999).

Young, Matt and Taner Edis, eds. WHY INTELLIGENT DESIGN FAILS: A SCIENTIFIC CRITIQUE OF THE NEW CREATIONISM. (New Brunswick, NJ: Rutgers Univ. Press, 2004).

INDEX

ABOUT THE AUTHOR, PAUL H. CARR

This book is result of Paul H Carr's life-long quest to yoke science and spirituality to meet the challenges of our time. He majored in physics at Massachusetts Institute of Technology, studied the theology of culture under Paul Tillich at Harvard University, and earned his Ph.D. (physics) at Brandeis University. From 1967 to 1995, he led a group at the AF Research Laboratory on microwave ultrasonic surface acoustic waves (SAW) and superconductors. This resulted in smaller and lower-cost components for radar, television and cell phones. The John Templeton Foundation awarded him a grant for the philosophy course "Science and Religion: Cosmos to Consciousness," which he taught at the University of Massachusetts Lowell from 1998 to 2000.

Dr. Carr has published over eighty papers in refereed scientific journals, *ZYGON: Journal of Religion and Science* and in the book *RELIGION IN THE NEW MILLENNIUM: THEOLOGY IN THE SPIRIT OF PAUL*

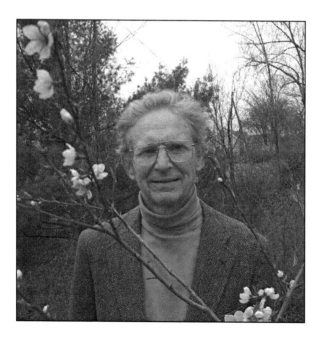

FIGURE A.2: Paul H. Carr near his peach tree.

TILLICH. He has been awarded ten patents for microwave devices. He has presented papers and organized workshops at professional meetings, universities, and churches in the United States and abroad. The John Templeton Foundation awarded him three science and religion grants. He has won prizes for his nature photography exhibits at the Manchester, New Hampshire Artists Association and the Marblehead, Massachusetts Artists Association.

Dr. Carr is a life fellow of the Institute of Electrical and Electronic Engineers, co-editor of the newsletter of the New England Section of the American Physical Society of which he is life-member, and President of the Hanscom Sigma Xi Chapter. He was a board member of the Faith and Science Exchange and the North American Paul Tillich Society. He is an active member of the Institute of Religion in an Age of Science, the American Scientific Affiliation, and the Thoreau Society.

In memory of his father, a Methodist minister, Paul has established the "Paul and Auburn Carr Scholarship in Science and Religion" at Boston University School of Theology, Reverend Auburn Carr's alma mater. Dr. Carr served as a deacon and teacher at the Congregational Church (UCC), Bedford, Massachusetts, where he and his wife Karin raised their five daughters. In 1986, Karin died of leukemia at age forty-six. In 2002, he moved to Bedford, New Hampshire to marry Virginia Kilpack and live next to a babbling brook. He is active in the adult education program of the Bedford, New Hampshire Presbyterian Church and a member of Presbyterian Association on Science, Technology, and Christian Faith.